PICTURING THE PAST

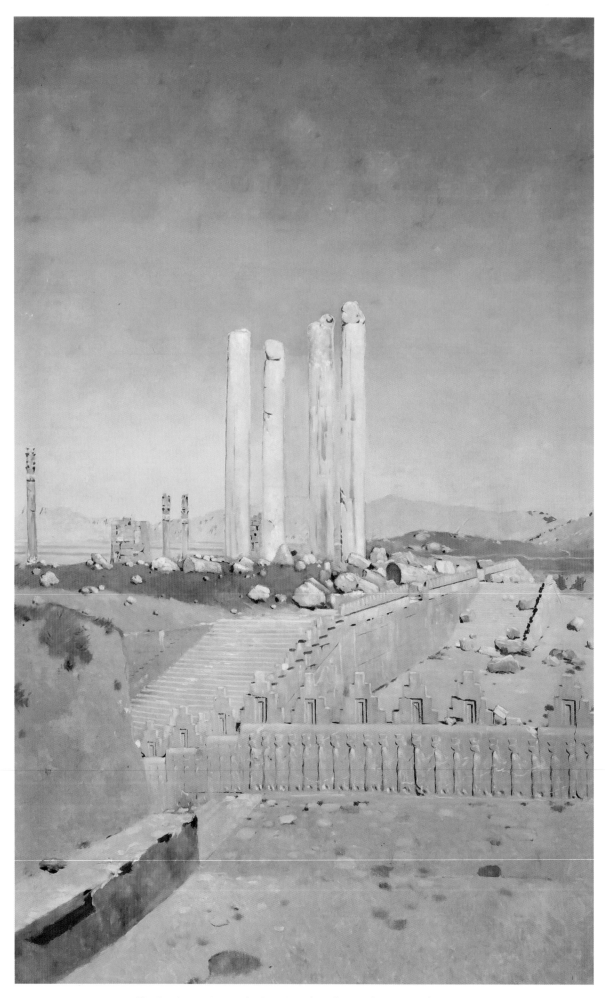

The Apadana at Persepolis, Iran. Joseph Lindon Smith. 1935. Catalog No. 19

PICTURING THE PAST

IMAGING AND IMAGINING
THE ANCIENT MIDDLE EAST

edited by

JACK GREEN
EMILY TEETER

and

JOHN A. LARSON

with new photography by Anna Ressman

ORIENTAL INSTITUTE MUSEUM PUBLICATIONS 34
THE ORIENTAL INSTITUTE OF THE UNIVERSITY OF CHICAGO

Library of Congress Control Number: 2001012345
ISBN-10: 1-885923-89-9
ISBN-13: 978-1-885923-89-9

The Oriental Institute, Chicago

This volume has been published in conjunction with the exhibition
Picturing the Past: Imaging and Imagining the Ancient Middle East
February 7–September 2, 2012

Oriental Institute Museum Publications 34

Series Editors

Leslie Schramer

and

Thomas G. Urban

with the assistance of
Rebecca Cain, Zuhal Kuru, *and* Jessen O'Brien

Published by The Oriental Institute of the University of Chicago
1155 East 58th Street
Chicago, Illinois, 60637 USA
oi.uchicago.edu

Cover Illustration

Front cover illustration: Archaeological plan and reconstruction of a temple/palace at Chogha Mish, Iran.
Farzin Rezaeian. 2007. Catalog No. 23 (reproduced with kind permission of Farzin Rezaeian)

Printed by Four Colour Print Group, Loves Park, Illinois

TABLE OF CONTENTS

Foreword. *Gil J. Stein* .. 7

Acknowledgments .. 9

List of Contributors .. 10

Map of the Middle East .. 12

1. Introduction. *Jack Green* ... 13

2. The Oriental Institute and Early Documentation in the Nile Valley. *Emily Teeter* 25

3. The Epigraphic Survey and the "Chicago Method." *W. Raymond Johnson* 31

4. The Sakkarah Expedition. *Ann Macy Roth* ... 39

5. Photography and Documentation of the Middle East. *Emily Teeter* 45

6. The Oriental Institute Photographic Archives. *John A. Larson* .. 51

7. Aerial Photographs and Satellite Images. *Scott Branting, Elise MacArthur,
 and Susan Penacho* ... 57

8. Facsimiles of Ancient Egyptian Paintings: The Work of Nina de Garis Davies,
 Amice Calverley, and Myrtle Broome. *Nigel Strudwick* ... 61

9. Preserving the Past in Plaster. *William H. Peck* ... 71

10. Drawing Reconstruction Images of Ancient Sites. *Jean-Claude Golvin* 77

11. The Persepolis Paintings of Joseph Lindon Smith. *Dennis O'Connor* 83

12. Three-Dimensional Digital Forensic Facial Reconstruction: The Case
 of Mummy Meresamun. *Joshua Harker* ... 91

13. A Brief History of Virtual Heritage. *Donald H. Sanders* .. 95

Catalog .. 105

The Epigraphic Process .. 108

Facsimiles .. 113

Architectural Renderings and Reconstructions ... 117

Reconstructing the Past from Fragments ... 138

Photography .. 145

Models and Copies .. 161

The Future of Documentation ... 169

Concordance of Museum Registration Numbers ... 173

Checklist of the Exhibit .. 174

Bibliography .. 175

FOREWORD

GIL J. STEIN
DIRECTOR, ORIENTAL INSTITUTE

In one of the most powerful passages in T. S. Eliot's poem "The Waste Land," he writes:

> What are the roots that clutch, what branches grow
> Out of this stony rubbish? Son of man,
> You cannot say, or guess, for you know only
> A heap of broken images

Eliot's haunting poem gets to the heart of the challenge that faces archaeologists in their research — how can we re-discover the past and communicate our findings to scholars and the public, when the surviving remains are so fragmentary? How can we reconstruct what was lost, understand what we have found, and represent it accurately, when all we have to work with are "a heap of broken images"? The Oriental Institute's special exhibit Picturing the Past: Imaging and Imagining the Ancient Middle East addresses the poet's challenge — and provides some fascinating answers that go to the very heart of the process of discovery. I want to thank exhibit co-curators Jack Green, Emily Teeter, and John Larson, along with the talented staff of the Oriental Institute's Museum, for the outstanding job they have done in showing us a new way to look at the ancient Near East, and for encouraging us to question how and why we see it as we do.

Recovering the physical remains of the past is difficult in and of itself, but a second set of challenges arises when we try to record these remains accurately and extrapolate from the surviving fragments how to construct an image of what they looked like originally and how they might have been used. As detailed by the contributors to this catalog, science, art, and imagination all form part of the process by which we reconstruct and visualize ancient societies from their material remains. As technology and our general state of knowledge improve, archaeologists have been able to make progressively better images of the past, for example, in going from drawings and paintings to photography to computer-generated three-dimensional reconstructions. Thus, for example, James Henry Breasted's pioneering combination of photography and pen-and-ink drawings raised the recording of Egyptian reliefs and inscriptions to new, and in some ways still-unmatched, levels of information-rich accuracy. Aerial photography and remote sensing satellite imagery now allow us to see ancient sites and landscapes in ways that were never before possible.

But technological innovations have their limits. We have to recognize that we are still "imagining" the past, and that the physical models and digital images we use to build our reconstructions are very much shaped by our prior conceptions and understandings. We are always filling in the gaps in what survives by using what we know (or think we know) from other sites, artifacts, or textual records to develop a composite imagining of a landscape, a building, or even an individual person from thousands of years ago. This combination of science and art epitomizes the very best in scholarship; some of our reconstructions of the ancient Middle East may be guesses, but they are highly educated guesses. Picturing the Past does a wonderful job in showing the creativity and detective work involved in extracting an accurate portrait of ancient civilizations out of the "heap of broken images" that survive from the actual past.

ACKNOWLEDGMENTS

This exhibit is the result of close teamwork involving the entire staff of the Oriental Institute Museum. Our Registrars, Helen McDonald and Susan Allison, kept track of the objects (no mean feat with some of the unregistered art), and our Conservators, Laura D'Alessandro and Alison Whyte, prepared the material for exhibit. Erik Lindahl and Brian Zimerle designed the show. Tom James, former Assistant Curator of Digital Images, and his successor, Curatorial Assistant Monica Velez, were of tremendous assistance with retrieving and storing images. The catalog would not have been possible without the constant assistance of Museum Archivist (and exhibit co-curator) John Larson, who searched out materials in folders, drawers, and boxes. We thank Anna Ressman for the new digital photography. Emily Teeter is responsible for the exhibit concept and most of the object selection, both of which were refined and shaped by her co-curators and our Community Advisory Group consisting of Randy Adamsick, Nathan Mason, Angela Adams, Molly Woulfe, Beverly Serrell, Matt Matcuk, Dianne Hanau-Strain, Patty McNamara, and Oriental Institute staff members Carole Krucoff and Wendy Ennes. We also thank Carole and Wendy for their feedback on labels and for designing and implementing public programming. Others who provided assistance or valuable insights include McGuire Gibson, Abbas Alizadeh, Eleanor Guralnick, Karen Wilson, Bruce B. Williams, Rozenn Bailleul-LeSuer, Elizabeth Barrell, Terry Friedman, Stephen Ritzel, Nigel Tallis, and Norma Franklin. We would also like to extend our thanks to the anonymous reviewer whose corrections and insights were greatly appreciated.

We thank Peggy and John Sanders for the loan of their painting of Nippur, and also Alain Charron, Conservator en Chef of the Départmental de Arles antique, for the loan of the works by Jean-Claude Golvin. We thank Mr. Golvin for his enthusiastic support of our request to borrow his original artwork. We also gratefully acknowledge the kind gesture of Dorothea Arnold, Curator in Charge of the Egyptian Department at the Metropolitan Museum of Art, to allow us to exhibit the Harry Burton photograph of the Tomb of Tutankhamun.

This catalog was also the result of many efforts. Emily Teeter and Jack Green took lead role in its contents and editing and John Larson provided invaluable help with the archival photographs. Claire Gainer and Joe Cain assisted in proofreading. Brian Zimerle designed the book cover, and our incredibly efficient, cheerful, and patient publications department consisting of Thomas Urban and Leslie Schramer did the final edit, unscrambled references and photo numbers, and designed the volume. Augusta Gudeman assisted with the bibliography. We also thank our colleagues who made their work available on the exhibit computer kiosk, including Carter Lupton of the Milwaukee Public Museum for sharing the Medinet Habu reconstruction by Brandon Trantor; Peter Der Manuelian, Harvard University, for his images of Giza; Jean-Claude Golvin; Donald Sanders of Learning Sites, Inc.; and especially Farzin Rezaeian, whose spectacular reconstruction of a fourth-millennium temple/palace also appears on the cover of this catalog.

Jack Green, Emily Teeter, and John A. Larson
Exhibit Curators

CONTRIBUTORS

About the Contributors*

AA **Abbas Alizadeh** is a senior research associate at the Oriental Institute and director of the Oriental Institute Iranian Prehistoric Project. He has conducted fieldwork in many areas of the Middle East, particularly in Fars and Khuzestan, Iran. He has published many books in English and Persian on the art and archaeology of Iran.

SB **Scott Branting** is director of the Center for Ancient Middle Eastern Landscapes (CAMEL) at the Oriental Institute, and research associate (assistant professor) in the Department of Near Eastern Languages and Civilizations at the University of Chicago. He is co-director of the Kerkenes Dağ Archaeological Project in Turkey.

JME **Jean M. Evans** is a research associate at the Oriental Institute, where she works on the Nippur Publication Project. Her research interests focus on Early Dynastic Mesopotamia, Sumerian sculpture, and religious practices. She is the co-author of the exhibit catalog *Beyond Babylon* (2008).

Jean-Claude Golvin is director of research emeritus at the CNRS, Ausonius Institute, University of Bordeaux-III. He was director of the Franco-Egyptian Center for the Study of the Temples of Karnak from 1979 to 1989. His reconstructions of ancient sites have appeared in a wide variety of publications, including the three-volume *L'Égypte restituée*. A retrospective of his work was presented at the Musée departemental Arles antique in 2011.

JG **Jack Green** (aka John D. M.) is chief curator of the Oriental Institute Museum and a co-curator of the exhibit Picturing the Past: Imaging and Imagining the Ancient Middle East. He is also a research associate at the Oriental Institute. He received his PhD from University College, London (2006), and was curator of the ancient Near East collections at the Ashmolean Museum, University of Oxford, from 2007 to 2011. He is also co-editor and major contributor to the Tell es-Saʿidiyeh (Jordan) Cemetery Publication Project of the British Museum.

Joshua Harker is a Chicago-area sculptor and artist who specializes in forensic reconstructions. Most recently, he restored the appearance of the "Belgrade mummy Nesmin."

WRJ **W. Raymond Johnson** is the field director of the University of Chicago's Epigraphic Survey in Luxor, Egypt. He is a specialist in the art of the reign of Amunhotep III. Since 1978 he has dedicated his life to the epigraphic recording and preservation of Egypt's ancient monuments.

JAL **John A. Larson** has been archivist of the Oriental Institute of the University of Chicago since 1980. He was the curator of the 2006 temporary exhibit Lost Nubia: A Centennial Exhibit of Photographs from the 1905–1907 Egyptian Expedition of the University of Chicago, and the editor of *Letters from James Henry Breasted to His Family, August 1919–July 1920*, the first volume in the series Oriental Institute Digital Archives (OIDA).

Elise V. MacArthur is a PhD student in Egyptian archaeology in the Department of Near Eastern Languages and Civilizations at the University of Chicago. She has worked at Giza and Tell Edfu. She was a curatorial assistant for the exhibit Before the Pyramids: The Origins of Egyptian Civilization at the Oriental Institute Museum. Her research interests include Predynastic and Early Dynastic Egypt, early writing, GIS technology, and photography.

Dennis O'Connor received his MA in Egyptology from the University of Memphis. He is presently an independent researcher writing a biography of Joseph Lindon Smith.

WHP **William H. Peck** is an independent Egyptologist and former museum curator. He is the author of *Drawings from Ancient Egypt*, *Splendors of Ancient Egypt*, and *Egypt in Toledo: The Egyptian Collection in the Toledo Museum of Art*. For many years, he has excavated at the precinct of the goddess Mut at Karnak.

Susan Penacho is a PhD candidate in Egyptian archaeology in the Department of Near Eastern Languages and Civilizations at the University of Chicago. She has done fieldwork at Kerkenes Dağ in Turkey and at Tell Edfu in

Egypt. Her dissertation is entitled "Interactions along Egypt's Southern Frontier: A GIS Analysis of the Natural and Built Environments of the Nubian Fortresses."

AR **Anna Ressman** is the head of photography at the Oriental Institute as well as a fine-art photographer. She was a co-founder of Space 419, a photography studio in Chicago, and she was a teaching artist at the Hyde Park Art Center. She has been published in national and international media outlets including CNN.com, WBEZ.org, the *Wall Street Journal*, *Archaeology* magazine, *Chicago Tribune*, and *Time Out Chicago*. Her work has been exhibited in Chicago and Pittsburgh and is in private and corporate collections in Illinois, California, New Mexico, and Pennsylvania.

SR **Seth Richardson** is a historian of the ancient Near East with interests in Assyriology, divination practices, and the history of violent conflict. He earned his PhD at Columbia University in 2002 and was assistant professor of ancient Near Eastern history at the University of Chicago until 2011. He is now the managing editor of the *Journal of Near Eastern Studies*.

Ann Macy Roth is currently a clinical associate professor and director of the program in Ancient Near Eastern and Egyptian Studies at New York University. While completing her doctorate at the University of Chicago, she served as an epigrapher for the Epigraphic Survey, and later initiated her own epigraphic project in the mastaba of Mereruka. More recently, she has directed epigraphic and archaeological research at the Giza plateau.

Donald H. Sanders, PhD, is trained and educated as an architect, architectural historian, and archaeologist. He is the president and founder of Learning Sites, Inc., and the Institute for the Visualization of History, Inc., both world leaders in virtual heritage. These companies have pioneered the use of virtual-reality technologies for interactive research, display, teaching, and publication of information about the past. He has been an invited keynote speaker, session chair, and panelist at numerous international venues.

Peggy Sanders is a Chicago-area artist who has served as an archaeological illustrator for excavations in Iraq, Egypt, Italy, and Greece. She has drawn pottery for publications by the Getty Museum, provided exhibition illustrations for the Art Institute of Chicago, and created computer-generated reconstructions for the University of Chicago excavations at Isthmia (Greece). Ms. Sanders holds a bachelor's degree in painting and drawing from the University of Wisconsin-Milwaukee. She has been a member of the Palette and Chisel Academy of Fine Art since 1995.

Nigel Strudwick is an Egyptologist who is currently teaching at the University of Memphis in Tennessee. He served as assistant keeper in the Egyptian Department of the British Museum. He has worked in the tombs of the nobles at Luxor since 1984, and he has written and lectured widely on Theban tombs and on the Old Kingdom.

ET **Emily Teeter** is a research associate and coordinator of special exhibits at the Oriental Institute. She is the editor of the exhibit catalogs *The Life of Meresamun: A Temple Singer in Ancient Egypt* and *Before the Pyramids: The Origins of Egyptian Civilization*. Her most recent books are *Religion and Ritual in Ancient Egypt* and *Baked Clay Figurines and Votive Beds from Medinet Habu*.

DW **Donald Whitcomb** directs a program in Islamic archaeology in the Department of Near Eastern Languages and Civilizations at the University of Chicago and he is a research associate at its Oriental Institute. He has conducted excavations in Egypt, Syria, Jordan, and the West Bank and field research in several other countries of the Middle East. His major interests include the early Islamic city and Islamic urbanism.

CW **Christopher Woods** is associate professor of Sumerology at the Oriental Institute, the Department of Near Eastern Languages and Civilizations, the Program on the Ancient Mediterranean World, and the College, University of Chicago. His research interests include Sumerian writing and grammar as well as early Mesopotamian religion and literature. His publications include *The Grammar of Perspective: The Sumerian Conjugation Prefixes as a System of Voice*. He was curator of the exhibit Visible Language: Inventions of Writing in the Ancient Middle East and Beyond.

* Initials identify contributors in the Catalog.

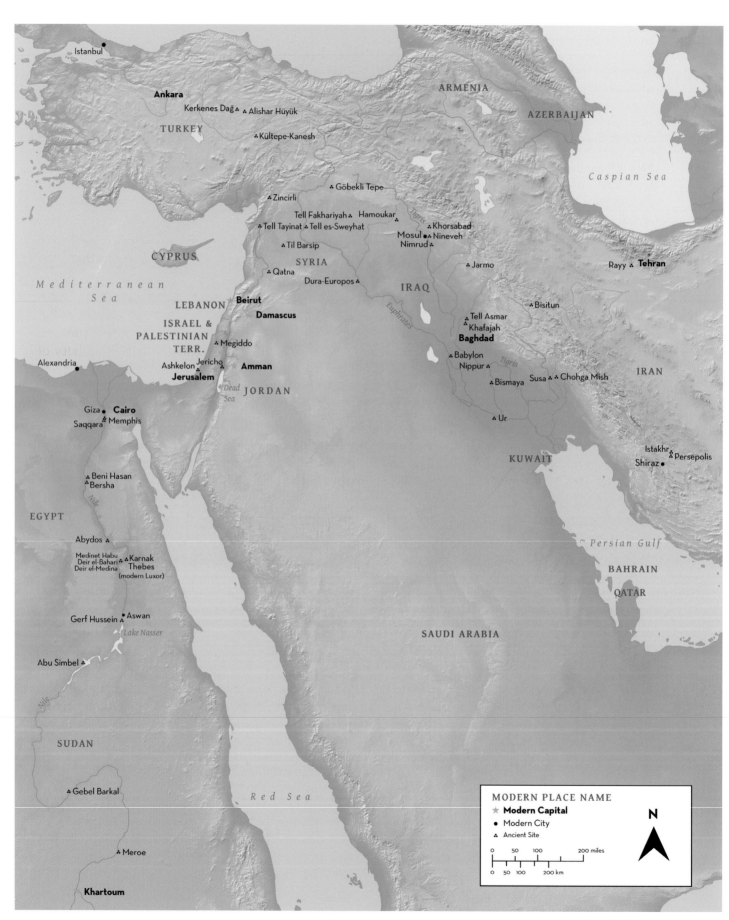

Istanbul

Ankara
Kerkenes Dağ ⚲ ⚲ Alishar Hüyük
TURKEY
⚲ Kültepe-Kanesh

ARMENIA

AZERBAIJAN

Caspian Sea

⚲ Göbekli Tepe
⚲ Zincirli
Tell Fakhariyah ⚲ ⚲ Hamoukar
Tell Tayinat ⚲ ⚲ Tell es-Sweyhat
⚲ Til Barsip
SYRIA
⚲ Khorsabad
Mosul ● ● Nineveh
Nimrud ⚲

⚲ Jarmo

Rayy ● **Tehran**

CYPRUS

Mediterranean Sea

⚲ Qatna
Dura-Europos ⚲

IRAQ

⚲ Bisitun

⚲ Tell Asmar
⚲ Khafajah
Baghdad

IRAN

LEBANON
Beirut
Damascus
ISRAEL &
PALESTINIAN
TERR.
⚲ Megiddo
Alexandria
Ashkelon ⚲ ⚲ Jericho ⭐ **Amman**
Jerusalem
Dead Sea
JORDAN

⚲ Babylon
Nippur ⚲

⚲ Bismaya
Susa ⚲ ⚲ Chohga Mish

⚲ Ur

KUWAIT

Istakhr ⚲
Shiraz ● ⚲ Persepolis

Giza ● **Cairo**
Saqqara ⚲ ⚲ Memphis

EGYPT

⚲ Beni Hasan
⚲ Bersha

Persian Gulf

BAHRAIN

QATAR

Abydos ⚲

Medinet Habu
Deir el-Bahari ⚲ ⚲ Karnak
Deir el-Medina ⚲ Thebes
(modern Luxor)

Gerf Hussein ⚲ ● Aswan
Lake Nasser

SAUDI ARABIA

Abu Simbel ⚲

Nile

SUDAN

⚲ Gebel Barkal

Red Sea

⚲ Meroe

Khartoum

MODERN PLACE NAME
⭐ **Modern Capital**
● Modern City
⚲ Ancient Site

N

0 50 100 200 miles
0 50 100 200 km

Map of the Middle East

1. INTRODUCTION

JACK GREEN

This catalog and its related essays explore an important but often overlooked set of themes in the archaeology of the Middle East, its history, and potential future directions. The content of the Picturing the Past exhibit consists largely of archival images, paintings, models, photographs, digital restorations, and equipment. Most items come from the collections of the Oriental Institute at the University of Chicago, supplemented by a small number of loans. These images and objects not only stand for a common desire to gather knowledge and information from a fragmentary past. They also represent the need to reassemble and restore those fragments into an authentic vision of how things might have been.

The founder of the Oriental Institute, James Henry Breasted (1865–1935), had an ambitious empirical approach to the study of archaeology, ancient language, and history. As both Emily Teeter and W. Raymond Johnson write (Chapters 2–3), Breasted's establishment of the Epigraphic Survey of Egypt was in response to the ongoing threat of destruction of archaeological sites and associated written records, joined by a desire to systematically collate and publish these records for future generations.

This need for attaining accuracy and completeness are common themes of the archaeological and epigraphic work of the Oriental Institute and they are strongly reflected in its research and publication style. As a consequence, the Oriental Institute has not been typically associated with the artistic process, although Breasted's extensive use of illustrations in popular books certainly contributed to his, and subsequently, the Oriental Institute's renown (Abt 2011, pp. 195–206). Many of the items featured in this exhibit and catalog reflect the tensions and conflict between the scientific method and the creative process, a long-standing issue from the antiquarian era of archaeological recording to the present day (Moser and Smiles 2005, p. 5). In the recording of facsimiles, as well as in restorative illustrations of buildings and monuments, there has often been a strong desire to project an objective and authentic approach to the past. What is revealed through the study of these works, however, is how potentially misleading they can be. Distinctions between what is observed and what is inferred may be embedded in the published text or hidden in unpublished archives, rather than incorporated into the final image.

The process of reviewing the items for this exhibition afforded an opportunity to consider the range of approaches to the creation and use of these images, including the initial motivations and selectivity of image creation, the identities and roles of the image creators, and the process of recording and creation of the images themselves. The dissemination and reception of images through publication, display in exhibitions, and promotional use must also be considered. Lastly, there is interpretation (and reinterpretation) of the image over time, and its impact in both scholarly and public settings. The painted view of Babylon and the model of the ziggurat at Babylon (Catalog Nos. 16 and 36) have become icons of the ancient world in their own right. Such restorations can become the focus of full-scale physical reconstruction (see below), which can be used to send strong cultural and political messages.

APPROACHES TO IMAGES

Images play an important role in the study and understanding of the past, both in terms of constructing and interpreting archaeological knowledge from the ground up, as well as providing content support within cultural heritage settings within museums and archaeological sites. In recreating a vision of a time and place that no longer exists, they help communicate information and ideas that may be difficult to describe in words, they can also evoke atmosphere and emotion, and inspire wonder and fascination in the past. Several edited volumes explore the theoretical, practical, and historical role of images in archaeology (Moser and Smiles 2005; Molynieux 1997;

Schlanger and Nordbladh 2008), although few contributors to these volumes focus on Egypt and the Near East. Exhibitions have provided opportunities to explore the role of the image in this region. For example, in *Babylon: Myth and Reality*, Finkel and Seymour (2008) explored visions of the ancient city from ancient textual sources and travelers' accounts, which in turn inspired grand artistic depictions of Babylon in the Renaissance. These representations persisted culturally well beyond the archaeological work conducted at Babylon over a century ago, which further transformed our knowledge and view of the ancient city in real terms.

Broadening the study of images into the wider context of art history, visual anthropology, and education (e.g., Banks and Ruby 2011; Elkins 2007; Mitchell 1994), it is clear that images should neither be judged on their aesthetic value as "art" objects, nor simply be viewed as scientific records or static carriers of information. Approaches to visual studies take into account factors such as changing media and modes of production, as well as communication and reception of images by diverse audiences. Roland Barthes (1977) was highly influential in his approach to visual discourse analysis and study of the semiotics of imagery, distrust of the image, as well as the relationship and analogy between text and image. Images and text can be read, both communicate meaning, and both may illicit different interpretations and responses depending on the reader. The ideological power of the image is also relevant: why are some images more popular and iconic than others, what social biases may be present (whether conscious or unconscious), and how might images be used as political tools?

Meanings of images might also change over time (Moser and Smiles 2005), so that what might at one time be considered relevant for scholarly consumption might now be more appreciated for its aesthetic value (e.g., Larson 2006). An underlying curatorial intention of the Picturing the Past exhibit and its related educational program is to attract a traditional "arts" audience. It is hoped that this exhibition and catalog play a role in breaking down this divide by generating new interest and perspectives in the works themselves, their archaeological inspiration, and those who created the images.

THE IMAGE CREATORS

The Oriental Institute's expeditions from the 1920s to the 1940s include listings of members with common titles such as "Photographer," "Architect," "Surveyor," and "Draftsman." This practice reflects the important roles of these expedition members in the creation of accurate records, technical drawings, and photographs. Trained architects played leading roles in many Oriental Institute expeditions of the 1920s–1940s. They included architectural historian Uvo Hölscher, field director of the Oriental Institute's Architectural Survey in Egypt, who produced detailed plans and restorations at Medinet Habu (Catalog No. 14). Architect Hamilton Darby served as Gordon Loud's assistant in the early seasons of excavations at Khorsabad in Iraq, as well as serving on the Diyala Project (Catalog No. 15). Charles B. Altman also worked on the Khorsabad Expedition, co-authoring the second volume of the Khorsabad series with Loud (Loud and Altman 1938) before continuing his work at Megiddo, Palestine, for several seasons. Richard C. (Carl) Haines was a trained architect initially working in Anatolia and Syria before becoming an architectural assistant for the Persepolis Expedition in Iran (fig. 1.1). He subsequently served as field director of the Nippur Expedition to Iraq from the late 1940s to the early 1960s. These examples demonstrate how important trained architects were in shaping the priorities and outcomes of archaeological expeditions. Excavations were geared heavily toward obtaining complete ground plans and architectural details, ultimately contributing to restoration drawings. The

FIGURE 1.1. Richard C. Haines at work in the Drafting Room of the Persepolis Expedition headquarters, 1939 (Oriental Institute photograph P.60820)

14

German method of architectural training within archaeology was clearly influential in the early years, exemplified by the work of Robert Koldewey at sites such as Assos, Zincirli, and Babylon in the late nineteenth to early twentieth centuries (Wartke 2008), and evident in Breasted's recruitment of Hölscher at Medinet Habu. Breasted, who earned his doctorate in Berlin, was familiar with the architectural approach to archaeology, including many architectural restorations from German publications in his popular books such as *Ancient Times* (1916).

Seldom were the terms "artist" or "illustrator" used by the Oriental Institute, presumably to differentiate this more subjective role from what were perceived as more precise recording methods. Although individuals worked under precise-sounding titles, many possessed highly developed artistic and creative skills. For example, G. Rachel Levy as a member of the Diyala Expedition is listed as "Recorder" (Frankfort, Jacobsen, and Preusser 1932, p. 4), that is, Registrar, which belittled the artistic talents that are evident in her watercolors of the Tell Asmar statues (Catalog No. 24). Watercolor painting was still a common technique of representing color in selected artifacts, prior to developments in color photography. Objects such as painted statues and pottery were presented in somewhat exaggerated hues and oblique views, and thus treated separately from more technical drawings. A good example of the tension between the desire for accurate recording and artistic representation can be seen in the facsimiles of *Ancient Egyptian Paintings* by Nina de Garis Davies (1936; Catalog No. 10 and Strudwick, Chapter 8) and those by Prentice Duell from the Old Kingdom Tomb of Mereruka at Saqqara (1938; Catalog No. 12; Roth, Chapter 4). Almost all the color plates from the latter publication came without supporting documentation. The authors and publishers attempted to reach an "art" audience, wishing to place these works within a continuum of art history from ancient times to the modern day. This was a considerable departure from the norm for the Oriental Institute.

Artists were occasionally commissioned to paint during the course of expeditions, but were often not listed as official expedition members. For example, a landscape painter named "Professor Wichgraf," made paintings as a visitor to the Alishar Expedition in Turkey (von der Osten and Schmidt 1930, p. 62). Joseph Lindon Smith was commissioned to produce

paintings of the ruins at Persepolis in 1935, one of which is featured in this exhibit and once displayed with others in the Oriental Institute Museum (Catalog No. 19; O'Connor, Chapter 11). Erich Schmidt, the field director of the Persepolis Expedition from 1935, does not acknowledge Smith's work or presence as a visitor in the three final reports of the Persepolis Expedition. Smith's paintings provide an impressionistic vision of the ruins and also capture the mountains and earth against the dramatic expanse of the blue sky. It was impossible to capture this atmosphere though the black-and-white photographs or line drawings that dominate Schmidt's final reports, which are nevertheless impressive in their own right (Schmidt 1953). In summary, the Oriental Institute appears often to have significantly underplayed or repressed the artistic skills of members of its expedition staff by comparison with the technical work of surveyors, architects, and recorders. There also appears to have been a gender divide between male architects and the women who were involved in the detailed and creative work of producing facsimiles and watercolors.

THE RESTORATION PROCESS

How does the architect or illustrator build up a picture of a site from archaeological evidence? The process is a complex one (see Golvin, Chapter 10). It depends on a process of selectivity of information, partly based on facts on the ground, additional information from textual sources and visual imagery, or architectural fragments from other sites or periods. The remainder is based on inference and educated guesswork. An often overlooked factor is the influence of earlier restorations on the creation of a new restoration. What elements should be incorporated, and what should be modified or removed?

A good example of the process comes from the Oriental Institute's Expedition to Khorsabad (1928–1935), Dur Sharrukin, the ancient Assyrian capital of King Sargon II (reigned 721–705 BC). At Khorsabad there was an explicit aim to complete and improve upon the unfinished work of the mid-nineteenth-century excavations conducted by French archaeologists Paul Émile Botta and Victor Place. Charles B. Altman's detailed perspective restoration of Khorsabad's Citadel (fig. 1.2) was published as the frontispiece of Khorsabad II (Loud and Altman 1938) in recognition of this crowning achievement of the expedition. On

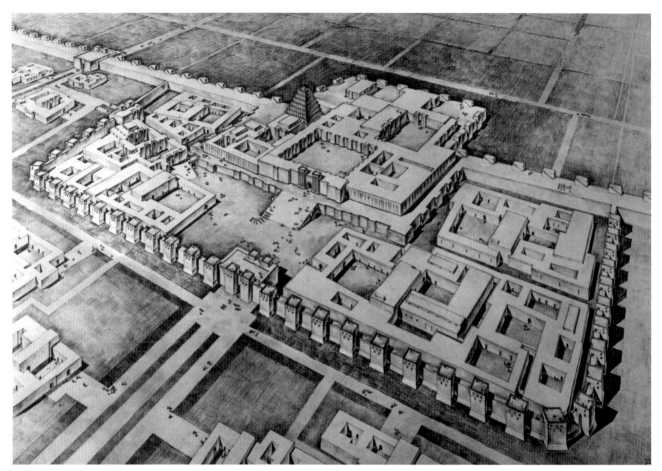

FIGURE 1.2. Khorsabad, the Citadel, restored. Bird's-eye view from the east. By Charles B. Altman (Loud and Altman 1938, pl. 1)

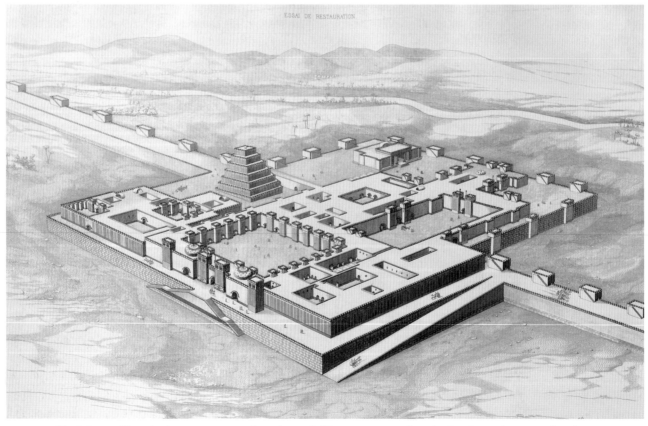

FIGURE 1.3. The Palace at Khorsabad: perspective view from the south (Place 1867–1870, vol. 3, pl. 18bis; Oriental Institute digital image D. 17479)

a practical level, Altman was able to insert Place's nineteenth-century restoration of the palace (fig. 1.3) within the much enlarged excavated area with only minor modifications to allow easy comparison between the two. Note the implicit reference and homage to the restoration published by Place (1867–1870) in terms of perspective, orientation, and style of execution. Place's view of Khorsabad provided the first credible architectural reconstruction of an ancient Near Eastern monument, apparently influencing Walter Andrae and Robert Koldewey in their subsequent work at Assur and Babylon (Micale 2008, p. 194).

Despite their reverence for the French excavators, Loud and Altman were justified in "taking liberties" to highlight limitations in their earlier plans and restorations (1938, pp. 54–56, 89–91). Despite finding that the nineteenth-century plans were substantially correct, precisely perpendicular and parallel walls had been assumed by the earlier excavators and did not take into account of significant irregularity of the axes of rooms and the two rectangular platforms upon which the palace was built (ibid., pp. 54, 89). Comparison of the highly regular palace in the center with the less regular buildings surrounding it illustrates this point (fig. 1.2). The ramp approaching the palace was found to be unlike Place's suggestion, and only one portal was found, as opposed to three in

Place's restoration. Vaults and domes in Place's restoration were considered by Loud and Altman to be nineteenth-century oriental affectations (ibid., pp. 89–90).

Loud and Altman generally toned down their restoration of Khorsabad, minimizing heights and elaborations of buildings, while keeping architectural features for which there was better archaeological and visual evidence, such as niches and reeds on facades and wall-top crenellations. The excavators omitted trees and gardens despite concluding that vegetation was likely to have been present. The final restoration is a composite of various fragments of archaeological evidence, multiple opinions, and Place's earlier vision. Is it a faithful restoration? It is quite possible that in their attempt to attain an objective, authentic, evidence-based image, Loud and Altman's restoration may have underplayed a grand, colorful, lush, and generally more elaborate citadel and palace.

Taking restorations to the next level, at another ancient Assyrian capital, Nineveh, city gates and portions of walls have been physically restored and rebuilt over the decades following World War II until relatively recently. Some gates are restored relatively faithfully in relation to how they were found archaeologically, such as the Mashki Gate. An exception is Nineveh's Nergal Gate (fig. 1.4; also see Beek 1962,

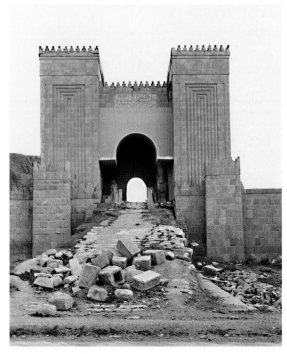

FIGURE 1.4. The restored Nergal Gate at Nineveh, Iraq, 2000 (photograph reproduced courtesy of Elizabeth Barrell)

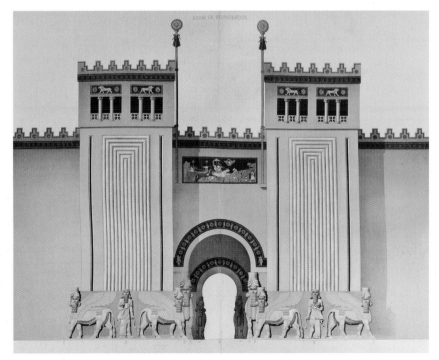

FIGURE 1.5. Architect Félix Thomas's restoration of the entrance gate to the Palace complex at Khorsabad (Place 1867–1870, vol. 3, pl. 21; Oriental Institute digital image D. 17457)

p. 37, pl. 67), which had been partially excavated in the mid-nineteenth century by Austen Henry Layard, and re-excavated in 1941 by the Iraqi Department of Antiquities (Finch 1948), before being rebuilt several years later. The gate was reconstructed to protect the surviving *lamassu* (colossal sculpted winged bulls) at its entrance and was probably also intended to attract tourists to the site. The restored gate is largely conjectural and incongruous in its placement. It clearly references Félix Thomas's nineteenth-century rendering of a gateway at Khorsabad (fig. 1.5), which itself was partly imagined due to its preservation just above the arch (there was no evidence for the scene depicted above it). Both Thomas's rendering and the reconstructed gate at Nineveh present a vision of the power, scale, and elaboration of Assyrian architecture, but the gate's placement in time and space is ultimately misleading.

REPRESENTING PEOPLE OF THE ANCIENT MIDDLE EAST

Engravings and color plates were common features of illustrated bibles, travel diaries, and "manners and customs" books of the nineteenth century. Paintings depicting the ancient world, including scenes of classical myths, ancient historical events, and biblical scenes were also highly influential, having an impact upon the restoration style of some of the earliest archaeologically excavated buildings in the Near East. For example, Austin Henry Layard's commissioned paintings of Nineveh and Nimrud (e.g., Layard 1853a, pl. 1; Micale 2008, pl. 10) echo the romanticized and moralistic visions of the ancient world created by artists such as John Martin, Ford Madox Brown, and Lawrence Alma-Tadema. For Egypt and the Near East, scenes of women at wells, nomads and farmers, and figures reclining among ancient ruins evoked and encouraged Western stereotypical and romanticized visions of Middle Eastern landscapes and people. James Henry Breasted's own "profusely illustrated" popular books on the ancient world (e.g., 1916, 1919, 1926) were published at a time when photography was being more readily introduced into publications. Breasted's books included many drawings of local people walking among ruins at Karnak (1919, fig. 24), farmers in a field (1919, fig. 54), or a worker posing by an excavated burial (1926, fig. 69). Many of these half-tone illustrations were actually redrawn from photographs that Breasted would have otherwise used had it not been for prohibitive reproduction costs (Abt 2011, p. 195). Although the intention was to reduce the publication costs, the resultant modern scenes provide both an impressionistic and consistent quality when presented alongside the restorations of ancient buildings in the same volumes, implying connections between ancient and modern people.

In reports of archaeological excavations conducted prior to 1940, the posing of local excavation workers in photographs for scale purposes was fairly common. But as measuring rods were widely available, human scale-models were not strictly necessary. It must therefore be concluded that there was an implicit attempt to bring archaeological space to life using a human figure. During his excavations of ancient Ur in Iraq in the 1920s and 1930s, Leonard Woolley took the photography of his workers to another level. He employed local Arab workmen and their families to pose in his photographs in daily life roles, attempting to bring to life his archaeological excavations of the well-preserved neighborhood of

FIGURE 1.6. An early second-millennium BC street excavated at Ur, Iraq, featuring Arab workmen and their wives. They carry pottery vessels of the period (Woolley and Moorey 1982, p. 196)

the Old Babylonian city. They posed as kitchen staff or residents within the ruins of buildings and streets, using ancient tools, standing close to installations, and carrying ancient pottery (fig. 1.6; Woolley and Moorey 1982, pp. 192, 197).

The 1935 documentary film *The Human Adventure* charted the progress of civilization through the findings of the Oriental Institute's expeditions. It also captured local workmen on film (referring to them frequently as "natives") engaged in excavation and other activities such as dancing. But photography and film aside, what is so striking about this prolific period of the Oriental Institute, and the seeking of a wide audience through popular books, museum displays, lectures, and films, is the marked lack of illustrations of ancient scenes of ordinary daily life.

Most of the Oriental Institute illustrations are technical in nature. Architectural restorations may include distant figures, largely for the purposes of scale. None can be considered scenes of daily life. Examples include Altman's perspective reconstruction of the Nabu Temple facade at Khorsabad (Loud and Altman 1938, pl. 44), which shows figures both at a distance and closer in the foreground, although they have their backs to the viewer. T. A. L. Concannon's reconstruction of an Iron Age portico at Megiddo depicts a faceless, androgynous figure wearing a long garment (fig. 1.7). A color restoration of a door of the Treasury at Persepolis incorporates an image of a

palace guard in characteristic striding side profile, after ancient representations from Susa (Schmidt 1953, fig. 68B). The guard figure gives a sense of scale and color, but due to the inherent rigidity and formalism of Achaemenid art, the figure does not appear to be realistic. A somewhat more evocative restoration is Hamilton Darby's Temple Oval at Khafajah (Catalog No. 15). Although the figures are too small in scale to depict details, this scene provides perspective, scale, and an impression of functional use of space. Most of these scenes depict either male or neutrally gendered figures rather than women.

A partial explanation for the limited focus on ancient daily-life scenes is that visual images could be sourced from the ancient world itself: warfare scenes from Assyrian sculpted reliefs; cylinder seal impressions illustrating a ritual scene; dress and hairstyles from sculpture; farming and craft activities from Egyptian tomb paintings. These types of images, represented in both photographs and line drawings, are common enough among Breasted's popular books. The images often represent the elites of society or an abstracted, idealized view of ancient life, and not daily life within domestic architectural settings. It is easy to criticize what appears to be a dehumanized and androcentric approach to representing the past, but the overall intention of the Oriental Institute expeditions was to convey unexaggerated realism and authenticity. Figures were reduced to the function of scale so as not to detract from the main subject — the architectural setting.

Ancient daily-life scenes did feature prominently in publications and museum displays of the 1920s and 1930s (and earlier), but largely within the developing field of anthropology and early world prehistory. There was already a long tradition of representing early humans in popular books and journals, either in highly romanticized settings or poses, intended to evoke savagery and primitiveness, or for satirical purposes (Moser and Gamble 1997). A series of large paintings of daily-life scenes by John Warner Norton (1876–1934) depicting the "History of Man" presented evocative notions of

FIGURE 1.7. Reconstruction of portico from Megiddo Stratum IV, by T. A. L. Concannon (Lamon and Shipman 1939, p. 57, fig. 68)

FIGURE 1.8. Paintings by John Warner Norton depicting the "History of Man" from Beloit College exhibited adjacent to objects and images from the Oriental Institute, University of Chicago. A Century of Progress International Exposition, part of the World's Fair of 1933–1934, Chicago (Oriental Institute photograph P. 24144)

human sacrifice. The relationship between text and image is important here, as the scene is based on Woolley's persuasive account of his grisly findings from Royal Cemetery at Ur. He proposed that the people buried in the "death pit" had willingly taken a draft of poison before laying down to die as consorts for their deceased queen (Woolley and Moorey 1982, pp. 71–76). There have been challenges to Woolley's interpretation over the decades, but Forestier's famous illustration has helped keep the interpretation alive for subsequent generations.

National Geographic magazine has been extremely influential in presenting daily-life scenes over the decades, including early examples by American artist Herbert M. Herget from the 1940s and early 1950s representing Mesopotamia and Egypt (Hayes and Herget 1941; Speiser and Herget 1951). These images were republished in the popular book *Everyday Life in Ancient Times* (Speiser and Herget 1951, and multiple reprints). The images include daily-life and pseudo-historical scenes of a type not commonly represented in archaeological reports, but echoing illustrated bibles and children's

daily life from prehistoric archaeology and anthropology. They were completed in the 1920s for the Logan Museum at Beloit College, Wisconsin, where they continue to be displayed today. During the World's Fair of 1933–1934 held in Chicago, Norton's paintings were seen hanging in the same exhibition hall alongside casts, objects, and images from Oriental Institute expeditions, as if they were to be viewed together as part of a continuum of human progress and emerging civilization (fig. 1.8). The contrast in visual representation and style of display is striking.

Illustrations and paintings did not become common forms of representing daily-life scenes for the ancient Middle East until the 1940s, although predating this era is an evocative and influential illustration from Woolley's excavations at Ur. The death-pit scene by Amédée Forestier, published in the *Illustrated London News* in 1928 (fig. 1.9) and reaching a large readership, has a hyper-real quality evoking solemnity and order, capturing the moments immediately leading up to a ritual of

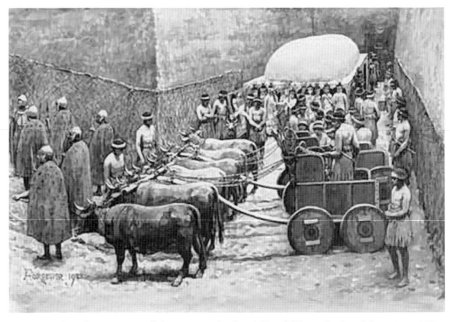

FIGURE 1.9. Artist's impression of the scene in the Death Pit of RT789, the Royal Cemetery at Ur, by Amédée Forestier, 1928

FIGURE 1.10. Reconstruction of a domestic scene at Numeira, Jordan, based on archaeological findings from an Early Bronze Age house (reproduced with permission of the artist, Eric Carlson)

was published in the reports of the Turkish excavations of the Assyrian colony at Kültepe-Kanesh (Özgüç and Özgüç 1953). Kathleen Kenyon commissioned illustrations during the course of her excavations at Jericho in the 1950s, including an often-reproduced drawing of a Middle Bronze Age Canaanite family "at home," despite all the objects and furniture having been based on material found in tombs (Kenyon 1960, pl. 40). The tradition of illustrated daily-life scenes has continued sporadically in Near Eastern archaeology, ranging from the Emergence of Man series of Time-Life books of the 1970s (e.g., Hamblin 1973) to more common representations in prehistoric archaeology, recently exemplified by the work of Eric Carlson at sites on the Dead Sea Plain of Jordan (fig. 1.10).

FROM TWO TO THREE DIMENSIONS: FROM PHYSICAL TO VIRTUAL HERITAGE

Conventional two-dimensional reconstructions and renderings of structures and spaces, as well as three-dimensional scale models and relief maps, have played an important role in representing the past within traditional "low tech" formats of publication, teaching, and exhibitions. The stereoscope viewer and cards (Catalog No. 26) also provided relatively affordable ways in which ancient sites, monuments, and Middle Eastern people and settings could be brought to life in three dimensions within nineteenth- and early twentieth-century homes. Three-dimensional scale models (e.g., Catalog Nos. 34 and 36) and dioramas may be dwindling in modern museums, but they remain a durable and appealing way of visualizing the past. They enable the viewers to control their own spatial perspective in immediate relation to a model of a site, building, or daily-life scene (Evans 2008). While a fully immersive, spatial experience cannot be achieved using scale models, it can be achieved from life-size reconstructions of buildings or other built space (on-site, or off-site in museums), with or without mannequins, or live or video-projected actors inhabiting those spaces. These restorations require large spaces and are expensive to design and build but can be highly effective.

Another approach to visualizing the past is the computer-aided or digital restoration used to create short video sequences or interactive virtual-reality (VR) models in which the viewer controls their movement within digital space (Sanders, Chapter 13).

books. These vivid and playful scenes were based on combinations of supposed facts (a historical event or ancient images or artifacts) and imagination, often in consultation with a specialist: "The archaeologist has invented an incident if the texts did not furnish him with something better and stranger than fiction; but he has sought to be true to the spirit of the time. Details rest on a solid foundation" (Speiser and Herget 1951, p. 21). Archaeologists today recognize the origin of much of the source material used and find fault in some of the details, yet the public impact of such images cannot be underestimated. *National Geographic* magazine continues to lead in its commissioning of illustrators and model makers to help bring archaeological findings to life. Some recent examples of scenes from the ancient Middle East include features on Ashkelon (Gore 2001), Qatna (Lange 2005), and Göbekli Tepe (Mann 2011).

An interesting shift in archaeological illustration in the immediate post-war era is an emphasis on intimate scenes of domestic life. For example, a series of line drawings of domestic settings and architecture

Second Life, an online virtual world, also has capacity for creation of digital restorations of ancient sites or buildings. Because of continual interactions and interventions of Second Life Residents (online participants), it can be difficult to distinguish between deliberate restorations intended for educational use, and more individualized, fantastical restorations.

Virtual reality can help enable remote viewers, as well as museum and site visitors, to immerse themselves into a past environment or setting. This provides perspective, movement, and new insights in providing convincing details. One digital reconstruction of an ancient Near Eastern site is that created by Donald Sanders and the late Samuel Paley is the Northwest Palace of the Neo-Assyrian ruler Ashurnasirpal II at Nimrud. This has been used for both viewer-controlled virtual-reality and short video sequences (Paley with Sanders 2010; Sanders, Chapter 13), including as part of a museum exhibit at Williams College Museum of Art. Although details of such restorations may prompt caution (Albenda 2011, p. 104), the immediacy of such digital restorations allows a certain degree of accessibility, immersion, and "wow factor." It is noted, however, that digital restorations using genuine virtual reality are not as widespread as short video sequences in museums. This may relate to visitors' expectations for cinematic "fly throughs" or "fly overs" made popular through digital restorations featured in television documentaries (Earl 2005). Many museums have avoided taking the plunge into viewer-controlled virtual reality in museums, either due to cost constraints or a lack of dedicated technical staff.

There are interesting similarities and connections between the creation of digital reconstructions and attempts to physically reconstruct ancient sites and monuments. At sites throughout the Middle East (and globally), efforts are often made to build up walls of buildings that have been exposed during the process of archaeological excavation. Modern mudbrick and stone can be used to protect original remains. In some cases, columns are re-erected and ancient structures partially rebuilt. These efforts in cultural heritage management help protect architectural remains from theft (for building materials), from the elements, and impact of visitors to the sites (Stanley-Price 1995). Most importantly, these restorations can enhance the visitor experience, allowing people to walk within buildings and rooms. In such settings, site or building restorations can often be subject to interpretation by cultural heritage specialists regarding levels of accuracy, preservation, and reception by visitors (Stanley-Price and King 2009). The example of the incongruous but monumental Nergal Gate at Nineveh, Iraq (fig. 1.4), is one example. The role of architectural perspective drawings and renderings in these situations cannot be underestimated, as they can serve as both the initial inspiration as well as the main reference source when rebuilding.

Examples of this restoration method are also attested at Babylon in Iraq, where in the 1970s and 1980s there was explicit use of Andrae's and Koldewey's hypothetical reconstruction drawings of the early twentieth century (Micale 2008, p. 198). At Babylon, the restoration of the ancient palace, processional way, and a reduced-scale Ishtar gate (see Catalog No. 16 for Bardin's painted restoration) all played an important role in nationalism, politics, and propaganda from its inception in the late 1970s until its completion in the 1980s (Curtis 2008; Goode 2010, pp. 119–21). Saddam Hussein's name was stamped on many of the bricks used in the rebuilding project, echoing the activities of ancient rulers of Mesopotamia. Interestingly, this enabled modern bricks to be distinguished from ancient remains. One envisaged project at Babylon during the Saddam Hussein era was to rebuild the Tower of Babel (Goode 2010, p. 120), also known as the ziggurat of the Etemenanki. Although the desire was present, the project was not undertaken, presumably due to financial constraints. A clear problem, noted at the time by at least one dissenting voice, was that no one knew what the original looked like (ibid., p. 120), although the well-known scale model of the ziggurat made from the German excavations of the site over a century ago (Catalog No. 36) would have served as a likely basis. Iraq is not the only country where such ambitious restoration projects have taken place. Physical landscaping and rebuilding of heritage sites are widespread, for example, at Karnak, Egypt, where Jean-Claude Golvin's illustration, including real and inferred elements, served as a basis for recent physical works at the site.

Where physical restorations and reconstructions are too costly or may lead to the destruction of in situ archaeological remains, digital restorations may provide a solution. Mobile devices such as smart phones and tablets with in-built GPS technology are becoming increasingly widespread. This could allow for less

expensive restorations, saving the need to physically rebuild monuments. Visitors to sites can envisage restorations of sites in real-time by holding up their mobile devices or viewing through goggles, switching between or layering a real-time physical view of a location with digital or virtual content. Content may include film footage or photographs taken from a fixed vantage point, or the layering over of virtual buildings or monuments that can move with the viewer. This digital method is commonly known as "augmented reality" (AR). Although a relatively new concept, it is likely to become a more common feature in museums and places of historical and archaeological interest in coming years (Schavemaker 2011). Such applications are already being used to enhance the visitor experience at archaeological sites and within museums, allowing for "interesting collisions between virtual (digital) heritage and real (analog) space" (ibid., p. 51). Recent commerical applications include "Google Goggles." More specific heritage-related examples include "Roma MVR Time Window"

by Altair4 Multimedia Productions, a downloadable application that allows the visitor to remotely experience digital restorations of ancient Rome within the modern city. Comparing ancient restorations with present-day views is not a new idea and is already well known from published acetate flip-books such as the Then and Now series (e.g,. Perring and Perring 1991) and *Persepolis Recreated* (Rezaeian 2004). The latter example is based on the digital movie of the same name (fig. 1.11).

Despite a posited future shift in the use of digital technology, the work of artists and illustrators will not come to an end. There is an impressionistic quality to their work that cannot be replicated digitally. Also, the work of archaeologists continues to provide raw data and moderating interpretations that help create virtual restorations. This may involve the mediation of conflicting interpretations of different archaeologists by allowing multiple versions of restorations to be depicted or finding ways to represent both restored and real elements within a single restoration (Gillings 2005). Virtual reality may therefore allow for varied interpretations to be presented digitally, which might not be easily achieved in a physically built environment. Therefore the same challenges faced by Loud and Altman in their drawn restorations of Khorsabad still exist for designers of virtual-reality restorations today: how can both authentic and inferred elements be represented together, and what level of variability of inference is acceptable? Although multiple versions could be more readily provided in the digital age, the impact this viewer choice has on the longevity and long-term impact of images in archaeology remains to be seen. Alongside the desire for scholarly authenticity, a balance must be struck with accessibility and the need to create iconic and accessible images that continue to inspire the viewer.

FIGURE 1.11. Image from *Persepolis Recreated* (reproduced with kind permission of Farzin Rezaeian)

2. THE ORIENTAL INSTITUTE AND EARLY DOCUMENTATION IN THE NILE VALLEY

EMILY TEETER

> "The ideal recording system ... must unite in one record three things: the speed and accuracy of the camera, the reading ability of the experienced orientalist, and the drawing skill of the accurate draftsman."
>
> — J. H. Breasted (Epigraphic Survey 1930, p. xi)

The Oriental Institute is among the leaders in the documentation of the past, whether in the form of photography, epigraphy, or the compilation of dictionaries of ancient languages that make it possible to study ancient cultures. The Oriental Institute's program of documentation was established by its founder, James Henry Breasted (1865–1935). His awareness of the importance of making accurate copies of texts stemmed from his initial training in Greek and Hebrew to study biblical texts as preparation for a career in the ministry. But having read and translated biblical texts in their original language, he was horrified to compare them to the accepted translations in the King James Bible. His son and biographer, Charles Breasted, recounted a conversation between Breasted and his mother:

> "Let me read you this, Mother." He read aloud the translation he had just made of the Hebrew passage. "What I've just read is correct. Now listen to this," and he read the King James rendering of the same passage. "Do you see it's full of mistakes which convey a meaning quite different from the original? I've found scores and scores of such mistakes. I could never be satisfied to preach on the basis of texts I know to be full of mistranslations. It's my nature to seek the sources of everything I study" (C. Breasted 1943, p. 22).

Breasted's quest for an accurate understanding of the ancient world led him to shift his focus to Egyptology, allowing him to concentrate on ancient texts and their translation. He had a keen appreciation of the importance of making accurate copies of the ancient texts in order to preserve the purity of the translation. Furthermore, he resolved to mine the texts for their historical importance rather than studying them for their linguistic and philological

value alone. His ultimate goal was to write a history of ancient Egypt based on accurate copies of the primary sources, a mission that would culminate in the 1905 publication of *A History of Egypt*. "Behind all this preliminary work looms my history of Egypt But before I write a history based on the original monuments, I intend to find out, to the last jot and tittle, *what the monuments say*. This is what the other fellows have not yet done. ... Had I been willing to compile a history out of the *books of Germans*, I could have finished it in six months. But I ask no odds of anyone, taking nothing second-hand from any middle man" (C. Breasted 1943, p. 104). He further recounted:

> In 1896 I had definitely launched upon one of the most arduous undertakings of my life, the plan for which had been steadily growing in my mind since my Berlin student days. I began the task of collecting all the historical sources of ancient Egypt, from earliest times to the Persian conquest, wherever they existed in the world; of translating them into English; and of creating thereby for the first time a solid foundation of documentary source material for the production of a modern history of ancient Egypt (C. Breasted 1943, p. 102).

In 1899, Breasted was invited by the Royal Academy in Berlin to make hand copies of all the historical inscriptions on Egyptian objects in Europe for the Berlin Egyptian Dictionary (Abt 2011, pp. 76–79; Catalog Nos. 1–2). These texts would be analyzed to create the lexical items for the dictionary and they supplied more data for Breasted's history. At times, he resorted to photographic documentation, decrying that his strained budget did not allow him to use the more convenient roll-film rather than cumbersome glass plate negatives (C. Breasted 1943, p. 109). But his enthusiasm and drive were undiminished. He

resolved "I am now laying plans to copy not merely the historical, but *all* the inscriptions of Egypt and publish them" (ibid., p. 110). As his son later wrote:

> When my father had taken photographs and made pen-and-ink copies of every ancient Egyptian relic in Europe bearing so much as a lone hieroglyph of historical import, we scoured the Mediterranean and Aegean world, and traveled southeastward to Egypt and the northern Sudan, where he copied and photographed every historical inscription along the Nile valley between Aswan and Khartoum (C. Breasted 1943, p. 103).

But Breasted had even greater ambitions. In 1902, he drafted plans to copy the inscriptions of Egyptian monuments in Nubia, noting "... no epigraphic work had been done in the country since the Prussian expedition in 1844 ..." (J. H. Breasted 1908, p. 3). Funding became available when the University's expedition to Bismaya in Iraq, supported by a grant from J. D. Rockefeller, Sr., was canceled. The balance of the "Oriental Exploration Fund" was designated for Breasted's photographic/epigraphic expedition to Nubia.

THE NUBIAN EXPEDITION AND A NEW EPIGRAPHIC METHOD

The First Epigraphic Expedition (fig. 2.1) was launched in November 1905. The expedition staff for the first season consisted of Breasted, American civil engineer Victor Persons, who had worked in Iraq, and the German photographer Friedrich Koch. Breasted's wife and their eight-year-old son Charles also joined the team. Their supplies and equipment for the six-month duration of the expedition were packed in a hundred wood packing crates. As Charles wrote years later:

> My father now entered upon another period of scientific drudgery at a self-appointed task the importance of which, he knew, would be recognized by scarcely a dozen men in the entire scientific world. As for the general public, the meticulous recording of long-known, steadily perishing, and largely unpublished historical monuments *above* ground had about it almost none of the excitement and fascination popularly associated with digging for *buried* ancient treasure. But he was more than ever convinced that however much the excavations of men like Petrie, Davis, Quibell and others might contribute to Egyptology, he himself could render it no greater service than to copy

FIGURE 2.1. The staff of the 1906–1907 season of the First Epigraphic Expedition at the Second Cataract, Sudan. Left to right: Mrs. Breasted, James Henry Breasted, Charles Breasted, and Norman de Garis Davies (Oriental Institute photograph P. B 1018)

while they were still legible the historical records on the ancient monuments of Egypt (C. Breasted 1943, pp. 163–64).

In the Nile Valley, Breasted was shocked at the condition of the primary sources and especially the rate of their degradation, recounting:

> Probably there are few Egyptologists who do not realize that the monuments of Egypt still *in situ* are rapidly falling to ruin. ... It would seem, however, that while the structural decay and barbarous demolition of the monuments are sufficiently well known, the invisible but steady disintegration of the surfaces of intact walls, especially those of the temples, involving the gradual disappearance of inscriptions and reliefs, is not generally understood. Add to this the wanton vandalism of modern visitors and native dealers, who hack out cartouches and heads, or especially well-made hieroglyphs, and the rate at which temple records are disappearing is appalling (J. H. Breasted 1906, pp. 1–3).

At the end of the nineteenth century and the early twentieth, the most commonly employed technique for making copies of reliefs and inscriptions was to make full-scale tracings directly on the surface of the wall. The final result varied considerably depending upon the artist and the scale in which the material was presented. For example, the decorated tombs at Beni Hasan, as recorded by the Egypt Exploration Fund (Newberry 1893, 1894a–b), were reduced to one-twentieth scale, so small that it was impossible

to show any of the rich details of the figures and hieroglyphs, most of which are shown as black silhouettes (fig. 2.2). For the publication of the scenes at Bersha (Newberry 1894a), a far superior one-fifth scale was used that allowed the interior detail to be recorded (fig. 2.3) (James 1982, p. 146). Perhaps the finest products of this style of documentation are the six volumes of reliefs and texts from the Temple of Hatshepsut at Deir el-Bahari at Thebes. There, from 1893 to 1898, Howard Carter (with his brother and other artists) worked for Édouard Naville of the Egypt Exploration Fund. Carter, as a very talented artist, did not trace, but worked mainly freehand (contra Davies 1982, p. 60), as he recounted in his autobiographical sketches:

> I felt that if I attempted to copy the scenes sculptured upon the walls of Hat.shep.sut's mortuary temple by the prevailing system of tracing, the essential charm of those beautiful reliefs would have vanished in my copy. And as Professor Naville had given to me a free hand in the matter, I felt bounden to study the problem, to find the means to attain the best results. I tried many expedients; but they resolved in the simple solution: to first observe the fundamental laws of Egyptian art, how it eliminates the unessential, to copy that art accurately and intelligently, with honest work, a free-hand, a good pencil, and suitable paper (Reeves and Taylor 1992, pp. 49–51).

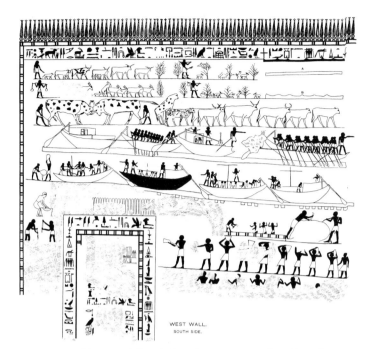

FIGURE 2.2. Publication of the reliefs and inscriptions at Beni Hasan by Newberry for the Egypt Exploration Fund. The figures and hieroglyphs, all of which have interior detail, have been rendered as black silhouettes (reproduced courtesy the Egypt Exploration Society; Newberry 1893, pl 12)

Naville then made a final comparison of the finished pencil or crayon drawings to the wall itself. Carter also did watercolor details of notable scenes (fig. 2.4). These drawings are considered to be some "… of the greatest epigraphic contributions to the science of Egyptology" (Davies 1982, p. 61).

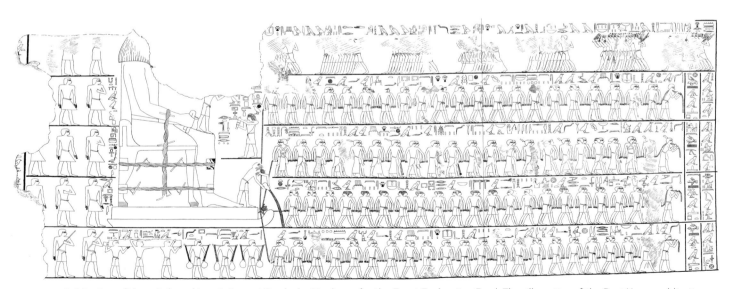

FIGURE 2.3. Publication of the reliefs and inscriptions at Bersha by Newberry for the Egypt Exploration Fund. The silhouettes of the Beni Hasan publication have been replaced by more informative line drawings that preserve details of the scene. The change in style may have been due to the influence of Howard Carter, who worked with Newberry (courtesy the Egypt Exploration Society; Newberry 1894a, pl. 15)

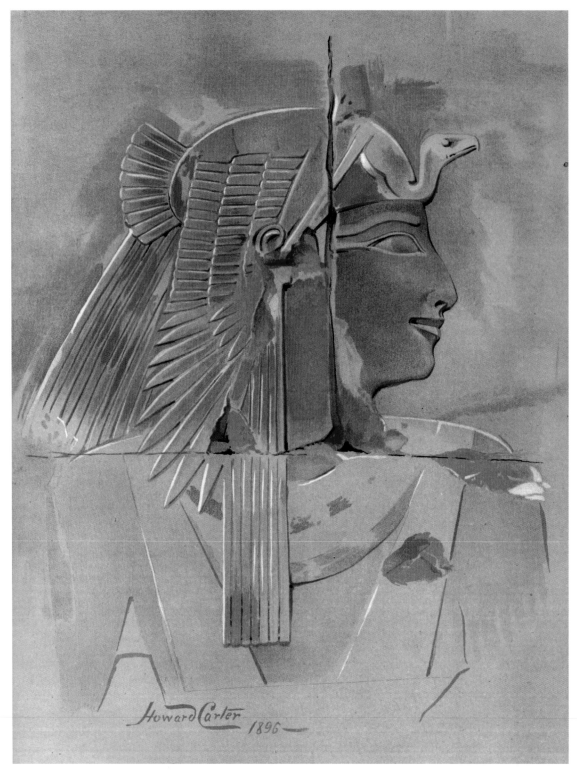

FIGURE 2.4. Watercolor of Queen Ahmose at Deir el-Bahari by Howard Carter, 1896. Carter was among the most talented and accurate copyists of his generation (after Naville 1898, pl. 67)

But Breasted needed a new, faster method. As he wrote:

The methods at present prevailing are far too slow. I believe that the solution of the problem is to be found in the *large* camera, which, besides being far more speedy and more accurate than the draughtsman, at the same time also furnishes a record more nearly complete, in that it fully preserves the plastic character of each sculptured figure or sign on the wall. A photograph, however, represents but one illumination of the wall; whereas it may be illuminated from many different directions successively, each different

illumination bringing out lines not visible before. Furthermore, the eye of the trained epigrapher, who can read the inscription and understand the broken connection, can discover more in the lacunae than the lense of the camera can ever carry to the plate (J. H. Breasted 1906, p. 5).

First the wall surface was surveyed to determine how it should be divided for photography. Then the cumbersome wood box camera, built by Kurt Bentzin of Görlitz and fitted with Zeiss lenses, was put into position on a tripod. To eliminate distortion, the photographer ensured that the film was perfectly parallel to the surface of the wall (see fig. 5.3 in Chapter 5 and Catalog No. 3). Each 21 x 27 centimeter (approximately 8.5 x 10.5 inches) glass plate negative was developed immediately in the Nile to ensure that they obtained a usable image. Only then could they move the scaffolds for the next section of text. A print was then made, initially a cyanotype, a blue-toned print, which was shortly replaced by silver-gelatin prints (Abt 2011, p. 131). Breasted took the print to the wall, and he compared the print to the texts, entering details in red ink that he could see on the wall, but were not visible on the photo (Catalog No. 4).

The confined spaces in some monuments presented incredible challenges. The photographer used time exposures, often employing reflectors and drapes to control the available light. Artificial light was produced by dangerous strips of burning magnesium tape. In other areas, they worked using candlelight that the bats would extinguish with the beating of their wings. It was tedious and difficult work. As Charles Breasted wrote:

> ... the men would have to work for days at a stretch in the suffocating blackness of the inner chambers of rock-hewn tombs or in the windowless storage rooms of temples, where the air which had never been changed was not merely hot but stank unspeakably from untold generations of bats hanging in regiments from fouled ceilings (C. Breasted 1943, p. 166).

The work of the expedition was grueling. Howling sandstorms drove dust and grit into everything. At Gerf Hussein the temperature reached 140 degrees. The emulsion on photographic plates was described as resembling "emery paper" (C. Breasted 1943, pp. 166, 168). Clouds of gnats descended "as thick as tar smoke." Scorpions and tarantulas dropped onto the desk from overhanging trees and when moored near other ships, their boat was overrun by "roving swarms of ugly, vicious rats" (ibid., p. 166).

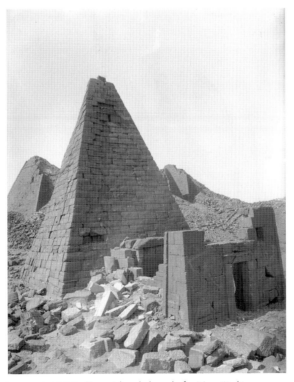

FIGURE 2.5. Pyramid and chapel of a Meroitic king (Oriental Institute photograph P. 2911)

The epigraphers faced their own challenges. Not only did they often work in insufficient — or blindingly bright — light, but many texts were badly eroded or obscured. At Amada, Breasted noted, "Melted fat or resin had run down the wall ... and slowly formed a dark, hard, gummy, or resinous enamel, which filled up hieroglyphs and made them totally illegible. It was exceedingly difficult to remove this tough, elastic surface, which was like the cartilaginous rubber surface of insulated wire" (J. H. Breasted 1906, p. 46).

The work at Meroe in 1906–1907 was exhausting. Temperatures were in the 130–140 degree range. As they copied inscriptions on the pyramid chapel walls, the sun's glare off the stone made their eyes swell (C. Breasted 1943, p. 181). The interiors of the chapels were so small and cramped that it was nearly impossible to photograph them with the large-format camera. Here, Breasted and his team were forced to rely primarily upon hand copies of the texts, unfortunately eliminating an important check on accuracy (J. H. Breasted 1908, pp. 12, 15). In addition to photographing the pyramids and their chapels, Norman de Garis Davies and Breasted drew plans of the tombs. The series of photographs of the pyramids at Meroe are today still among the most commonly reproduced images from the expedition (fig. 2.5).

Breasted summarized his report on the first season (1905–1906): "The following temples, chapels, stelae, and other important monuments were recorded for publication ..." (J. H. Breasted 1906, p. 64). In his report of the second — and what turned out to be the final — season he expressed some uncertainty about the publication of the data: "If, as a result of our work we are ever able to publish a corpus of the written records of this far-off land, we shall be but building upon their [Lepsius and Cailliaud] foundations" (J. H. Breasted 1908, p. 109).

Initially, Breasted envisioned that the results of the expedition would be published "in about sixteen folio volumes." In 1907, he drafted a much more ambitious proposal to John D. Rockefeller, Sr., for additional funds to extend the expedition for an additional fifteen years. This included a "publication program providing for 100 folio volumes, each in an edition of 300 copies ..." for a total budget of $455,000, nearly ten million dollars in 2011 (C. Breasted 1943, p. 209; Abt 2011, pp. 153–63). This grand proposal was turned down by Frederick Gates, Rockefeller's advisor, who wrote: "We have concluded that we are not prepared to recommend to Mr. Rockefeller the taking up of this monumental work involving such great expense and covering so many years. We recognize in you the one man in the world who is qualified to do this work, but we think ... it should be done by the Egyptian Government ... and not as a private enterprise" (C. Breasted 1943, p. 212).

In a further blow to Breasted, the University of Chicago canceled the Egyptian Expedition in July 1907, perhaps under the influence of Breasted's arch-rival Robert Francis Harper. Breasted took the news so hard that he threatened to resign his academic post. But a more sympathetic Professor Ernest Burton (later, the president of the University of Chicago) counseled him "I hope you ... will find a way to publish the valuable results of the work already done" (C. Breasted 1943, p. 213).

Ironically, the epigraphic and textual data were never incorporated into Breasted's most popular works because both *Ancient Records of Egypt* and his *History* were in press in 1905. And in a final irony, when the more than 1,100 photographs from the expedition were finally published, in 1975, they appeared in microfiche.[1]

Although Breasted's grand plans to copy and publish all the inscriptions on pre-Ptolemaic temples in the Nile Valley never reached fruition, his experience in Nubia led him to develop an epigraphic method that was further refined by his staff for making accurate records of temples and tombs in Thebes from 1924 to the present day.

NOTE

[1] They are now available on the Oriental Institute website: http://oi.uchicago.edu/museum/collections/pa/breasted/

3. THE EPIGRAPHIC SURVEY AND THE "CHICAGO METHOD"

W. RAYMOND JOHNSON

The aftermath of World War I presented a new, favorable opportunity for American scientific involvement in the Middle East. In 1919, James Henry Breasted successfully secured funding from John D. Rockefeller, Jr., and the University of Chicago for the founding of the Oriental Institute of the University of Chicago as a new American center for Middle Eastern research. Thereafter, Breasted renewed his efforts to expand the field expeditions of the University, and in particular to fund a broad epigraphic survey of Egypt's ancient monuments. In 1922, while laying the groundwork for the Oriental Institute's Coffin Text Project in Cairo, Breasted was invited by Lord Carnarvon and Howard Carter to visit the recently discovered Tomb of Tutankhamun in Luxor, and to assist with the reading of the impressed seals on the outer and inner doors of the tomb. Breasted returned the following year to revisit the tomb, and while in Luxor, he suffered a bout of malaria that laid him up for five weeks. During his convalescence "in a wheelchair in the beautiful gardens of the Winter Palace," he conceived the idea of a permanent headquarters of the Oriental Institute based in Luxor for a long-term epigraphic and architectural survey of all the ancient temples of the Nile Valley. This project would start with the extensive monuments of ancient Luxor, beginning with the great mortuary temple complex of Ramesses III at Medinet Habu in Western Thebes.

Breasted sent a draft of his vision to Dr. Harold H. Nelson, head of the Department of History at the American University of Beirut, and convinced him to be the first director of what came to be known as the Epigraphic Survey of the Oriental Institute, University of Chicago. Breasted himself designed the first expedition field house on the west bank to the north of Medinet Habu (fig. 3.1) and the construction of the first "Chicago House" was supervised by A. R. Callendar, who had been an assistant to Howard Carter. The field house was completed by the summer of 1924, and in October 1924 the expedition members moved in. On November 18, Harold Nelson cabled Breasted, "Work began yesterday" at the mortuary Temple of Ramesses III. The Epigraphic Survey was launched and continues to this day. Soon thereafter (1926), the Architectural Survey was established under the directorship of Professor Uvo Hölscher of Hannover, Germany. In addition to documenting and analyzing the considerable architectural remains at Medinet Habu, Hölscher also directed excavations at the site (already started in the nineteenth century by Georges Daressy), at the Ramesseum, and the mortuary temple complex of Aye and Horemheb immediately to the north of Medinet Habu. His drawings, plans, and reconstructions of the Medinet Habu complex and environs are among the best ever done of any site in Egypt (Catalog No. 14).

In 1930 the original mudbrick and wood Chicago House facility, despite numerous additions, was clearly insufficient for the needs of the growing expedition. Thanks to a generous gift from John D. Rockefeller, Jr., three and a half acres of land for the present facility were acquired on the east bank of Luxor in 1929, north of Luxor proper and just south of Karnak, on the Nile. Two young University of Pennsylvania architects, L. LeGrande Hunter and L. C. Woolman, drew up plans in close consultation with Breasted, and construction of the present-day Chicago House

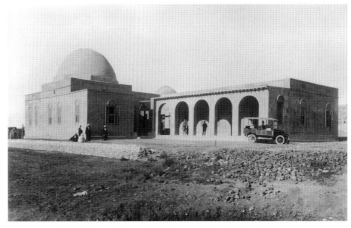

FIGURE 3.1. "Old Chicago House" on the west bank of the Nile, ca. 1924 (Oriental Institute photograph P. 11143)

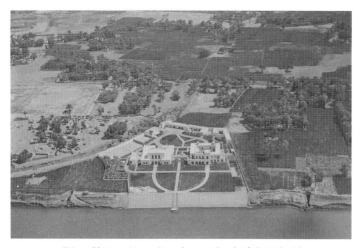

FIGURE 3.2. "New Chicago House" on the east bank of the Nile. Photo by James H. Breasted, Jr., March 10, 1933 (Oriental Institute photograph P. 22323)

began in 1930. The complex, consisting a main residence wing, a large library and office wing, art studios, photography studio with three darkrooms, and back garage and support area, was constructed of permanent materials — stone, baked brick, and reinforced concrete — and was completed in 1931 (fig. 3.2). The professional staff took up residence in 1932 (fig. 3.3). The gardens were planned and planted by Harold and Mrs. Nelson in the mid-1930s with exotic plants and trees, many from the botanical gardens of Cairo and Aswan, and are in their glory today. The old facility on the west bank was kept as a rest house for the Medinet Habu epigraphic staff and archaeologists, but was later demolished in 1940.[1]

FIGURE 3.3. The staff of Chicago House, 1927 (Oriental Institute photograph P. 21615)
Back Row: R. J. Barr, private secretary to James Henry Breasted; Virgilio Canziani, draftsman; Phoebe Byles, chief librarian; John A. Wilson, epigrapher; Mary Wilson, assistant librarian; Alfred Bollacher, draftsman
Middle Row: Caroline Ransom Williams, epigrapher; Uvo Hölscher, architect; Harold Nelson, head of Medinet Habu work; James Henry Breasted; Clarence Fischer, head of excavations at Megiddo; Alan Gardiner, Egyptologist; William Edgerton, epigrapher.
Bottom Row: Mr. Clark, architect; Edward de Loach; Adriaan de Buck

Breasted's dream was to precisely record *all* the monuments of Egypt, starting in the south. In 1930–1931 that vision was extended northward to the site of the ancient political and administrative capital of Egypt, great Memphis, established by Menes/Narmer at the beginning of the First Dynasty. Here was constructed, again with the support of John D. Rockefeller, Jr., an expedition field house that would house a second, northern epigraphic expedition, whose purpose was to record the ancient Old Kingdom monuments of Saqqara (see Roth, this volume).

EPIGRAPHIC RECORDING

The fact that anything from Egypt's remote antiquity survives to the present day is nothing short of miraculous. Yet over the thousands of years since the eclipse of pharaonic civilization, Egypt's dry climate and low population allowed the preservation of much of the ancient landscape, particularly in the south, where the majority of the best-preserved temple sites are to be found. Temples, mortuary complexes, and even cities — an astonishing array of cultural heritage sites — with literally miles of inscribed walls offer us today a wealth of information about these deep roots of Western civilization. Unfortunately, the conditions that allowed this preservation are now rapidly changing as weather patterns shift and Egypt's population grows. Even Breasted could see beautifully inscribed wall surfaces slowly fading and vanishing in front of his eyes as wind and rain and the depredations of man scoured the fragile, ancient stone. Higher air humidity, growing cities, and agricultural expansion are now causing that decay to accelerate alarmingly. In recent years the Epigraphic Survey has added conservation and restoration to its programs, in addition to its core documentation work, in an effort to help keep up with Egypt's rapidly changing environment.

The point of epigraphic recording, and the primary task of the Epigraphic Survey even today, is to create precise, facsimile copies of the carved and painted wall surfaces of Egypt's ancient temple and tomb monuments in order to preserve for all time the information found on them as part of the scientific record. Breasted believed that this documentation should be so precise it could stand in for the original. The documentation program of the Epigraphic Survey was designed accordingly, and today the drawings and photographs produced by Chicago House are so

FIGURE 3.4. Photographer Yarko Kobylecky using a large-format camera in the blockyard of Luxor Temple. Photographic assistant Ellie Smith holds a measuring device that is exactly the distance necessary for a 1:5 scale photographic image and that also enables the camera lens to be completely parallel to the subject to eliminate distortion (photo by W. Raymond Johnson)

exact that they are even used by conservators in the physical consolidation and reconstruction of those walls as a fixed reference to their condition at the time of recording.

Archival, large-format, black-and-white (and sometimes color) film photography (8 x 10, 5 x 7, and 4 x 5 inches) was, and still is, the first step in the recording program of the Epigraphic Survey. In recent years this has been supplemented with digital color photography. Contact prints are made directly from the black-and-white negatives. These form the core of the Chicago House Photographic Archives, which presently houses over 20,000 negatives and 21,000 prints. Our digital image archives is considerably larger and growing rapidly.

Intact, carved wall surfaces and well-preserved painted plaster walls can be recorded quite well with photography alone. Many of the walls and inscribed columns in the mortuary Temple of Ramesses III, for instance, do not require drawings and so they are published in clear, crisp black-and-white photographs that show most, if not all, of the inscribed details. More recent digital photography can now capture and reproduce color and painted details on wall surfaces in a way that is quite extraordinary. Three-dimensional imaging can capture a tremendous amount of information as well.

Although an avid photographer himself, Breasted quickly learned through experience that unless an

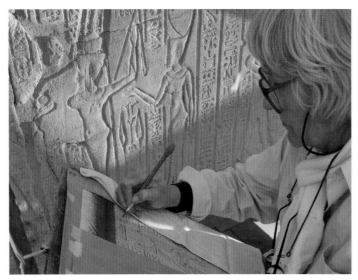

FIGURE 3.5. Survey artist Margaret De Jong penciling details on a photograph in the small temple at Medinet Habu (photo by W. Raymond Johnson)

ancient, inscribed wall surface is in a pristine state, photography alone often cannot capture all the details preserved on it. In the case of a wall surface that is damaged or has been modified through recarving, many details that are visible to the naked eye are often invisible to the camera lens. In cases like these, to supplement and clarify the photographic record, precise line drawings are produced at Chicago House that clearly present the carved details and combine the talents of the photographer, artist, and Egyptologist.

Photography is still the first step. First, the wall surface is carefully photographed with a large-format camera whose lens is positioned exactly parallel to the wall to eliminate distortion (fig. 3.4). A series of photographic negatives are taken along the length of the wall, each the same distance from the wall, taking care to make sure that the edges of each overlap slightly for joining of scenes later. From these negatives, when necessary, photographic enlargements up to 20 x 24 inches are produced, printed on a special matte-surface paper with an emulsion coating that can take pencil and ink lines. All hard-copy negatives and duplicates are archived at Chicago House and the Oriental Institute, and all negatives are scanned at high resolution for digital archiving in both locations as well.

An artist takes the enlarged photographic print mounted on a drawing board to the wall itself and pencils all the carved details that are visible on the wall surface directly onto the photograph, adding those that are not visible or clear on the photograph

(fig. 3.5). This non-invasive system, where no tracing paper or plastic is ever pressed against the wall, is particularly well suited to fragile, decayed wall surfaces that should not be touched. Back at the Chicago House studio — or at home during the summer — the penciled lines are carefully inked by the artist with a series of thin and thick black lines to show the three dimensions of the relief (thin where the hypothetical sun — always from the upper left — strikes the reliefs, and a thicker line where a shadow is cast; Catalog No. 6). Damage that interrupts the carving is rendered with very thin, broken lines that imitate the nature of the break. With care, a skilled artist can indicate with the inked line alone whether the stone is limestone or sandstone, and even differentiate between natural damage and deliberate defacement.

When the inking is complete, the entire photograph is immersed in an iodine bath that dissolves the photographic image containing all the "background noise" that obscures the carved information, leaving

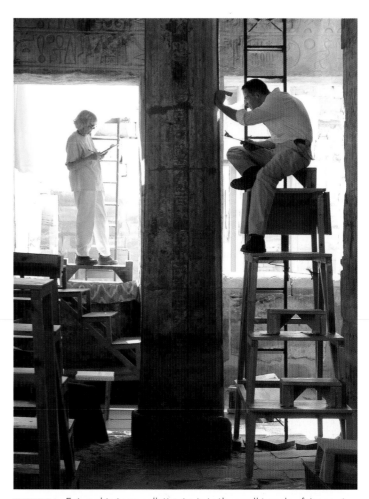

FIGURE 3.6. Epigraphic team collating texts in the small temple of Amun at Medinet Habu. Margaret De Jong (at left) and J. Brett McClain (photo by W. Raymond Johnson)

34

just the ink drawing of the carved details and any damage that interrupts the carved line. The drawing is then blueprinted or scanned (Catalog No. 7). The blueprint is cut into sections, and each is mounted on a sheet of stiff white paper. These "collation sheets" are taken back to the wall where the inked details are thoroughly examined by two Egyptologist epigraphers, one after the other ("first epigrapher" and "second epigrapher") (fig. 3.6). The collation step of the process is a crucial component in all epigraphic recording and allows several sets of additional eyes to ferret out additional information from the carved wall surface that otherwise might be missed. The epigraphers pencil corrections and refinements onto the blueprint itself with explanations and instructions to the artist written in the margins (fig. 3.7, Catalog No. 8).

When the epigraphers have met and consolidated their corrections, the collation sheets are then returned to the artist, who in turn takes them back to the wall and carefully checks each correction or

FIGURE 3.8. Epigraphers and artist checking a drawing at Khonsu Temple. Left to right: J. Brett McClain, Jen Kimpton, Keli Alberts (photo by W. Raymond Johnson)

refinement, one by one (fig. 3.8). When the review is finished, the artist and epigraphers iron out any questions at the wall. When everyone is in agreement, the artist adds the corrections to the inked drawing back in the studio using the collation sheets as a guide, the transferred corrections are checked for accuracy by the epigraphers, and the drawing receives a final review by the field director back at the wall itself (fig. 3.9). During the course of the collation process, the first epigrapher is also responsible for translations and preliminary analysis of the texts being documented, which are later compiled and synthesized by the senior epigrapher.

Ancient Egyptian inscribed wall reliefs were usually intended to be plastered with whitewash and painted with bright, mineral-based pigments. Sadly, most painted details are now missing from the ancient Egyptian monuments, scoured away by time and the elements. But not all monuments are lacking paint. Because many more details were painted than carved, traces of painted details often survive within carved outlines. The convention for paint boundaries in the Chicago House black-and-white line drawings is a row of small consecutive dots. The eye sees the dots as a thin gray line, differentiated from the carved lines that are rendered with unbroken ink lines.

In some rare and wonderful cases when the painted surface is well preserved, full-color reproduction is necessary. Today, color photography — film and digital — can be utilized to capture and reproduce

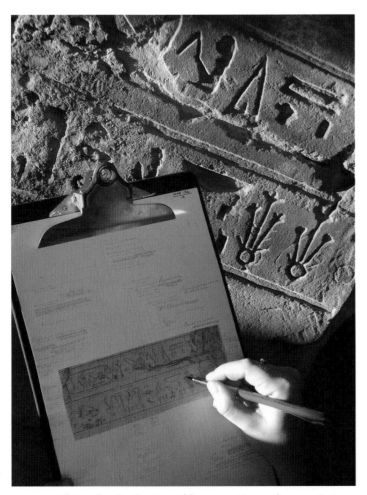

FIGURE 3.7. Epigrapher Jen Kimpton adding corrections and comments to a collation sheet (photo by W. Raymond Johnson)

FIGURE 3.9. Field Director W. Raymond Johnson checking a final drawing with epigrapher Virginia Emery (photo by Margaret De Jong)

perfect for all situations. Each inscribed area has its own set of conditions and challenges, and Chicago House uses whatever methodology is appropriate to record it. Wall areas that are partly obscured behind later walls or are behind columns cannot be photographed, for instance. In such cases tracing (using paper or transparent tracing film) is the only way to document them, and those tracings can be reduced digitally and integrated with the photographs and/ or drawings. Reused blocks in floors, foundations, and walls where inscribed surfaces are barely visible is another situation in which photography is impossible. The reused material in the walls and floors of Khonsu Temple, Karnak, which the Epigraphic Survey is currently documenting with the American Research Center in Egypt (ARCE), is a perfect example. In many instances this material cannot even be traced! But with care, aluminum foil can be slipped in the gaps between the blocks, and rubbings made of the invisible surfaces (utilizing long sticks with cotton tips), with extraordinary results (fig. 3.11). These rubbings can then be traced, reduced digitally, and scale drawings inked according to our normal

true color and is now standard in documentation and publication (fig. 3.10). At the time the Epigraphic Survey and Sakkarah Expedition started work, color photography was not adequate for the task of color reproduction. Instead, a number of talented epigraphic artists mixed colors at the wall surface and instead of penciling photographs, painted directly on the photographic enlargements, matching the colors by eye as they saw them. Printed in Austria and Germany, the published results are sensational and form an exciting component of the early, published record of both expeditions. Chief among the extraordinary artists who perfected this technique were Alfred Bollacher and Virgilio Canziani, whose work can be seen throughout the Medinet Habu volumes. Sakkarah Expedition field director Prentice Duell himself was responsible for many of the color paintings in the Mereruka volumes (Catalog No. 12).

While photography and the Chicago House photographic drawing method are very well suited for certain types of inscribed wall surfaces, they are not

FIGURE 3.10. Color photograph of the king being led into the temple by Montu-Re and Atum at Medinet Habu, published in Medinet Habu IX (photo by Yarko Kobylecky and Sue Lezon; Epigraphic Survey 2009, pl. 113)

FIGURE 3.11. Copying reliefs and inscriptions between flooring blocks at Khonsu Temple. Left to right: J. Brett McClain, Jen Kimpton, Krisztián Vértes (photo by W. Raymond Johnson)

FIGURE 3.12. Epigrapher Tina Di Cerbo recording graffiti on the Medinet Habu second court roof (photo by W. Raymond Johnson)

weighted line conventions. The possibilities are endless; the present author has used the aluminum foil technique quite successfully in ancient Memphis to record blocks that were actually underwater!

Facsimile drawings of graffiti (fig. 3.12) throughout the Medinet Habu complex are now done exclusively digitally, utilizing a modified Chicago House method. Scanned or digital photographs are the basis for digital tracing using Photoshop and Illustrator software on drawing tablets. Preliminary drawings are done in the studio as a layer over the digital photograph, which is then printed and taken to the wall or roof area for collation. Corrections are added back in the studio and checked again at the wall or roof area. We are also experimenting with digital "inking" of our facsimile drawing enlargements on Wacom drawing tablets (fig. 3.13). It is quite possible that a time will come when large-format negative film and photographic paper are no longer available, and all our drawings will be done digitally. We will be ready. We are also looking forward to experimenting with three-dimensional imaging as a future methodology in our Luxor program.

Whatever the method of recording — be it drawing on photographs, tracing with paper or transparent film, doing aluminum foil rubbings, or digital drawings — consultations between the artist, epigraphers, and field director (the consensus of all talents combined) ensure a scientific, facsimile drawing that is faithful to every detail preserved on the wall (fig. 3.14). This is the new definition of what is generally referred to as the Chicago House method. Our goal is to continue improving, refining, and broadening it.

Once the facsimile drawing has received its final review and is cleared for publication by the director, it is archived at Chicago House until the whole

FIGURE 3.13. Digital "inking" by Krisztián Vértes (photo by W. Raymond Johnson)

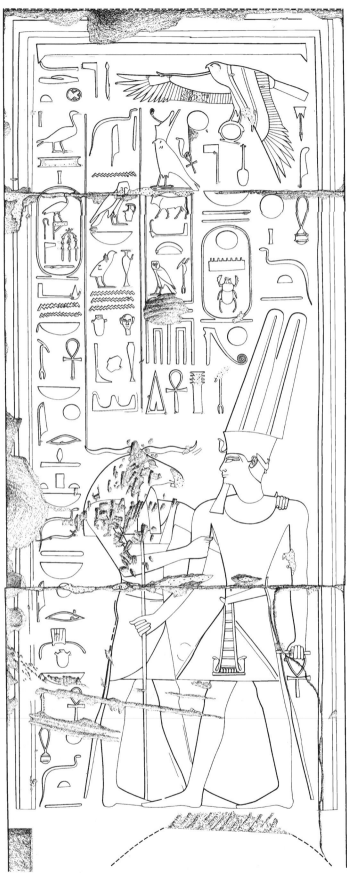

monument being recorded is finished, after which all drawings are taken back as a group to Chicago where the publications are organized and printed. The hard-copy drawings are scanned in high resolution for plate production (after which they are permanently archived at the Oriental Institute) and the whole publication is designed electronically. In fact, all the Epigraphic Survey's publications are now printed digitally, allowing accessibility in electronic as well as in hard copy. Thanks to an exciting new program inaugurated by the Oriental Institute (generously funded by Lewis and Misty Gruber), all past Epigraphic Survey publications have been scanned as well and are now available without charge in PDF format for electronic download from the Oriental Institute Publications website:

http://oi.uchicago.edu/research/pubs/catalog/egypt.html

Eventually all Oriental Institute publications will be available in this format. One of the most exciting aspects of the new digital revolution is that so much information — even archaeological data — can now be made accessible to anyone, anywhere in the world, who wishes it, gratis. The Oriental Institute is leading the way in sharing its data with the world, and this is just the beginning. I believe that James Henry Breasted would be tremendously pleased.

NOTE

[1] Architectural elements from the original house — and the land — were sold to Sheikh Ali Abdul Rasool, who used them to construct the Marsam Hotel and rest house on the original site, still in operation today.

FIGURE 3.14. Final epigraphic drawing by artist Sue Osgood. Medinet Habu small Amun Temple ambulatory, to be published in Medinet Habu X (photo by Yarko Kobylecky)

4. THE SAKKARAH EXPEDITION

ANN MACY ROTH

In 1929, with the Oriental Institute's Epigraphic Survey at Chicago House firmly established in Luxor, its founder, James Henry Breasted, toured the Middle East with John D. Rockefeller, Jr., to inspect the Oriental Institute projects that had largely been made possible by his sponsorship. John A. Wilson noted that an official of the Rockefeller Foundation had asked Professor Breasted (rather desperately, one suspects, given his previous success) not to request further funding from his patron. Breasted, however, "was a man of such bounding enthusiasm and vision" that Rockefeller was entranced by the possibilities of further research and recording and "generously volunteered to support three new copying projects" (Wilson 1964, p. 172).

One of these projects, the Sakkarah Expedition, had as its object the mastaba tombs at Saqqara, which date to the later Old Kingdom (ca. 2495–2181 BC), and more specifically the carved and painted walls of their decorated chapels. Here the highest officials of the era built their tombs and the chapels in which their mortuary cults would be carried out — in perpetuity, they hoped. Only spottily published, these chapels had long intrigued scholars and tourists alike with their many scenes of what appeared to be pictures of daily life: peasants harvesting in the fields, children playing games, fishermen pulling in their nets, tax collectors torturing their victims, and craftsmen working at their benches (fig. 4.1). Such is the charm and convincing nature of these scenes that only in recent years has it been pointed out that their contents are highly selective and probably distorted,[1] and that we have, in fact, little real understanding of their meaning and function.

The initial plan was that the expedition should copy the decoration in most of the major tombs at Saqqara: Mereruka, Kagemni, Idut, Ti, Ptahhotep, and a few others (Breasted 1933, p. 147; Teeter 2010, p. 104). The decision to begin with the Tomb of Mereruka was an excellent one. One of the largest tombs surviving from the period, the central mastaba chapel of Mereruka had ten decorated rooms as well as another ten smaller, undecorated rooms, mostly storerooms. In addition, the two three-room chapels of Mereruka's wife, the Princess Watetkhethor, and of his son, Meriteti, were integral parts of the mastaba, an arrangement unparalleled by other tombs. Only a few walls of any of these had been published, despite the tremendous variety of scenes, their excellent preservation, and the number of them that were unparalleled in other mastaba chapels of the period.

The scholar hired to direct the Sakkarah project was Prentice Van Walbeck Duell, previously a professor at Bryn Mawr College. Professor Duell's wide-ranging background included study of the architecture of Spanish missions in the American Southwest, registration as a practicing architect in New York City, work as an architect on several archaeological expeditions in Greece during a fellowship at the American School of Classical Studies in Athens, and a project funded by the Guggenheim Foundation to copy "in color the best preserved paintings" at the fifth-century Etruscan tombs at Tarquinia, Italy, which unfortunately was never published (Harvard Library 2000). It was presumably because of this last experience and the extensive paint surviving on the

FIGURE 4.1. Wall relief from the mastaba of Mereruka, showing metalworkers (Sakkarah Expedition 1938, vol. 1, pl. 32)

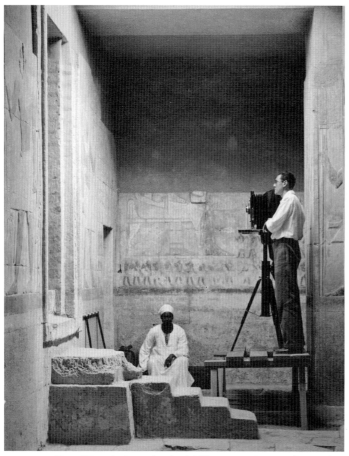

FIGURE 4.2. Expedition photographer Leslie Thompson photographing in the mastaba of Mereruka (Oriental Institute photograph P. 24465)

walls of the chapel of Mereruka that Duell, who had no Egyptological training or expertise, was selected as director.

Despite the experience of its director in Italy, the expedition adopted a recording method that was largely developed by Dr. Caroline Ransom Williams for the work at Chicago House (Nims 1973, p. 91).[2] Large-format photographs of the wall decoration were made (fig. 4.2), on which the carved lines were over-drawn in pencil. "Sun" and "shadow" lines showing the height of the relief were distinguished on the assumption that the sun was coming from the upper left, and erased versions[3] were indicated in an even lighter line. Traces of painted details not shown in the carving were (sometimes) indicated by stippling. When the artist had checked and inked the drawing, the photograph was bleached away, leaving only the inked lines. Blueprints were made of the drawing and Egyptologists checked them again against the walls of the chapel and made further corrections. Keith C. Seele and Charles F. Nims, Egyptologists who had both received their epigraphic training and experience at Chicago House, served as epigraphers for the expedition. According to the foreword of the publication, Breasted and the contemporary director of Chicago House, Harold H. Nelson, also helped with the collation of the Mereruka drawings.

According to Nims, who worked on the expedition during its final season in 1935/36, Duell's original plan for the project was to make these painstaking drawings only of the best-preserved parts of the decorated chapel walls, and record the more poorly preserved and less attractive parts only in photograph (personal communication, 1985). This would have been in line with his preference for recording only the best preserved of the Etruscan paintings. It may also have reflected a different aim for the project: Breasted's foreword to the final volumes (Sakkarah Expedition 1938, vol. 1, p. xi) states that the publication was not intended for specialists, but for art historians generally. The fact that the director of the expedition was an art historian rather than an Egyptologist (as at Chicago House) and the unusually large scale at which the drawings were made and reproduced also tends to confirm this assumption. Nonetheless, the Egyptologists working on the project convinced Duell that the more damaged areas would most benefit from the painstaking epigraphic work of the expedition, and that they should therefore also be drawn (Nims, personal communication, 1985).

Nonetheless, parts of the chapel and most of the underground burial chamber were recorded almost entirely in photographs, as were the sunk reliefs on the exterior of the mastaba. In general, the photographic coverage was excellent, beginning with overall shots of each room from several different angles, and followed by photographs of the individual walls and sometimes additional enlargements of interesting details. The expedition photographer throughout the work was Leslie F. Thompson.

The drawings were the work of seven expedition artists, some presumably working in only one or two field seasons (fig. 4.3). Stanley R. Shepherd was responsible for almost forty drawings, while Vcevold Strekalovski and H. M. Lack each completed about twenty. By contrast, Raymond T. Cowern, Donald Nash, Clyde R. Shuford, and E. A. Warren completed fewer than eight each.

In addition to the photographs and line drawings, there were also a number of paintings of the well-preserved walls on which paint remained (Catalog

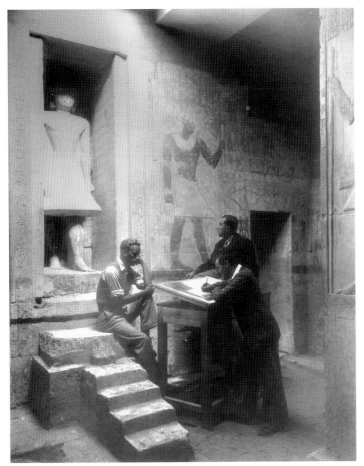

FIGURE 4.3. A posed image of the staff at work in the mastaba of Mereruka, ca. 1934 (Oriental Institute photograph P. 24466)

No. 12). Most of them represented the wall as it was, but a few showed a reconstruction of the original appearance, insofar as the preserved evidence allowed. Shepherd's portrait of Mereruka on the covers of both volumes was one such reconstruction. The paintings attempted to reproduce both the colors and the three-dimensional quality of the reliefs, but techniques used in making them are nowhere described. In some cases, they were clearly based directly on the drawings, as can be seen by comparing the photograph, drawing, and painting of the same wall, for example in plates 42, 43, and 45 (Sakkarah Expedition 1938, vol. 1; fig. 4.4). The expressions on the faces of the men in the painting are identical to those in the drawing, and in several cases noticeably different from those in the photograph.

Four of these paintings were done by the director himself, presumably making use of techniques he had used to record his Etruscan tombs. Expedition artists Strekalovski and Shepherd were responsible for six and five paintings respectively. Duell's paintings, in particular when there seems to be no underlying

FIGURE 4.4. Three forms of documentation of the same scene: top to bottom: photograph, drawing, painting (Sakkarah Expedition 1938, vol. 1, details from pls. 42, 43, 45)

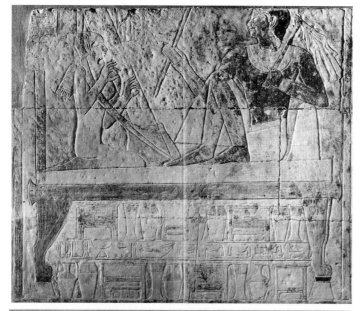

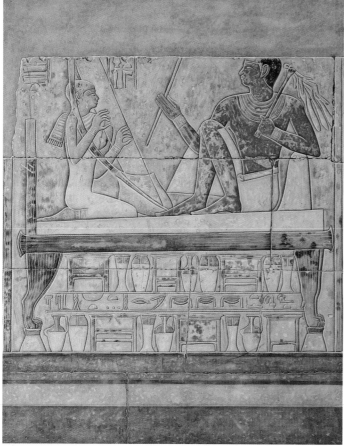

FIGURE 4.5. Significant differences can be seen between the photograph (top) and the color rendering (bottom; Cat. No. 12) (Sakkarah Expedition 1938, vol. 1, details from pls. 94 and 95; bottom, Oriental Institute digital image D. 17471)

drawing, show his lack of experience with Egyptian conventions, for example, in his painting of Mereruka on a bed with Watetkhethor, listening as she plays a harp (Sakkarah Expedition 1938, vol. 1, pl. 95; Catalog

No. 12). When compared to the photo on the adjacent plate 94 (fig. 4.5), both faces show abbreviation at the outer edges of the eye and mouth, as if Duell were trying to foreshorten these features and push the faces toward a true profile view rather than the aspective representation of the original, in which the eye is shown from the front, and the mouth is also shown from the front, but cut by the contour of the profile of the lips.

Finally, in addition to the photographs, drawings, and paintings, one shaded pencil drawing by Shepherd was published as plate 131. It shows the women of Mereruka's family mourning his death. This anomalous technique was probably adopted for reasons of economy; since there was no color on these reliefs, to reproduce a colored painting would have been an unnecessary extravagance.

The two final volumes that resulted from these seasons of fieldwork were heavy and oversized, owing to the large scale of the drawings. They made available the reliefs of the ten decorated rooms of Mereruka's section of the mastaba chapel, and included 219 plates. The only text sections in the volumes were the front matter. A foreword by Breasted, finished after his death by Thomas George Allen, focused on the history of excavation and publication in the Saqqara necropolis. Duell's extensive introduction also discusses earlier work at Mereruka's mastaba. The introduction begins with the descriptions of the chapels of Mereruka's wife and son, and continues with a survey of his family relationships, as far as they could be reconstructed from the monument. Duell's description of the date and history of the mastaba focuses on the undecorated exterior and the underground part of the tomb, and concludes oddly with a discussion of the broken remains of both Mereruka and his wife. The section on the architecture and decoration that follows is a quite thorough and insightful architectural analysis, illustrating Duell's unusual competence in this area. His greatest interest, however, clearly lay in the painting of the relief, which he analyzes in a long section on pigments and an even longer one on technique. A section dealing with the decorative program in general and some observations on the most interesting scenes concludes the introduction.

There is no further text, and the plentiful inscriptions in the tomb chapel are not translated or discussed. This is in many ways a pity, because this chapel is full of *Reden und Rufe*, the texts that represent

conversations (allegedly) taking place between the workers depicted. These, while normally full of suspiciously extravagant praise of the tomb owner, represent rare examples of colloquial speech, and in some cases include songs and magical incantations. Since the books were intended for a larger audience of art historians, translations of the captions too would have been useful because they describe what the tomb owner is doing in each scene.

The book was generally quite well received. One of the most enthusiastic reviewers was William Stevenson Smith (1939). As a specialist in Old Kingdom art, he waxes rhapsodic about the new material made available to scholars and the beauty of the drawings and paintings. Hermann Ranke (1939), though generally positive, complains that some of the broken areas are not recorded in photograph and that the paintings are "not as successful as one might desire" and do not "convey the real colouring of the original." Norman de Garis Davies took an even less enthusiastic view (1939). He described the decoration of the tomb as clumsy and far inferior to the paintings of the Theban region, complaining that the drawings flatter the carving and that the book lacks an index, necessary because the heavy book "cannot be rapidly run over without considerable physical fatigue."

One of the criticisms shared by many of the reviewers was Duell's decision to record the rooms

FIGURE 4.6. (*above*) Architectural and (*below*) conceptual plans for the headquarters of the Sakkarah Expedition (Oriental Institute digital images D.1289, 1290)

belonging to Mereruka's wife and those of his son only verbally. Duell dismissed these in his introduction as "with few exceptions, similar to those in Mereruka's portion," and merely described them with references to the plates of similar scenes in the chapel of the paterfamilias. These two smaller chapels have since been published by the Australian Centre for Egyptology along with Mereruka's rooms, all fully translated (Kanawati and Abder-Raziq 2004 and 2008; Kanawati et al. 2010 and 2011).

One of the criticisms not voiced in the reviews, but mentioned by both Wilson (1964) and Teeter (2010, p. 104), was the less-than-austere living quarters of the expedition, whose gardens and luxurious appointments (fig. 4.6) must have been a galling contrast for staff members of expeditions housed in the more isolated and primitive archaeological dig houses of the day. Breasted seems to have been ahead of his time in his understanding that a comfortable living situation is essential to the productivity of the members of an archaeological or epigraphic expedition and in preventing the gossip, backbiting, scandal, and violent feuds that tend to develop over the course of a long and intense field season. While the quarters of the Sakkarah Expedition do not seem to have achieved practical success in avoiding all these evils (Nims, personal communication, 1985), certainly the consistent beauty and accuracy of the drawings created by the staff support the theory that a pleasant house helps.

The ambitious plan to go on to record other mastaba tomb chapels at Saqqara was never realized. Other projects had begun to work on some of them in the meantime, and the money supplied was exhausted. Breasted had died in 1935, leaving his foreword to *The Mastaba of Mereruka* to be completed by a colleague, and perhaps the absence of his "bounding enthusiasm and vision" left Mr. Rockefeller less inclined to continue the projects they had devised. After the close of the project, Professor Duell spent several years studying in London and Vienna before being appointed a research fellow in Etruscan art at the Fogg Art Museum of Harvard University, where he remained until

his death. Nims and Seele returned to the Oriental Institute, where Nims finished his doctorate and Seele took up a teaching position. The same year the Mereruka volumes appeared, Nims published an extensive analysis of the complicated recuttings in the chapel of Meriteti, Mereruka's son, a testament to the missed opportunity represented by the omission of this chapel from the epigraphic publication. This research, presumably done while Nims was working for the expedition, was cited frequently by Duell in his discussion of Mereruka's family and his description of the son's tomb. Nims ultimately became director of the Epigraphic Survey at Chicago House (1964–1972), while Seele later served as director of the Oriental Institute's extensive work in the Nubian archaeological salvage campaign from 1960 to 1964.

The two massive volumes of detailed photographs and facsimile drawings they produced, however, set a standard for the epigraphic recording of Old Kingdom tomb chapels that has rarely been matched in its thoroughness, detail, and accuracy.

NOTES

[1] For example, regardless of their activities, all the participants of these scenes, including the tomb owner himself, are dressed in clothing appropriate only to the summer months; and despite the fact that melons occur frequently in mortuary offerings, neither they nor their cultivation are depicted in the tomb chapel reliefs (Weeks 1979).

[2] The exact origin of the Chicago House method adopted by the Sakkarah Expedition is somewhat contested. While both Nims (1973) and Wilson (1972) agree that the original method proposed was scrapped after two years and replaced in 1926 by the collation of drawings made on photographic enlargements, Wilson credits this improvement to Nelson and Breasted, while Nims credited it "largely" to Ransom Williams. He was considerably more emphatic about her role in conversation (1985). On the one hand, Nims did not arrive at Chicago House until 1936, so his version was clearly hearsay; on the other hand, Breasted in his introduction to the first Medinet Habu volume thanks Ransom Williams for her "very valuable work" (Epigraphic Survey 1930), which may allude to her refinement of the epigraphic method.

[3] An example of this is the homoioteleuton recorded on the lowest register of the A8 wall shown on plate 58 (Sakkarah Expedition 1938, vol. 1), where a festival was omitted from the sequence and had to be squeezed in and recarved.

5. PHOTOGRAPHY AND DOCUMENTATION OF THE MIDDLE EAST

EMILY TEETER

Photography has played an important role both in documenting the past and building an audience for those images. The first photographic method was patented in 1839 by Louis J.-M. Daguerre. The technique was applied to the documentation of the ancient Middle East that same year when François Arago suggested that it be used to record hieroglyphic inscriptions, continuing the work of the Napoleonic expedition. He proposed:

To copy the millions of hieroglyphics which cover even the exterior of the great monuments of Thebes, Memphis, Karnak, and others would require decades of time and legions of draftsmen. ... Equip the Egyptian Institute with two or three of Daguerre's apparatus, and before long ... innumerable hieroglyphics as they are in reality will replace those which now are invented or drawn by approximation. These designs will excel the works of the most accomplished painters, in fidelity of

FIGURE 5.1. Beato. View of the first pylon of Luxor Temple, ca. 1862. At that time the pylon and the colossal statues of Ramesses II were still encumbered by meters of soil. Local people have been included in the photograph for scale and probably to add an exotic "Oriental" atmosphere (Oriental Institute photograph P. 955)

FIGURE 5.2. Bonfils. The pyramids at Giza during the inundation, ca. 1880 (Oriental Institute photograph P. 529)

detail and true reproduction of the local atmosphere (Bohrer 2007, p. 183).

The first image of Egypt (indeed the first image from Africa) also appeared that same year, Frédéric Goupil-Fesquit's daguerreotype of the "Harem at Alexandria." Mohammed Ali Pasha, the ruler of Egypt, declared, "It's the work of the devil" (Bull and Lorimer 1979, p. viii). The practical application of photography was limited by the inability to make more than a single copy of each daguerreotype. An even greater problem was that these early "photographs" had to be reproduced as engravings. This had the disadvantage that the engraver, who etched the photograph backward on a metal printing plate, was probably completely unfamiliar with the details of the subject matter, leading to errors. As techniques of

photography evolved, especially the ability to make multiple copies from paper negative calotypes (Bull and Lorimer 1979, p. x), there was a corresponding growth in the audience and demand for photos. The early photographers did not initially consider the artistic potential of the new medium. As a result, the early images of Egyptian temples and sites are composed more like paintings, being views of picturesque ruins with locals included to give color and scale. A similar mood can be seen in Gabriel Tranchand's calotypes of the excavations at Khorsabad, Iraq, in the mid-nineteenth century. They do not document the stages of the work, but rather they use the monumental architecture as a "backdrop of a stage" against which members of the expedition pose. The images record the romance of fieldwork rather than the fieldwork itself (Bohrer 2007, p. 189).

The idea that photography could be used for strictly documentary purposes (as would prove to be so common in archaeology) was tested by William Fox Talbot in 1844 (who was himself an Assyriologist who played a role in the decipherment of cuneiform) when he photographed "Articles of China," a group of decorative ware. This has been heralded as "demonstrating photography's ability to present neutral information in pictorial form, and its potential as evidence" (Marien 2002, p. 31). In 1846, the *Art Union* called photography "an indispensable accompaniment to all exploring expeditions" (Marien 2002, p. 50), a statement that certainly holds to this day.

Egypt was of special interest to early photographers. In 1841, Hector Horeau's *Panorama d'Egypte et Nubie* appeared, consisting of aquatints made from daguerreotypes shot by Joly de Lotbinière (Bull and Lorimer 1979, pp. ix–x; Marien 2002, p. 51). By the middle of the century, several photographers were active in the Middle East, among them Maxime Du Camp, who was commissioned by the French Ministry of Public Education to make images of Egyptian monuments. His *Egypt, Nubie, Palestine et Syrie* (1852), with 125 images, was one of the first travel books to have reproductions of photos rather than calotypes (Marien 2002, pp. 53–54). Many other commercial photographers followed, including Francis Frith (1856–59), Antonio Beato (1870) (fig. 5.1), and Félix Teynard (1851–52, 1859). Others became major commercial successes, selling images of the Nile Valley to Europeans and Americans on the Grand Tour. Of special note are the Bonfils family, who by 1888 offered a selection of more than 15,000 prints and nearly 600 stereo views of Egypt (fig. 5.2), and Lehnert & Landrock (active in Egypt from 1923), who still operate stores in Cairo and Luxor (Evans 2000, pp. 8–11).

As technological developments made photography and the reproduction of images easier, the public demand for images of the Middle East rose. Stereoscope photos appeared in the 1850s and they became a fixture of nearly every parlor for the next seventy years (see Catalog No. 26). Yet early photographic equipment was heavy (see fig. 5.3), and the chemicals and lighting sources were dangerous. Until the 1940s, color photography was expensive and did not accurately record pigment, necessitating that other methods, such as color facsimiles, be employed (Catalog Nos. 10–12).

Archaeologists were quick to adopt new developments, including low- and high-altitude aerial photography (see Branting in this volume and Catalog Nos. 30–33). James Henry Breasted himself experimented, rather unsuccessfully, with aerial photography in Egypt in 1920 (Emberling and Teeter 2010, pp. 52–54). Digital photography has now revolutionized the way that field archaeologists work and how research is published.

Archaeology is a destructive practice. Upper strata of an excavation vanish and are preserved only through notes, drawings, and photographs. The Oriental Institute has always appreciated the role that photography plays in fieldwork, and most of the expeditions from 1905 onward had a designated photographer. As Frederick Bohrer has noted (2005, pp. 188–89), the photos of archaeological work are themselves transformed into a sort of artifact because their content and context must be puzzled out, just as the site was. In their crucial role in the epigraphic process (see Johnson, this volume), photographs have value in "filtering, reorganizing, and fundamentally improv[ing] upon real conditions" because they assist the epigrapher in distinguishing the visual "noise" of salt and erosion from the carved signs. These epigraphic photos likewise can be said to have been transformed from objective documents to archaeological artifacts in their own right (Bohrer 2007, pp. 183–84).

Photography is often assumed to record rather than imagine the subject, but photos, like paintings

FIGURE 5.3. Expedition photographer Horst Schliephack photographing the inscription of Thutmose I at Tombos, 1906–1907. This image illustrates some of the challenges of using a large-format camera in the field (Oriental Institute photograph P. 6332)

FIGURE 5.4. Bonfils. View of the Edfu Temple, ca. 1880 (Oriental Institute photograph P.367)

or reconstructions, can be subjective. As photographer Elliot Erwitt has stated, "[photography] has little to do with the things you see and everything to do with the way you see them. Photography is an art of observation." Indeed, the questions of the objectivity and/or the deliberate manipulation of photos were raised beginning in the mid-nineteenth century. Deliberate falsification of images appeared as early as 1840, when Hippolyte Bayard published the staged "Self-Portrait as a Drowned Man," showing himself as a corpse (Marien 2002, p. 15, fig. 1.14). This image, which has been described as giving the "impression of reality with the fantasy of dreams" (ibid., p. 32), produced an uncomfortable mixture of fact and fiction that continues to be an important issue in the era of Photoshop. The question of the veracity of photos became very sensitive as images became part of the dialogue about the historicity of the Bible, as

with George Skene Keith's daguerreotypes published (as engravings) in *Evidence of the Truth of the Christian Religion* (1844) "that would show the veracity of the Bible" and would "convince the unprejudiced inquirer or the rational and sincere believer, that it is impossible that his faith be false" (Marien 2002, p. 52). Photography and its relationship to drawings that are often used in conjunction with images played a similar role in the work in Félicien de Saulcy's *Jerusalem* (1856). Saulcy ascribed earlier dates than other scholars to some artifacts and architectural features in Jerusalem, basing his conclusions on "close visual examination and comparison." He commissioned photographs to augment his own drawings because the photos were considered to be more objective: "photographs are more than tales [*récits*], they are facts endowed with a convincing brute force" (Bohrer 2005, p. 181).

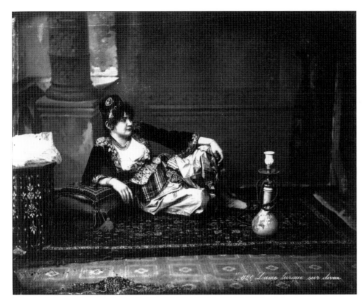

FIGURE 5.5. "Dame turque sur divan" by Zangaki, ca 1870. This genre of carefully posed studio portrait created an Orientalizing vision of decadence and languor in the minds of Westerners (from *Lost Egypt*; Epigraphic Survey 1992, vol. 1, pl. 1)

Photographs of the Middle East attracted a huge audience of "arm-chair travelers" who devoured the early images of the pyramids and the Holy Land, sites that were inaccessible to all but the most privileged and intrepid (figs. 5.4–5). This relatively inexpensive, vicarious, and safe form of travel through images continues today, as noted by Susan Sontag in her commentary on tourist photography: "As photographs give people an imaginary possession of a past that is unreal, they also help people take possession of a space in which they are insecure" (Sontag 1977, p. 9). The thirst for images of the region is evident in issues of *National Geographic* magazine, which for more than 125 years has been filled with images of the places, people, and customs of the Middle East. This reliance upon photos to learn and experience the region also caters to a juvenile audience as exemplified by the magazine *National Geographic Kids* and Richard Halliburton's *Second Book of Marvels: The Orient* (1938). As the author stated in the preface to its companion volume *Book of Marvels: The Occident,*"

> When I was a boy in school my favorite subject was geography, and my prize possession was my geography book. This book was filled with pictures of the world's most wonderful cities and mountains and temples, and had big maps to show where they were. I loved that book because it carried me away to all the strange and romantic lands. I read about the Egyptian Pyramids, and India's marble towers, about the great cathedrals of France, and

the ruins of ancient Babylon (Halliburton 1937, p. 1).

These images created a view of the ancient and modern Middle East in the mind of the public, many of them becoming iconic, whether accurate or not.

The images also had a secondary value to archaeologists. Not only do they inform the public about their scientific work and educate more generally about the ancient world, but the photos had a monetary value. This worth was recognized as early as the 1850s, when Hugh Welch Diamond's images of mental patients, initially taken for medical study, were sold to raise funds for an asylum (Marien 2002, p. 37). This same secondary value of photographs was utilized by Howard Carter, who discovered the Tomb of Tutankhamun in 1922, and who used the Harry Burton photographs (Catalog No. 29) for publicity purposes to fulfill a lucrative contract with the *Times of London*. In 1934 (Abt 2011, p. 383), in an effort to bring its work to a broader audience, the Oriental Institute made its only significant foray in filmmaking with the production of a popular film entitled *The Human Adventure* (fig. 5.6).

Today, in the era of good-quality compact digital cameras, it is rare for an expedition to not have a blog or website that is as important for its fundraising efforts as it is for recording its work.

FIGURE 5.6. Photograph taken during the filming of *The Human Adventure* (Oriental Institute photograph P. 28743)

6. THE ORIENTAL INSTITUTE PHOTOGRAPHIC ARCHIVES

JOHN A. LARSON

Photography is a means of recording a moment in time. Archaeology is inherently a destructive process, and photography provides us with an opportunity to collect and store data in a more-or-less permanent way. During the period from 1919 to 1940, Oriental Institute archaeological field expeditions and projects used documentary photography as one of the principal methods for recording the setting of each expedition, the progress of the fieldwork, and the discoveries that were made. In the era from 1946 to the present, photography has been joined by a whole array of techniques for recording archaeological data. The Oriental Institute Photographic Archives currently contains more than 100,000 images, and it continues to be a rich resource for early photography as well as an ongoing source of documentary photographs. This essay provides a snapshot of the range of the Oriental Institute's photographic holdings and a historical background to its formation.

The Oriental Institute was established by Professor James Henry Breasted at the University of Chicago in May 1919 with the financial assistance of John D. Rockefeller, Jr. Its collections, however, had their origins in the Haskell Oriental Museum, which opened its doors to the public in 1896. The first accession of photographs consisted of nineteenth-century views of Egypt, which were purchased by Breasted in 1894/1895 (fig. 6.1). The photographers represented by this collection include Antonio Beato, Maison Bonfils, Emil Brugsch, G. Lekegian, and Zangaki Frères. In addition, Breasted bought photographs of objects in the British Museum in London from Clarke & Davies and of the Musée du Louvre in Paris from A. Giraudon, which served as the core of a teaching collection that would be used for many years to come.

During the next twenty years there were a number of noteworthy additions to the collections. In 1901, the Haskell Oriental Museum received the gift of more than 150 photographs by Antoin Sevruguin of Persian subjects from Mary A. Clarke of Chicago (fig. 6.2). In 1902, Breasted purchased 198 lantern slides of objects found in the Royal Tombs of Abydos and elsewhere by William Flinders Petrie, a substantial addition to the teaching collection (fig. 6.3).

The earliest original photography in the collections that now comprise the Oriental Institute Photographic Archives are the pictures that were taken

FIGURE 6.1. A *dahabiya*, or "golden boat," in front of Luxor Temple, showing the Colonnade Hall of Tutankhamun and the Sun-court of Amunhotep III, looking east from the Nile River, Luxor, Egypt. Photographer unknown, before 1900 (Oriental Institute photograph P. 1005)

FIGURE 6.2. Nasir al-Din Shah, the shah of Persia, resting during a hunting expedition. Photographed by Antoin Sevruguin, before 1896 (Oriental Institute photograph P. 1101)

During the winter season of 1905/1906 and again in 1906/1907, Breasted and his colleagues made two reconnaissance trips to Nubia. Their photographic record comprises almost 1,200 original black-and-white images. Nearly 90 percent of this corpus, 1,055 photographs, was published in 1975 by the University of Chicago Press in a two-volume microfiche edition under the title *The 1905–1907 Breasted Expeditions to Egypt and the Sudan: A Photographic Study.* In 2001 (revised, June 18, 2010), digital scans of these photographs were posted on the Oriental Institute website, now at URL http://oi.uchicago.edu/museum/collections/pa/breasted.

The first season of the University of Chicago expedition lasted from November 1905 to April 1906. Professor Breasted was accompanied by his wife Frances Hart Breasted; their son Charles; an American engineer, Victor Smith Persons; and a German photographer, Friedrich Koch. The principal objective of the first campaign was the Temple of Ramesses II at Abu Simbel (fig. 6.5). Breasted and his team worked for forty days at Abu Simbel, photographing the monuments and copying the inscriptions. By April 3, 1906, Breasted had finished copying the historic inscriptions in all the pre-Ptolemaic temples of Lower Nubia. He had accomplished this by means of a new recording method, whereby the photographer would photograph an inscription and make blueprints from the negatives, which Breasted would then collate with the original. Breasted's procedure became the basis for the method that is still employed by the Epigraphic

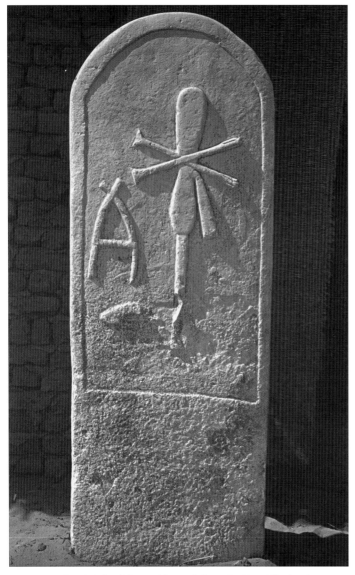

FIGURE 6.3. Great stela of Queen Merneith from the Royal Tombs at Abydos, Egypt, found by the Egypt Exploration Fund, season of 1899/1900. Photographed by William Matthew Flinders Petrie, 1900 (Oriental Institute lantern slide S. 407)

on the Breasteds' honeymoon trip to Egypt during winter 1894/1895. This was not a completely successful effort, and only a handful of photographs survive from this trip. Among the pictures that do survive are eight photographs taken in and around the Tomb of Ramose, Theban tomb-chapel number 55, before the tomb-chapel was restored (fig. 6.4).

Although the photography from the Bismaya expedition did not enter the collections until 1922, the photographs taken by Edgar James Banks (1903–1905) and Victor Smith Persons (1904–1905) at the site of Bismaya (ancient Adab) in southern Iraq are the earliest archaeological field expedition images in the collections.

FIGURE 6.4. Frances Hart Breasted, the wife of James Henry Breasted, at the Tomb of Ramose, tomb-chapel number 55, at West Thebes (Luxor), Egypt. Photographed by James Henry Breasted, 1894 (Oriental Institute photograph P. B 118)

Survey of the Oriental Institute, founded by Breasted in 1924 and headquartered in Luxor, Egypt.

Beginning the second season in October 1906, the expedition focused on Upper Nubia in the northern Sudan — a remote part of the world that was less hospitable and less frequently traveled than Lower Nubia. Accompanying Breasted were photographer Horst Schliephack and English Egyptologist Norman de Garis Davies, who was also an excellent copyist and draftsman. The expedition began work at Meroe, where Breasted and Davies made key plans of the pyramids, while Schliephack produced the photographic record. During its second season in Nubia, the University of Chicago expedition had doubled the distance traveled by the celebrated Amelia Edwards, author of *A Thousand Miles Up the Nile* (1876). More than a century later, the documentary photographs of the Breasted Expedition are still important records of the land that is Nubia.

FIGURE 6.6. Photographer John Hartman adjusts his large-format view camera to take a picture of a coffin panel in a room of the Egyptian Museum, Cairo, field season of 1922/1923. Photographed by John Hartman, 1923 (unnumbered photograph)

FIGURE 6.5. Close-up of the third colossus of Ramesses II from the exterior facade of the Temple of Ramesses II at Abu Simbel, Egypt. James Henry Breasted sits atop the uraeus of the king and Victor Persons assists in the measurement from the ladder below, while Breasted's son Charles and wife Frances look on, to the right of the ladder. Photographed by Friedrich Koch, January 1906 (Oriental Institute photograph P. 27264)

The years between the wars, 1919–1940, mark the heyday of Oriental Institute field expeditions and projects. The inaugural reconnaissance trip of the Oriental Institute was led by Professor Breasted and lasted nearly a full year, from August 18, 1919, to July 1920. He was accompanied by Daniel David Luckenbill, Ludlow Sequine Bull, William Franklin Edgerton, and William Arthur Shelton. Luckenbill was the "official" photographer of the expedition, but all the participants carried cameras. Of the five men, only Bull seems to have left no known photographic record of the experience. The photographs from this expedition, as well as the letters which Breasted wrote to his family during the course of the trip, served as the basis for the temporary exhibition Pioneers to the Past: American Archaeologists in the Middle East, 1919–1920, which was presented at the Oriental Institute Museum from January 12 to August 29, 2010.[1] The home letters of Breasted have been published in the first volume of the Oriental Institute Digital Archives (OIDA), entitled *Letters from James Henry Breasted to His Family, August 1919–July 1920: Letters Home during the Oriental Institute's First Expedition to the Middle East* (http://oi.uchicago.edu/pubs/catalog/oida/oida1.html).

The Ancient Egyptian Coffin Texts Project was the first field project of the Oriental Institute, and most of the photography of the coffins was undertaken by Austrian photographer John Hartman during the season of 1922/1923 in the Egyptian Museum, Cairo (fig. 6.6). That same John Hartman served as the first

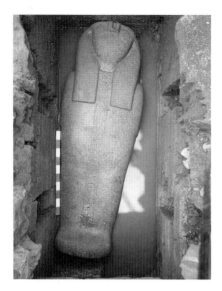

FIGURE 6.7. Stone sarcophagus lid with a falcon head in the excavation of the Tomb of Harsiese at Medinet Habu, West Thebes (Luxor), Egypt. Field Season of 1927/1928, Twenty-second Dynasty, now in the Egyptian Museum, Cairo, 59896. Photographed by Henry Leichter, 1928 (Architectural Survey field negative M. H. Exc. A.64/Oriental Institute photograph P. 14179)

photographer for the Epigraphic Survey in Egypt, under the direction of Harold Hayden Nelson, from October 1924 until his death on December 5, 1926.

In 1926, the Oriental Institute launched three expeditions in the Middle East: the Prehistoric Survey of Egypt, the Megiddo Expedition, and the Hittite Expedition (later re-named the Anatolian Expedition, centered on the site of Alishar Hüyük). The Prehistoric Survey of Egypt was conducted by Kenneth Stuart Sandford and William Joscelyn Arkell, two British geologists of the University of Oxford, from 1926 to 1932. The principal photographer at Megiddo was Olaf Ericson Lind, who served from 1926 to 1936. In 1937, he was succeeded by Charles B. Altman, who also served as architect. Megiddo was a massive undertaking, and one of the most important aspects was the Megiddo balloon series of photographs, taken under P. L. O. Guy from a meteorological balloon inflated with hydrogen (Catalog Nos. 30, 31).

In 1926, an expedition under the direction of Hans Henning von der Osten was sent out by the Oriental Institute to Asia Minor in order to survey sites in central Anatolia; the photographers of the expedition were Dr. von der Osten and his wife Maria. In subsequent years, the photographers at Alishar Hüyük were Hermann Schüler (1929–1932) and

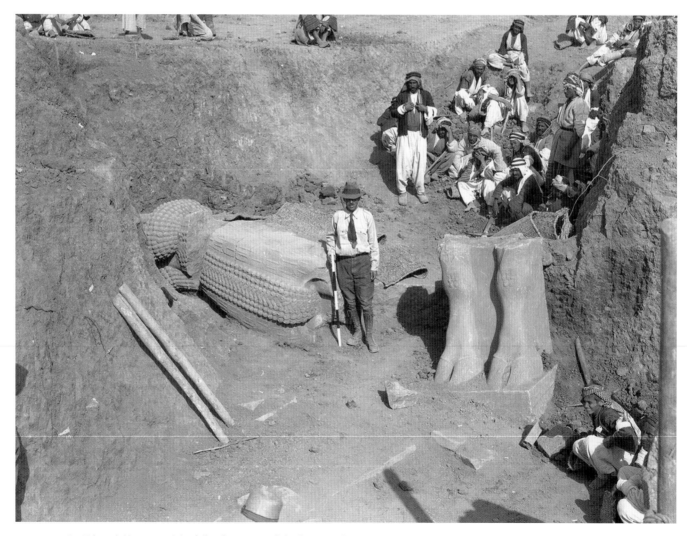

FIGURE 6.8. Dr. Edward Chiera amid the fallen fragments of the *lamassu*, the great human-headed winged bull, now OIM A7369. Photographed by Mrs. Chiera, 1929 (Khorsabad field negative D. S. 231 [1929]/Oriental Institute photograph P. 17586)

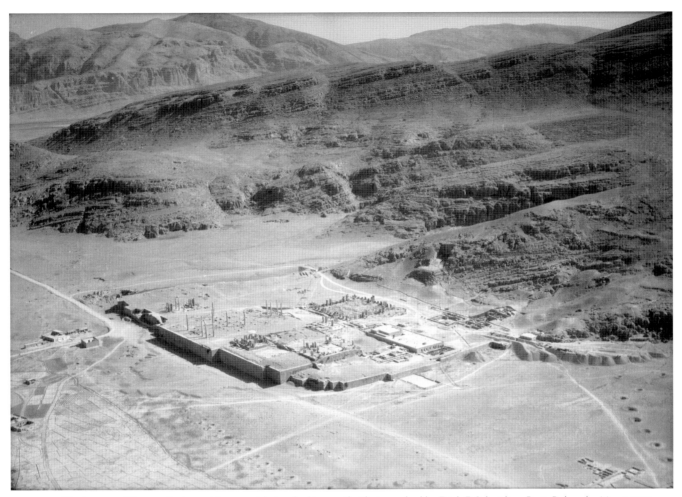

FIGURE 6.9. The terrace of Persepolis, Iran, oblique aerial view, looking north. Photographed by Erich F. Schmidt or Boris Dubensky, May 4, 1937 (Aerial Survey of Iran field negative AE-349)

B. P. Neil (1930). Although the results of this expedition were published in a timely fashion, the Alishar Hüyük material lay almost overlooked until the last ten years, when there has been a resurgence of interest in all things Anatolian.

From March 1927 to April 1928, Olaf Ericson Lind was seconded from Megiddo to serve as photographer for the Epigraphic Survey and the new Architectural Survey at Medinet Habu under Uvo Hölscher. From October 1928 to 1930, Arthur Q. Morrison was the photographer for the Epigraphic Survey, and Henry Leichter served as photographer for the Architectural Survey from 1928 until it shut down in 1933. In 1930, Leichter succeeded Morrison as photographer of the Epigraphic Survey, as well, and he served in that capacity until Chicago House was closed for World War II in 1940 (fig. 6.7).

The Oriental Institute worked at the site of Khorsabad (ancient Dur-Sharrukin) from the field season of 1928/1929 until 1935. Due to the presence of its ancient Neo-Assyrian reliefs, Khorsabad was

one of the most photogenic sites ever excavated by the Oriental Institute. The work was begun by Edward Chiera and continued from 1930 to 1935 under

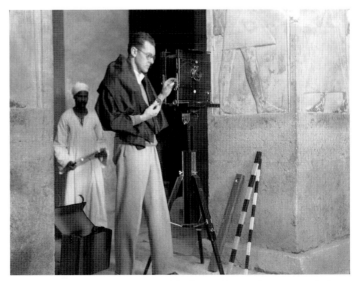

FIGURE 6.10. Leslie F. Thompson and Ibrahim Mohammed Moussa with the view camera in the mastaba of Mereruka at Saqqara, Egypt. Photographed by Leslie F. Thompson, 1933 (Thompson negative E4/404)

Gordon Loud. The dramatic images of the retrieval of the *lamassu* form the centerpiece of the photographic record of Khorsabad (fig. 6.8).

In 1930, the Iraq Expedition was established in the Diyala River Valley region of Iraq, under the direction of Henri Frankfort. Rigmor (Mrs. Thorkild) Jacobsen was the photographer. From 1931 to 1935, H. W. von Busse served as photographer of the Persepolis Expedition in Iran, under the direction of Dr. Ernst E. Herzfeld. In 1935, Herzfeld was replaced as field director of the Persepolis Expedition by Erich F. Schmidt, and von Busse was succeeded by Boris Dubensky, who served until 1937. Ursula Schneider served as photographer at Persepolis during the season of 1938/1939. From 1935 to 1937, the Aerial Survey of Iran was active, under the supervision of Erich F. Schmidt; Schmidt and Dubensky were the photographers of the Aerial Survey of Iran (fig. 6.9). In 1940, the Oriental Institute published a selection of the images from the Aerial Survey of Iran under the title *Flights Over Ancient Cities of Iran*. In the years since, these photographs have served the needs of both archaeology and military, including aerial reconnaissance.

From October 1, 1931, to June 30, 1936, Leslie Frederick Thompson served as the photographer of the Sakkarah Expedition, and it was he who photographed the mastaba of Mereruka (fig. 6.10).

During the winter of 1933/1934, the Oriental Institute sponsored a documentary film called *The Human Adventure*. Charles Breasted narrated the film, which included nearly all the sites that were then being worked on by the Oriental Institute. The cinematographer was Reed Haythorne and the unofficial photographer of *The Human Adventure* project was James Henry Breasted, Jr. (see fig. 5.6).

Early in 1940, as World War II was underway in Europe, a small Oriental Institute expedition was working at the site of Tell Fakhariyah in Syria, when the expedition was abruptly forced to abandon the site. The staff consisted of Dr. and Mrs. Calvin W. McEwan, Harold D. Hill, and Abdullah Said Osman al-Sudain.

In the years following the end of World War II, the Oriental Institute Photographic Archives has continued to grow but at a somewhat slower pace than before. We have added field negatives from Nippur and Jarmo in Iraq, the Nubian Salvage Project, and the site of Tell es-Sweyhat in Syria. Other expeditions, such as Hamoukar and Zincirli, remain in the hands of the excavators until such time as it is appropriate to turn the materials over to the Archives for long-term storage.

John J. Jena and Herbert P. Burtch were the photographers of record during the 1920s, when the Haskell Oriental Museum housed the collections of the Oriental Institute. Luin Wesley Hough was the photographer of the new Oriental Institute Museum from November 1933 until his retirement on August 31, 1955. Ursula W. Schneider served as Museum photographer from 1955 until her retirement in August 1973. That same year Jean M. Grant succeeded Ursula and served for thirty-four years until her retirement in 2007. Anna Ressman became Museum photographer on September 4, 2007, and the Oriental Institute Museum entered the Digital Age.

Today, we average a dozen scholarly visitors from outside the Oriental Institute each year and an equal number from within the Institute. Most of our traffic comes to us via e-mail. Beginning in 1985, we started transferring data from the photographic catalog cards to a simple database using FileMaker Pro. At first, the process was a slow one and utilized the efforts of a handful of volunteers. In recent years, the pace has picked up under a series of MAPSS (Master of Arts Program in the Social Sciences) students who have managed to get nearly two-thirds of the data entered into the photo database. The process of scanning the actual photographic images and merging them into an integrated database remains to be finished, but we have made a start, and we look forward to visitors who will take advantage of these developments.

From Breasted at Abu Simbel to Chiera at Khorsabad, from McEwan at Tell Tayinat to Herzfeld and Schmidt at Persepolis, and from von der Osten at Alishar Hüyük to Guy and Loud at Megiddo, the early years of the Oriental Institute in the Middle East are among the brightest chapters in the history of archaeology. There are over 100,000 images in the Photographic Archives of the Oriental Institute, and the photography continues to enlighten and instruct us.

NOTE

[1] The catalog of the exhibit is available for free PDF download on the Oriental Institute website: http://oi.uchicago.edu/research/pubs/catalog/oimp/oimp30.html.

7. AERIAL PHOTOGRAPHS AND SATELLITE IMAGES

SCOTT BRANTING, ELISE MacARTHUR, AND SUSAN PENACHO

Looking out the window of an airplane you can see the world unfolding beneath you. A landscape of towns, mountains, fields, forests, rivers, and cities lie like a map as far as the eye can see. This aerial perspective provides a unique vantage point for perceiving portions of the ancient world that remain visible in the landscape far below. Missing swaths of the ancient landscapes, obliterated by more modern features and practices on the ground, can also be imagined from these heights and reconstructed in the areas between the scattered portions that remain. In the hands of a trained archaeologist, photographs taken from high overhead can profoundly change understandings and preservation strategies for ancient sites and regions. They provide a record of landscapes that are constantly under threat and preserve knowledge about those landscapes even if they are subsequently destroyed.

William Sumner, former director of the Oriental Institute, once remarked that he understood more about his site of Tal-e Malyan in Iran by looking at a particular aerial photograph than he had been able to through ten years of excavation and survey (Gerster and Trümpler 2005, p. 25). Both avenues of investigation by archaeologists are complementary. Interpreting an aerial photograph requires knowledge of what you see in the photograph, knowledge that can only be gained by someone on the ground having visited or excavated it. However, in areas difficult to visit, features similar to sites known from elsewhere can be identified with such imagery. The pioneering aviator Charles Lindbergh made several airplane trips with his wife reconnoitering archaeological sites in the American Southwest and Central America. He noted that "from my ship I can find one undiscovered ruin for every one that has been located from the ground" (Weyer 1929, p. 54).

A hot-air balloon was the first platform to provide such a photographic perspective for archaeological purposes. In 1906 the British Army photographed Stonehenge, the first time that an archaeological site had been photographed from the air (Capper 1907). This was followed in the years leading up to World War I by the Italian Army using a balloon to photograph Rome and its ancient port of Ostia, and Henry Wellcome using a box kite to photograph excavations at Jebel Moya, Sudan, in 1913 (Addison 1949, p. 6). The Oriental Institute made use of balloon photography starting in 1929 during the excavations at Megiddo (Guy 1932) (see Catalog Nos. 30, 31). Photography from both manned and unmanned balloons continues to be used in archaeology. The current Oriental Institute and British Institute of Archaeology at Ankara project at Kerkenes Dağ, for example, made extensive use of balloon photography in the 1990s to map a very large Iron Age city in Turkey.

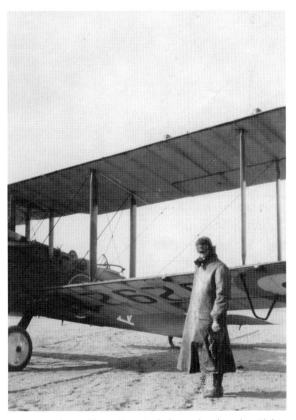

FIGURE 7.1. James Henry Breasted, dressed and ready with his camera in front of the British Royal Air Force biplane used for his historic flight over ancient sites in Egypt. Heliopolis Aerodome, January 1920 (Oriental Institute photograph P. 68544)

FIGURE 7.2. Mary-Helen Warden, wife of the Oriental Institute's Erich Schmidt, standing in front of the airplane that she purchased for her husband's extensive research in Iran in the 1930s. Schmidt used the plane to capture over a thousand aerial photos across wide areas of the Iranian landscape. These were the first aerial images taken in Iran (unnumbered photograph)

World War I introduced the use of airplanes for aerial photography and during 1917–1918 the German Army Air Service and the British Royal Flying Corps took the first airplane photographs specifically of archaeological sites in the Middle East. O. G. S. Crawford, the acknowledged father of aerial archaeology, dated the birth of aerial archaeology to his own work with the Royal Air Force (RAF) in Britain in 1922. However, the Oriental Institute foreshadowed his use of aerial archaeology by several years. In January of 1920, James Henry Breasted, the founder of the Oriental Institute, photographed both Egyptian pyramids and temples and Dura-Europas in Syria from RAF planes (fig. 7.1). Early aerial archaeology conducted by the Oriental Institute continued through the 1930s, culminating in thousands of aerial photographs taken from airplanes in Egypt, Palestine, Syria, Iraq, and Iran by both James Henry Breasted, Jr., and Erich Schmidt (Schmidt 1940) (figs. 7.2–3). As with balloon photography, aerial archaeology continues to

be practiced in various parts of the world. However, security concerns in many countries make acquiring permits to undertake such work extremely difficult (Kennedy 2002).

Photography from airplanes, balloons, and kites continues to be used to locate and record archaeological features and landscapes. However, satellites now provide a more convenient platform for capturing such imagery on both local and global scales. Initial spy satellites launched in the very late 1950s and 1960s carried cameras with film rolls that were jettisoned high in orbit and then caught by airplanes in mid-air as they fell back to earth. These early satellite photographs remained highly classified and unavailable to the public until 1996. Since then those declassified spy satellite photographs have become invaluable resources for archaeologists, and the Oriental Institute maintains one of the largest collections of their images pertaining to the Middle East anywhere in the world (Catalog No. 32). With non-spy satellite images becoming available in the 1970s, the Oriental Institute was quick to incorporate them into research projects. Robert McCormick Adams utilized LANDSAT satellite images, the first series of satellites launched by the United States government to provide publicly available satellite imagery, to complement his extensive surveys of central and southern Mesopotamia (fig. 7.4). Despite their low resolution he noted how they allowed much more widespread overviews of the landscape than even aerial photographs, allowing him to form a better context for the settlement and watercourse systems that he had spent so much time surveying (Adams 1981, p. 33).

Each image taken from high above can provide invaluable information. However, combining these images can yield even more information. Overlaying images that were collected at different points in time within a Geographic Information System (GIS) can reveal what changes took place over that time span (fig. 7.5). Comparing aerial photographs from the 1920s and 1930s with satellite images from the 1960s and today, one can see the spread of cities, towns, and agricultural fields over the twentieth century obliterating traces of archaeological features and ancient landscapes. Some images can also look beyond the spectrum of wavelengths that comprise the visible colors that we see with our eyes. Images taken in infrared or ultraviolet wavelengths can be combined with black-and-white photographs of a place to reveal what may

FIGURE 7.3. Aerial photographs of the ancient Persian capital of Persepolis captured by Erich Schmidt in 1935–1936 (clockwise from upper left: Oriental Institute photographs AE 252, AE 253, AE 64, AE 251)

FIGURE 7.4. The series of LANDSAT satellites, first launched by the United States government in 1972, were the first satellites to provide non-classified digital images of sections of the earth. This portion of a LANDSAT image, taken in southern Mesopotamia on December 25, 1972, is similar to the images used by the Oriental Institute's Robert McCormick Adams for his book *Heartland of Cities* (1981). Image courtesy of the U.S. Geological Survey (USGS) and the Global Land Cover Facility (GLCF)

lie buried beneath the ground. In the years to come sharper images taken across a wider spectrum of wavelengths will become increasingly available. Yet the thousands of historical aerial photographs from the early years of aerial archaeology, including those collected by the Oriental Institute, will always remain irreplaceable glimpses into a long lost past.

FIGURE 7.5. Overlaying different images allows archaeologists to peel back time and see changes taking place in an area over decades. These images of Persepolis from top to bottom span six and a half decades.

The top image is a high-resolution commercial QuickBird-2 image showing how Persepolis appeared in 2002, with much of the monumental zone excavated and reconstructed and the modern park constructed in the foreground. The terrain of the area is shown by draping it on top of a terrain model created by the U.S. space shuttle *Endeavor* in 2009.

The middle image is a small portion of the declassified U.S. spy satellite photograph from 1970 (see Catalog No. 32). In this image, which is not as high a resolution as the images above and below it, changes can be seen in the excavation areas and the park has not yet been built.

The bottom image is an aerial photograph captured by Erich Schmidt in 1937. Elements of the landscape that were destroyed decades ago, such as the *qanat* water system seen as a line of dark spots in the foreground of the image, can still be seen and mapped using this process of overlaying historical imagery.

Images courtesy of the U.S. Geological Survey (USGS) and DigitalGlobe

8. FACSIMILES OF ANCIENT EGYPTIAN PAINTINGS: THE WORK OF NINA DE GARIS DAVIES, AMICE CALVERLEY, AND MYRTLE BROOME

NIGEL STRUDWICK

Serious Western fascination with the monuments of Egypt developed in the wake of the Napoleonic expedition to Egypt between 1798 and 1801. This interest rose out of man's insatiable curiosity and wish to communicate to the world the remarkable culture that still remained so evidently in the land of Egypt. Gradually it moved toward the preservation in scholarly records of these monuments, and this desire to preserve has increased with importance over the years as time, nature, and modern living have taken their inevitable toll on these ancient structures.

The *Oxford English Dictionary* defines a facsimile as "an exact copy or likeness; an exact counterpart or representation." This short essay briefly covers the development of the methods of making facsimiles of Egyptian two-dimensional decoration in the nineteenth century, and then considers in more detail two of the most important epigraphic projects of the twentieth century.[1]

The audience for such facsimiles has varied over the years. Early facsimiles were important not only in providing reliable copies of material for scholars to study and to make the early discoveries that played such important roles in the construction of an impression of an ancient society; they, along with the remarkable watercolors of artists like David Roberts (Catalog No. 13), were also essential in bringing ancient Egypt to life for the non-specialist. Thus they have played a major role in establishing the fascination with Egypt that continues to the present day.

THE NINETEENTH CENTURY: THE INTRODUCTION OF THE FACSIMILE

While not the first to copy scenes and inscriptions, the first serious modern recordings were made by the Napoleonic expedition that produced the magnificent *Description de l'Egypte*, published between 1809 and 1822. The French, who were recording before hieroglyphs could be read, were followed by a number of English artists and scholars in the 1820s. These included John Gardner Wilkinson (Thompson 1992) and Robert Hay (Tillett 1984), both of whom produced superb copies but whose work still remains largely unpublished, although accessible in London and Oxford.[2] Around the same time, Jean-François Champollion, the decipherer of hieroglyphs, led an important Franco-Tuscan expedition to record the monuments (Champollion 1835–1845). Of even greater importance was the trip to Egypt of the first German Egyptologist, Richard Lepsius, whose expedition recorded an unprecedented range of material in the early 1840s, published as the *Denkmäler aus Ägypten und Äthiopien* from 1849 (Lepsius 1849–1859); this brought the art of recording to a new height.

In the days before the camera, hand copying or hand facsimiles were the only option available. Thus the *savants* of Napoleon were a mixture of scholars and artists; later, Champollion and Lepsius took artists along with them. Hay also took artists who often took advantage of the relatively recently developed *camera lucida* as a non-interventionist method for making more accurate drawings than could be achieved freehand (Tillett 1984, p. 65; see also Catalog Nos. 11 and 13). All these individuals copied scenes and reliefs, some freehand, some recorded by tracings and squeezes. A particular difficulty of the reproduction processes of the age was that when the original drawings were brought home and to the publisher, reprographic techniques required that the originals be redrawn (in reverse) onto printing plates by someone other than the original artist. Given, particularly in the earliest examples, how unfamiliar European typographers and printers were with the unusual conventions of Egyptian art being put to them, it is hardly surprising that there was a tendency that the plate images were not as faithful to the originals as we would wish; nonetheless, this has to be put in the context of the times, and it must

be appreciated that they were doing the best that was possible in their day.

However, the promise of the earlier nineteenth century was lost later in the 1850s to 1880s, and the next boost to recording standards was only given by the foundation of the Archaeological Survey of the Egypt Exploration Fund in 1889–1890 (James 1982).

THE TWENTIETH CENTURY

Many landmark recording projects took place during the twentieth century. This essay examines those of Davies and Calverley, but one other highly important set of epigraphic work (actually from the end of the nineteenth century) should be mentioned. The drawings Howard Carter made in the Temple of Hatshepsut at Deir el-Bahari from 1893 to 1899 are recognized for their excellence (see fig. 2.4 in this volume). Carter employed a somewhat different technique from those described in the remainder of this essay as his

facsimiles were basically drawn freehand, largely due to Carter's wish not to lose the artistic merit of the subject; the plates were reproduced directly from Carter's pencil drawings (James 1992, pp. 51–53). This avenue of epigraphy was never followed further, primarily one presumes due to the lack of artists of ability who also wished to work this way.

NORMAN AND NINA DE GARIS DAVIES

Norman de Garis Davies (1865–1941; obituary Gardiner 1942) was appointed surveyor to the Egyptian Exploration Fund Archaeological Survey not long after he worked with British archaeologist Flinders Petrie in 1898; he began his work in the Tomb of Akhethotep at Saqqara, and then moved to copying tombs along the Nile Valley. The pinnacle of this phase of his career was his work at Amarna, for which he was awarded the Leibniz Medal of the Prussian Academy of Sciences (Davies 1903–1908). In 1907 he moved to the new Egyptian Expedition of the Metropolitan Museum of Art and concentrated on working primarily in Thebes, where he and his wife Nina (1881–1965; Strudwick 2004) continued until 1939.

The work of Norman and Nina Davies consisted of a mixture of the reproduction of scenes not just in line drawings but also the production of a selected number of color facsimiles, although black-and-white line drawings form the backbone of the epigraphic material in their publications. Considerations of cost almost always meant that the number of color facsimiles was limited, whereas the coverage in line drawings was complete (or nearly so). The publications rarely indicate which line drawings were produced by whom, and, where Nina is specifically credited (Davies and Gardiner 1915; Davies and Gardiner 1926), there are no obvious differences from publications drawn solely by Norman. A more specific division of labor is

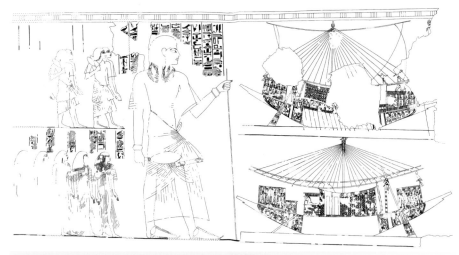

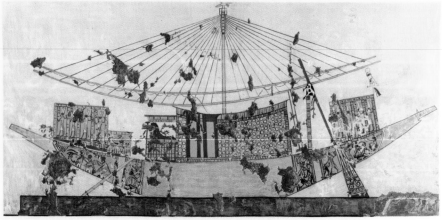

FIGURE 8.1. Above: Huy, viceroy of Nubia, with two boats, from a scene in his tomb at Thebes (Theban Tomb 40), line drawing by Nina de Garis Davies (Davies 1926, pl. 11); below: painting by Nina de Garis Davies of the lower boat in the line drawing (Davies 1936, vol. 1, pl. 82)

FIGURE 8.2. Djehuty and his mother (also called Djehuty) seated before a food offering, from Djehuty's tomb at Thebes (Theban Tomb 45). Painting by Nina de Garis Davies (Davies 1936, vol. 1, pl. 35)

indicated in the publication of the Tomb of Ramose, where Nina appears to have been responsible for the line drawings of the one painted scene (Davies 1941, pls. 23–27).

Neither Davies left any account of how they worked, and the following description has been built up from a variety of unpublished sources (see Strudwick 2004, p. 193 n. *, p. 200 n. 1). The first step in producing a color or line facsimile of a scene was to make a pencil tracing against the wall. Their basic material was tracing paper in sheets averaging about 90 x 50 cm. The amount of detail traced is unclear, but I suspect that it was not complete. If it were to be made into a painting it had to be transferred to the intended paper or board, and this was done using graphite (carbon) paper. Nina Davies would then draw a rectangular border around the desired area, and probably enhanced some of the transferred lines in pencil. She then painted the rest by eye, but in front of the wall. Light was normally provided by mirrors and diffusers; sometimes several mirrors were required.

If the tracing were to become a line drawing (fig. 8.1), it seems that the tracing paper was put on a drawing board in front of the wall, and details added in pencil by hand, with constant comparison to the wall — for artists of the caliber of either Davies, this would be much easier than constant lifting and

FIGURE 8.3. An offering bearer from a scene in the Tomb of Tjenra at Thebes (Theban Tomb 101), showing Nina de Garis Davies's rendering of damage and layering of color (Davies 1936, vol. 1, pl. 34)

of their credit to him and are not substantially different, other than changes and improvements in the materials used. However, Davies was not averse to experimenting with alternative methods, and it appears that he was drawing on photographs in the Theban tombs of Rekhmire and Ramose in the 1920s (Unattributed 1928, pp. 182–83), and the publication of the latter tomb owed much to this technique (Davies 1941, p. v).

The copying of scenes in color has largely died out since the death of Nina Davies in 1965. This is in part due to the now ubiquitous nature of color photography, but also perhaps due to the lack of artists prepared to take the time and trouble to do such work. At the beginning of the twentieth century, it was normal for paintings in Egypt to be made using watercolors, which do not, however, have the same texture as the ancient paints, and which produce a rather flat finish as they are absorbed by the paper. Not long after the Davies settled in Qurna, they undertook some experiments with watercolors. They were apparently dissatisfied by the overall result, since watercolors are essentially transparent, and do not represent the opacity of the Egyptian originals. One of the Davies's first assistants, Francis Unwin, is credited with suggesting the use of tempera, specifically egg tempera (Aldred 1965, p. 197). The opaque result of this was much more satisfactory, and this technique became their basic method. The oft-seen term "Davies watercolors" is thus largely inappropriate.

The key to the success of Nina Davies's work is the method of application of paint. It is quite clear from examination of the originals that she found the best way of reproducing most aspects of the painting was to use the same sequence of colors as the original artist. This surprisingly logical solution is not as obvious as it seems. Thus when painting a male figure wearing a white robe through which the body color is partially visible, she would paint the background, apply a solid area of color for the body, overlay it with the white for the robe, and draw the red-brown outline, cleaning the figure up, as had the ancient painter, by application of further background color (fig. 8.2). Her brush strokes reproduce the variability and color of the originals to such an extent that, even close up, the observer can for a moment think he is in the presence of the original. Nina did not, however, decide to create a facsimile of the damage to a scene,

replacing of the tracing paper (due to its opacity) on the wall to check details. The pencil tracing thus produced then had to be drawn over in ink ("inked") to make it suitable for publication. While the paintings must have been made completely in front of the wall, inking was perhaps divided between the tomb, the Davies's house in Qurna, and time spent between seasons in England. Areas of damage tended to be left blank in line drawings, and traces of sketches were not always recorded. Compare the upper and lower images in figure 8.1 for a line drawing and color facsimile of the same scene, both the work of Nina Davies.

Norman Davies was probably the most important individual in the developing process of copying tomb scenes in the course of the twentieth century. The methods largely in use to this day owe most

but rather she developed a way of recording it using "indeterminate washes" that indicate the texture and the composition of the damaged areas (fig. 8.3), but that do not distract the viewer of the painting, a problem that afflicts color photography. Cracks in the original wall were carefully drawn, and often seem three dimensional (fig. 8.4).

However, work of this quality was not quickly done, and Nina indicated to the art historian Arpag Mekhitarian in 1952 that one (unspecified) painting had taken her almost three months; Mekhitarian also recalls that she had a phenomenal memory for colors. She was by no means the first person to copy Egyptian painting, but it is generally agreed that she was the best, and that since she died no one has taken her place (Aldred 1965, p. 199). A large part of her excellence was simply due to her abilities as an artist, but the precise methods she employed must have played a part.

The best collection of her work is *Ancient Egyptian Paintings* (Davies 1936), the ultimate result of a project instituted by Alan Gardiner, generously funded by J. D. Rockefeller, Jr., and published in Chicago (Strudwick 2004, pp. 202–03). This large-format publication brings together 104 plates of scenes from the Fourth to the Twenty-first Dynasties, including most of the great colored works of Egyptian art (figs. 8.2–5). While it could be argued that taking these images out of their original context and presenting them as "works of art" may devalue them to some extent, it does permit the reader to see and examine both the wonder of the originals and extent of Nina Davies's genius.

We can of course find areas in which they could have improved: Norman particularly had a tendency to ignore decoration that was not part of the final original tomb design,

including traces of the preparatory sketch, and there are cases in which he did not attempt to copy damaged or heavily blackened areas; he also had a tendency to reconstruct scenes, sometimes with erroneous results. But Egyptology's debt to this couple is immense; it is most unlikely that two people will ever

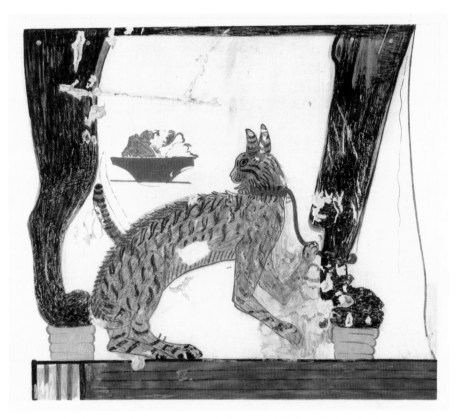

FIGURE 8.4. A cat under a chair. Scene in the Tomb of May at Thebes (Theban Tomb 130), showing Nina de Garis Davies's technique of recording cracks in the wall (Davies 1936, vol. 1, pl. 27)

FIGURE 8.5. Cattle in the Tomb of Qenamun at Thebes (Theban Tomb 93), showing Nina de Garis Davies's treatment of larger damaged areas and also the faithful copying of the original grid lines (Davies 1936, vol. I, pl. 32)

again leave such a legacy of high-quality documentation for posterity.

AMICE M. CALVERLEY AND MYRTLE F. BROOME

As the second example, in the inter-war period, the Egypt Exploration Society's work at Abydos took them onto the documentation of the magnificent Temple of Seti I. For this work they were fortunate in engaging Amice M. Calverley (1896–1959; Lesko 2004), ably assisted by Myrtle F. Broome (1888–1978; Ruffle 2004). James H. Breasted, the pioneer of Chicago epigraphy, was connected with this project, as he took Rockefeller, his principal benefactor, to see the work in 1928–1929 and Rockefeller agreed to fund a very elaborate publication of this very important and very beautiful temple (his contribution to the work of Nina Davies has been noted above). This funding allowed Calverley and Broome to work in the field until 1937; by 1938 they had published three volumes (Calverley, Broome, and Gardiner 1933, 1935, 1938).

FIGURE 8.6. King Seti I opens the shrine of the god Horus (artist: Broome). Detail from the chapel of Horus at Abydos, north wall, western section (Calverley, Broome, and Gardiner 1933, pl. 26)

After World War II, Calverley was able to spend only a limited time in Egypt and the fourth volume was not published until 1958 (Calverley, Broome, and Gardiner 1958). These volumes are some of the most magnificent in the Egyptological library, but at a level of opulence which modern research funding could not (and perhaps should not?) achieve. However, large parts of the front hall and side rooms of the temple still remain unpublished.

The Egypt Exploration Society's (EES) work on the temple was originally intended to use photographs primarily, and in 1925–1927 Herbert Felton produced a series of negatives. At that point it was decided that this needed to be supplemented by line drawings (fig. 8.6), and Calverley was engaged in 1928, producing both drawings and further photos herself (see Baines 1984, pp. 21–22, for a note on the photographic archive). The EES was planning on using a combination of facsimiles of the relief with hand copies of the inscriptions, but gradually it became realized that only the full facsimile approach would truly do the monument justice. With Rockefeller's support, the project went from strength to strength; it was possible to bring Broome in at this point (Calverley, Broome, and Gardiner 1933, p. vii).

Calverley included in the prefaces to volumes 1 and 3 some notes on the methods used (Calverley, Broome, and Gardiner 1933, pp. vii–viii; idem 1938, p. vii; the reader will also find it useful to read Baines 1990, pp. 70–72, and James 1982, pp. 152–55). I can do no better than quote/summarize Calverley, Broome, and Gardiner 1933:

> The photographs were first enlarged to scale, and were then traced by hand over a specially constructed tracing-board, which consisted of a box furnished with a ground-glass top and containing powerful electric lamps. The use of such a tracing-board has a double advantage over the bleaching-out method often employed, inasmuch as the enlargements could be preserved for future reference, and also fine drawing paper could be used. The tracings were subsequently taken to Egypt, where the drawing was finished in front of the originals. Finally experts were called in to check the inscriptions. A convention had to be adopted for dealing with places where the surface had been damaged by natural action or by human destructiveness. All definite lacunæ in the inscriptions are outlined, and indistinct areas are hatched. As regards the sculptures, a different plan has been followed. Here broken

FIGURE 8.7. The prow of the sacred boat of Amun-Re (artist: Broome). Detail from the chapel of Amun-Re at Abydos, north wall, western section (Calverley, Broome, and Gardiner 1935, frontispiece)

outlines are merely discontinued so that the flow of the drawing is interrupted as little as possible. No reconstruction has been attempted. ...

For the false doors and the thicknesses of the entrances line-drawings appeared insufficient, as they failed to give an adequate idea of the constructional peculiarities and the fine details of the hieroglyphs in low relief. To meet such requirements a process of drawing on photographs was evolved, whereby the advantages of both techniques were retained. It is proposed to employ this method much more extensively in the third and subsequent volumes.

Where curved surfaces had to be dealt with, as in ceilings and columns, rubbings were made on fine tissue paper with soft red carbons. The rubbings were then photographically reduced and drawings made from them (Calverley, Broome, and Gardiner 1933, pp. vii–viii).

The Seti project thus used high-quality photographs as its basic technique, but in a manner

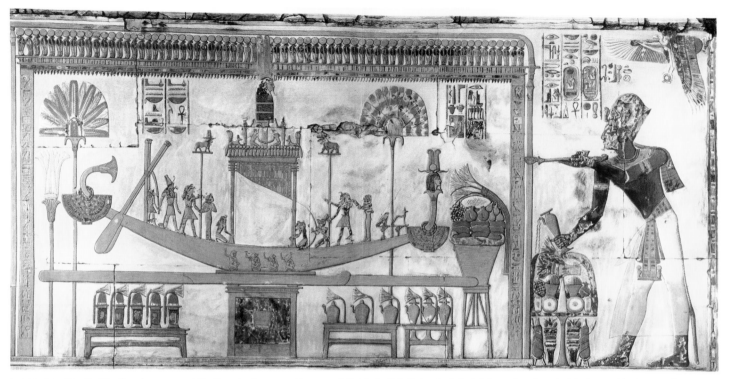

FIGURE 8.8. King Seti I offers incense and libations to the sacred barque of Osiris (artist: Calverley). Detail from the chapel of Osiris at Abydos, north wall, western section (Calverley, Broome, and Gardiner 1933, pl. 7)

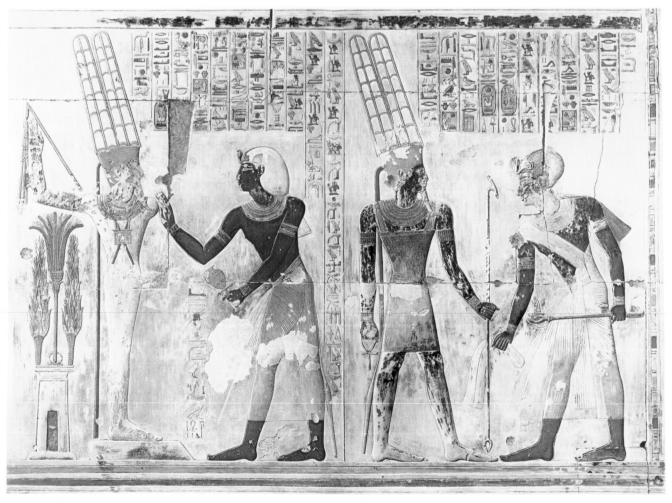

FIGURE 8.9. King Seti I cleans the sanctuary of Amun-Re and prepares to pour a libation to him (artist: Broome). Detail of Chapel of Amun-Re at Abydos, north wall, western section (Calverley, Broome, and Gardiner 1935, pl. 6)

quite different from those of the Epigraphic Survey (Baines 1990, pp. 70–71; and Johnson, this volume); in addition, a letter from Broome indicates that they also projected negatives onto tracing paper in the field using electric light (James 1982, pp. 154–55). The fourth volume of the temple uses, as Calverley indicated above, a considerable number of photographs on which drawings were executed; in volume 1 these were termed "retouched photographs," as they are in fact a combination of the two techniques (the term "reinforced photographs" is used in Baines 1990).

One particularly beautiful aspect of the decoration of the Temple of Seti is the amount of paint preserved on the reliefs, and Calverley and Broome realized it was essential that the colors be reproduced as well as possible within the means at their disposal:

> As basis for the [color plates] yellow sensitive negatives were employed. These rendered in soft tones all colour values except red, which was held back by retouching the negative with a red solution. Enlargements were then prepared, a monochrome collotype print being made on hot-pressed Whatman paper.[3] The ink used was of a pale golden-brown tone which worked in with the various colours. In this way much time was saved, no preparatory drawings being necessary and accuracy of line being assured. Other advantages were that the unpleasant quality of painted photographs was avoided, and we did not have the oily muddy-toned gelatine surface of photographic prints to contend with. This method enabled us to reproduce the brilliancy of colour and soft patina of the originals (Calverley, Broome, and Gardiner 1933 p. viii).

Calverley only here describes the initial stages of how the main features of the colored image were realized; what she does not say is that the rest of the

FIGURE 8.10. King Seti I kneels before Ptah while Re-Horakhty inscribes his name on the leaves of the sacred *ished*-tree. Above: painting by Nina de Garis Davies, collection of the Oriental Institute (published in Davies 1936, vol. 2, pl. 86; Oriental Institute digital image D. 17458); below: retouched photograph by Calverley and Broome (Calverley, Broome, and Gardiner 1958, pl. 25)

color was added by conventional painting, showing what excellent artists she and Broome were (Baines 1990, p. 71) (figs. 8.6–9).

The quality of the documentation achieved in this project was remarkable and of a highly pioneering nature. This particular set of techniques has not actually to my knowledge been used again in a publication project — large-scale monuments have subsequently tended to be reproduced either by variants on the

Epigraphic Survey method, or by pure photography. The achievements of Calverley and Broome were great; one can find faults, such as the apparent lack of indications of scale of the illustrations, or perhaps the lack of relief indication in the line drawings (i.e., not using the "sun and shadow" technique preferred by many copyists of relief), and the lack of any discussion and commentary on the scenes published. Nonetheless, it is a work that stands as both a monument to its creators and those with the foresight to put the project into action and fund it.

NORMAN/NINA DAVIES AND CALVERLEY/BROOME

It is nigh impossible and rather invidious to compare these two partnerships, working as they were with very different monuments and techniques and for different masters. Both produced documentation of the highest order, yet neither was perfect. Let us compare one small area where they overlapped. For *Ancient Egyptian Paintings*, Nina Davies copied one scene in the Temple of Seti (fig. 8.10 [upper]), which scene is also reproduced in a retouched (black and white) photograph in Calverley, Broome, and Gardiner (fig. 8.10 [lower]). Calverley commented "In [Davies's copy] it was impossible to record both the complex painted detail and the sculptured relief" (Calverley, Broome, and Gardiner 1958, p. ix). Nina's copy, however, inevitably brings out the color (the scene is fully painted) in a way in which the retouched photograph cannot: this is evident in areas where the paint surface has been damaged, which are unclear in Calverley. Most particularly, the hieroglyph on which the king kneels bore a pattern in paint depicting the markings characteristic of this particular alabaster bowl — these are clearly visible in Davies, but have not survived on the retouched photograph. Thus Nina's copy inevitably emphasizes the paint more than the relief, which, as Calverley said, is perhaps brought out better in the photograph, although it could be argued that it is the unnatural fact of the removal of the "distraction" of the color which permits the relief to be better appreciated. Lovers of painting may prefer Davies; those who rejoice in relief, Calverley. The ideal solution is the utterly impractical one that both are needed to document work of this quality.

CONCLUDING REMARKS

Many of the most important epigraphic advances of the twentieth century were made in its first fifty years. In the post-war era, it has been harder to distinguish individual steps forward. Advances in technology have played a greater part in developments than ever before, largely because most of the ground-rules had been formulated in the early part of the twentieth century by the practitioners discussed in these essays. An example of one technical development is the move from making the full-size facsimile on tracing paper (as used by Davies) to the use of transparent tracing media, usually a film of plastic, often generically referred to as "acetate" and with commercial names such as Perspex (UK) or Mylar (USA). These materials seem to have been first employed at the beginning of the 1960s (Martin 1979, p. 1). Further technical developments now concern the use of computer technology for the production of both templates and facsimiles (Manuelian 1998 and Malatkova 2011).

The making of facsimiles serves a multitude of purposes: to preserve the monuments in another medium against the inevitable ravages of man and of time; to provide scholars with material to form the basis of their research; and, of equal importance, to provide, where possible, access for the non-specialist into the world of Egyptian monuments. The paintings of Davies, Calverley, and Broome have played their part in bringing the beauty of Egyptian monuments to a wider audience, and it is good that they continue to be reproduced in this digital age.

This short essay has tried to show how modern epigraphy stands on the shoulders of giants, and we owe it to these our predecessors to maintain and improve the exacting.

NOTES

[1] See Dorman 2008, pp. 83–91, for a summary of techniques that can be applied, and Caminos 1976 for a historical perspective.

[2] The Robert Hay manuscripts are in the British Library. Squeezes made by John Gardner Wilkinson are in the Department of Ancient Egypt and Sudan at the British Museum, and other papers of his are in the Bodleian Library and the Griffith Institute, Oxford.

[3] A particularly high-quality woven paper much favored by artists since the eighteenth century.

9. PRESERVING THE PAST IN PLASTER

WILLIAM H. PECK

Plaster casts have a long and venerable history as educational tools used for a variety of purposes. The most familiar service rendered by casts is to the visual arts, where they have served to represent otherwise unattainable works for the benefit of the art historian, classicist, and art student. However, there are other specialties in which casts have been useful. The discipline of paleontology has made use of replicas of dinosaur bones and fossils for teaching purposes, mathematicians have demonstrated complicated theorems in plaster models, and anthropologists use casts of skulls and other body parts as a part of the physical side of their studies.

One of the most important benefits to be derived from casts is the preservation of images and inscriptions once known and now lost. This is especially true of artifacts cast and recorded in situ that have since become damaged or have disappeared completely as the result of vandalism, natural weathering due to exposure, or modern atmospheric pollution. A good example of this is illustrated by the fate of a Mayan relief carving found intact at the site of Copan in Mexico. When discovered, the stela was in good condition. At some later time it was broken up, the pieces used in the construction of a wall, and the information it contained would have been lost forever. However, a cast had been made which is now preserved in the Peabody Museum at Harvard. When Mayan hieroglyphs could finally be read the figure depicted was identified as the last ruler of Copan with further information concerning his lineage.[1]

There are many similar examples from ancient cultures around the world to illustrate the damage or disappearance of historic evidence or works of art. In my own museum experience, I have examined casts of cylinder seal impressions after the original seals had long ago left the collection.

With certain exceptions, the exhibition of plaster casts of famous works of art is generally considered passé today in modern museums of art and history, but this was not always the case, nor is it a completely abandoned practice in many major institutions of the world.[2] Traditionally, casts of key examples of sculpture and architectural detail illustrating the history of art have played an important role in the education of the public as well as in the training of the visual artist. No art school in the nineteenth century was without its collection of reproductions of selected classic works but also of what can only be considered "anatomical parts." No public museum that considered its educational function could exist in the past without its collection of key masterpieces.

A renewed interest in the field of casts and casting and the history of cast collections is clearly evidenced by a recent conference held at Oxford in September 2007, Plaster Casts: Making, Collecting and Displaying from Classical Antiquity to the Present was attended by an international group of scholars, the result of which was a comprehensive publication with essays ranging from various aspects of the history of casts and collections to the problems of conservation (Frederiksen and Marchand 2010). Interest in the subject is further demonstrated by a number of online catalogs of cast collections as well as a partial database of collections worldwide.[3] This variety of activities signals a revived appreciation of the important roles that casts have played in the preservation of visual and historical information.

The history of duplicating important or popular works through the medium of the cast can be traced to antiquity. Pliny the Elder in his *Natural History* asserts that it was Lysistratus of Sicyon in the fourth century BC who was the first to make impressions of human faces (life masks) and to take casts of statues in plaster. Certainly the casting of Greek sculpture made it possible for the many Roman copies and variations based on admired originals. A popular image of the Venus Genetrix exists in over sixty stone examples, not including the many small terra-cottas based on the same image. These could hardly have been produced without the aid of casts.

Plaster was a common and much used material in Roman architecture; the stucco embellishments in monuments such as the Golden House of Nero in Rome clearly attest to this. The Roman satirist Juvenal, writing in the second century AD, comments that uneducated people were apt to have plaster images of famous philosophers cluttering up their houses to prove to their guests that they were sophisticated and "learned" (*Satire* II, 3, 4).

The Renaissance interest in the arts of antiquity provided a special impetus for a medium that would allow the study and appreciation of ancient masterpieces from afar. The artists Primaticcio in the sixteenth century and Velazquez in the seventeenth century were each commissioned in their own time by their royal patrons to identify and collect casts of famous originals for the courts of France and Spain. Primaticcio's specific task for Francis I was to provide the images that could be cast in bronze to decorate the grounds of Fontainebleau. Velazquez traveled to Italy to collect paintings and sculpture, both originals and casts, for the collections of Philip IV. Curiosity cabinets from the time of the Renaissance on were apt to contain plaster impressions of seals and other intaglios representing a range of ancient cultures.

In 1874 Amelia Edwards, one of the founders of the Egypt Exploration Fund (now the Egypt Exploration Society), made an epic boat trip up the Nile. When she arrived at the rock-cut Temple of Abu Simbel in Lower Nubia she was dismayed to see that the face of one of the four colossal statues of Ramesses II was white with the residue from the process of producing a plaster cast (Edwards 1877, pp. 449–50). Miss Edwards explained that the casting was the work of Scottish artist and collector Robert Hay, and went on to say there was some common misunderstanding about who had left the white blotches that disfigured the head, with the blame being given by various authors to Richard Lepsius or the Crystal Palace Company or even to Jean-François Champollion. She had her boatmen brew up a quantity of coffee and had them attempt to recolor the statue using sponges on sticks. As was the case with many casts produced by Robert Hay, the image of this mammoth face was destined for the British Museum in London; the duplication of extraordinary works of art such as this was a common practice in the nineteenth century. Hay had made the cast in 1827, in a time, as T. G. H. James characterized it, when "… the methods used were

fairly casual" (James 1997, p. 147) and there seemed no need or responsibility to clean up the residue of the casting. The white mask-like results are visible in many photographs of the period, especially those of Francis Frith made in the middle of the century. For many years Hay's giant cast was exhibited at the British Museum in the vestibule north of the main gallery of Egyptian sculpture.

When the possibility of acquiring original works of ancient art seemed limited, few art and university museums lacked a comprehensive collection of plaster masterpieces. Collecting casts served two main purposes. At that time, when it was considered nearly impossible to acquire original works of ancient art, casts were considered a reasonable substitute and to fulfill some notion of "completeness." Only casts could serve to represent the unique masterpieces of antiquity. These museum collections contained not only casts of antiquities but they also included the works of neoclassical sculptors such as Canova and Thorvaldsen, as well as some contemporary artists. Architectural details were particularly desirable for display and study because they were often parts of standing monuments that could only be studied first hand on the site (like the head from Abu Simbel) but still could be made available at a distance through the medium of casts.

The Kelsey Museum of Archaeology at the University of Michigan now displays a cast of part of the rock-cut Bisitun relief from northern Iran. It was made from direct squeezes taken in 1948 that added details to the known and previously published inscription. This text, in Old Persian, Elamite, and Babylonian, had long been identified as a key to further decipherment of languages written in cuneiform. The impressions, made in the 1940s, preserve details that are now subject to weather and water erosion at the site and represent one of the important ways that physical copies help to preserve knowledge of the past.

In the United States collecting of casts had occurred in colleges, universities, and art academies beginning as early as the late eighteenth century, continuing throughout the nineteenth century and ranging from Harvard, Bryn Mawr, and Vassar in the east to the distant Universities of Michigan, Illinois, Missouri, and California.[4] A concentrated attention to cast collection in the United States closely followed the founding of major public museums such as the

Museum of Fine Arts in Boston, the Metropolitan Museum of Art in New York, and the Art Institute of Chicago. In 1870, the Metropolitan Museum of Art received a fund to begin a plaster collection that would grow to include architectural elements of the Parthenon, the Erectheion, the Lysikrates Monument, and the Temple of Vespasian, all done to full scale. It also participated in expeditions to make casts at sites like Persepolis in Iran. In recent years, the Metropolitan Museum has made a policy of distributing the remains of the plaster collection to universities and small museums that will restore, use, and display them. Many other museums have done the same, particularly those in the United States that were founded in the last quarter of the nineteenth century.

When the Museum of Fine Arts opened, in 1876, it already included a selection of casts on loan from the Boston Athenaeum, and its own collection gradually grew to approximately eight hundred examples of the expected masterpieces as well as replicas of recently discovered archaeological material. The Art Institute of Chicago was a bit later in its development but the necessity for displaying the artistic and historic heritage of the ancient world was just as evident in nineteenth-century Chicago as it was in the east. The cast collection in Chicago (fig. 9.1) began with funds provided by Mrs. Addie M. Hall Ellis and, as contemporary illustrations suggest, it contained considerable architectural material as well as the necessary "key monuments."

Whereas many earlier casts had generally to be imported from established European manufactories, in the latter part of the nineteenth century the American demand began to be supplied by P. P. Caproni & Brother of Boston. Pietro P. Caproni, an Italian immigrant, found work and later bought an established concern and, with his brother, launched his company

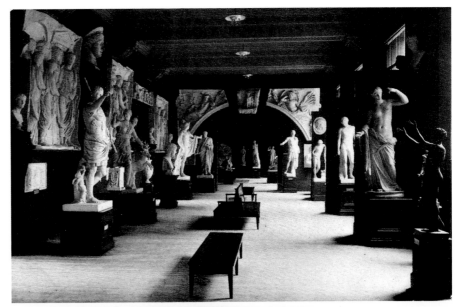

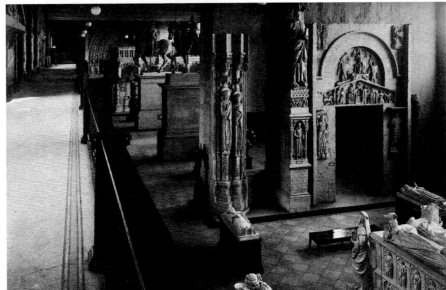

FIGURE 9.1. Early twentieth-century postcards from the Art Institute of Chicago. Above: gallery of Greek and Roman sculpture casts with a number of recognizable works: the Prima Porta Augustus (near left), the Apollo Belvedere (center left), and the Venus de Milo (under arch) — standards in almost every collection of classical casts; below: Blackstone Hall, a gallery of architectural, funerary, and monumental casts. The second equestrian statue on the right is the figure of Bartolomeo Colleoni, by Verrocchio from Venice, shown on a pedestal of its original height

in 1892, a firm they maintained until 1927. They issued several catalogs that show the range of historic and decorative casts they offered. Among the "subjects for art schools," as the 1901 catalog described them, could be had the Apollo Belvedere at 7' 6", $100.00, the Laocoön, 6' 3", $200.00, and the Nike of Samothrace, 9' 3", $200.00 (fig. 9.2).

Numerous cast collections in Europe and the United Kingdom have been regularly maintained. The cast collection of the Ashmolean Museum at Oxford is one of the oldest and best preserved in the United

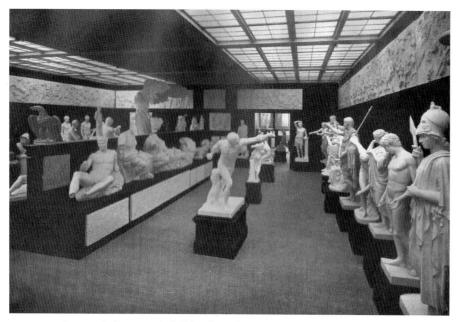

FIGURE 9.2. Caproni Gallery main hall. Taken from the Caproni catalog of 1901, this view shows the variety of casts available to American museums and institutions. On the left are pedimental figures from the Parthenon. Beyond them on the left is the Nike of Samothrace. In the near center the "Borghese" warrior

considered a detriment but rather an asset by some, was the even white surface of plaster. Rarely have casts been colored to resemble the original stone[5] and some critics have commented that it was easier to see and study the sculptural form through the even medium of plaster. A significant exception to the "colorless" attitude was the display of replicas of colossal figures from Abu Simbel at the Great Exhibition (the Crystal Palace Exhibition) in London in 1851. These figures were, however, not made from casts.

With all the varied uses for exhibition, exposition, and study, the most important aspect of casting to history is the preservation of information that has been lost, damaged, or otherwise altered. The example of the rock-cut inscription at Bisitun mentioned above is a typical example. The preservation of casts of architectural details has enabled the reconstruction of war-damaged churches and other monuments. The Victoria and Albert Museum in London is an outstanding example, with an extensive representation housed in its Cast Courts. Probably the largest example is a cast of Trajan's Column of the first century

Kingdom. Begun over two hundred years ago, it reflects the intense interest in the classical world of Greece and Rome in the eighteenth and nineteenth centuries as well as the desire to collect the uncollectable through the medium of copies. The collection is cataloged by date of acquisition, beginning with the 1880s, and by geographical or architectural source, which makes it possible to find together the pieces representing a specific temple or monument.

I was once told by an eminent classical art historian of his experience at the Ashmolean as a young "cast boy." For a lecture on Greek sculpture he was required to fetch examples on command of the lecturer, "Bring out the Hermes of Praxiteles" — wheel the cast out, turn it around several times so it could be seen and studied from all sides, and eventually return it to storage to wait for the command to produce the next example. The students could study and experience a three-dimensional work of art in a far more satisfactory way than through the medium of photography. The only drawback, incidentally not

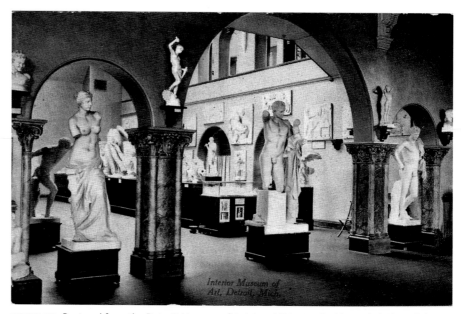

FIGURE 9.3. Postcard from the Detroit Museum of Art. In addition to the Venus de Milo and the Hermes of Praxilites, some of the pedimental sculpture from the Parthenon in Athens can be seen through the arch. Wolverine News Co. Early twentieth century

AD. It was acquired by the museum in 1864 and consequently preserves many details of the original that have suffered from the modern pollution of present-day Rome. Among other examples that preserve the appearance of lost or damaged originals are casts of a fifteenth-century relief of Christ from Lubeck, now destroyed, and the tympanum from Hildesheim Cathedral that has suffered, like Trajan's Column, from a century of pollution.[6]

In the catalog for the Berlin Gipsformerei published in 1968, a statement was made in the director's preface that the collection still included molds and casts of many museum pieces that were lost or badly damaged during the war but that almost all the casts had survived. These are documented in entries and illustrations in the publication, probably one of the most immediate examples of copies preserving material no longer in existence in their original form.[7]

An American example that is roughly comparable to the collections at the Victoria and Albert Museum is the Busch-Reisinger Museum at Harvard. Originally founded as the Germanic Museum, it had its beginnings as a collection of casts, primarily of German sculpture and architecture. Other museums at Harvard still maintain casts, notable among them a large representation of images from the Parthenon and Pre-Columbian stone reliefs.

The fate of once extensive collections is often sad to relate. The collection in the Art Institute of Chicago was, like many other American collections, dispersed through gifts to other institutions, sales, and simple destruction. The casts in Detroit (fig. 9.3) did not make the transition from the original Detroit Museum of Art of the late nineteenth century to the newly formed Detroit Institute of Arts in the 1920s. The newly developed twentieth-century attitude toward "copies" versus originals had a great deal to do with the disregard in which plaster casts were beginning to be held and the saga of neglected and destroyed collections is evidence that the material was no longer considered a valid teaching medium. Fortunately, this attitude has been somewhat reversed in some institutions.[8] The renewed recognition of plaster casts as important historical documents that merit preservation has generated hopeful beginnings of organized study, conservation, restoration, and preservation.

NOTES

[1] www.news.harvard.edu.hwm/mexico/stories/cast.html. Accessed 6/14/2011.

[2] In some museums, notably in the United Kingdom, plaster casts have enjoyed a renewed appreciation. For example, the Ashmolean Museum and the Victoria and Albert Museum have recently opened extensive new galleries of casts. Further, in Continental Europe, especially Germany, casts continue to be important representations of classical art.

[3] http://www.plastercastcollection.org/en/database.php

[4] The information on collections in museums and institutions of higher learning is derived in part from Dyson 2010.

[5] Among the exceptions, the bright pigments on a cast of a statue of Augustus of Prima Porta on exhibit in the Ashmolean Museum have been restored.

[6] Information on the Victoria and Albert Museum cast collection is partly derived from its extensive and informative website: http://www.vam.ac.uk/page/c/cast-courts/

[7] I am indebted to Jacobus van Dijk for information about this catalog: *Katalog der Originalabgüsse*, Heft 1/2: *Aegypten. Freiplastik und Reliefs*. Zusammengestellt und bearbeitet von Dr. Gerda Hübschmann. Berlin: Gipsformerei der Staatlichen Museen Preußischer Kulturbesitz, 1968.

[8] Editor's note. The Oriental Institute houses a large number of casts of sculpture, inscriptions, and other artifacts from the ancient Middle East. Iconic examples displayed in its museum include the Hammurabi law code stela, the Black Obelisk of Shalmaneser III, and the Rosetta Stone.

10. DRAWING RECONSTRUCTION IMAGES OF ANCIENT SITES

My interest in architectural reconstruction was born in Egypt during the ten unforgettable years spent in Luxor (1979–1989) as director of the Franco-Egyptian Center for the Study of the Temples of Karnak, near friendly Chicago House, seat of the Theban mission of the Oriental Institute of the University of Chicago. The project involved teamwork, for the production of reconstructions involved both the Egyptologists and architects of the Center, whose main goal was the study of the principal phases of evolution of the Temple of Amun-Re (fig. 10.1) and their subsequent computer modeling in the 1990s.

Thereafter, in France, reconstruction imaging became one of the main themes of my research (fig. 10.1). Under the auspices of the Ausonius Institute at the University of Bordeaux III, our work focused on the study of the many sites and monuments of the Graeco-Roman period. This era proved to be an ideal topic, since the last decades of the twentieth century were characterized by a renewed interest in architectural reconstruction, most likely as the result of an intense development of computer tools and audiovisual media.

There was no reason for an archaeologist to be uninterested in the creation of theoretical models of

FIGURE 10.1. First reconstruction ever drawn by the author, in 1990: the Temples of Karnak during the Roman period. This view gives an idea to the maximum extension of the temple delimited by the great enclosure wall of Nectanebo I. The first pylon remains unfinished. The remains of the mudbrick ramps and massive scaffoldings used to build it can be seen against its western face. On the left is the Temple of Montu; on the right the northern section of the precinct of Mut (published in Aufrère and Golvin 1991, vol. 1)

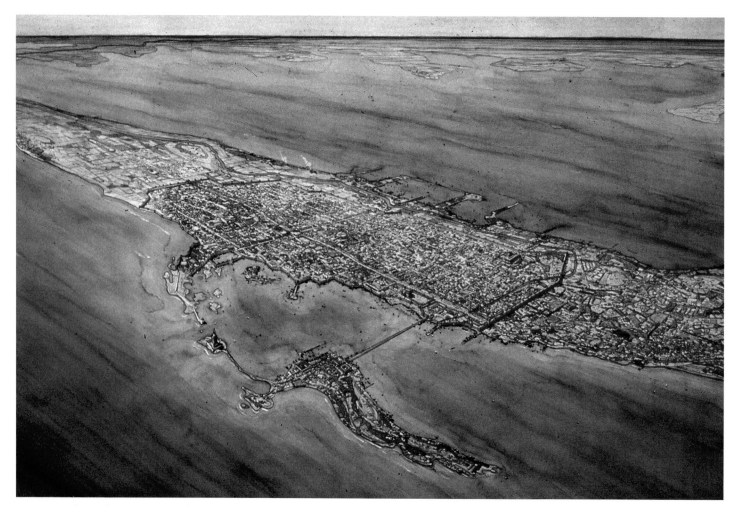

FIGURE 10.2. General representation of a city: Alexandria during the Roman period, as seen from the Mediterranean Sea at a northwest angle. It gives an idea of the great town with its streets crossing at right angles and its position between the sea and Lake Mareotis. On this very flat coast the lighthouse appeared as the only signal of the position of the town for sailors from a long distance. The island of Pharos is linked to the coast by the heptastadion. The lighthouse dominates the great harbor shut at the east by Cape Lochias, site of the ancient royal palaces (produced for the exhibit La gloire d'Alexandrie, 1998, in collaboration with Jean-Yves Empereur)

their objects of study, for other disciplines (astronomy, medicine, and physics) had been engaged in such studies for a long time. The goal of building this type of model that gathers all the accumulated knowledge of a specific site on a computer is to give a synthetic representation of the object of study that is useful for further research and to communicate it to the public. This double objective required careful consideration and the development of an appropriate methodology.

"To restitute" signifies "to render." More precisely, in our case, the process involves the rendering of the concept of an ancient site by means of an image. The goal is to portray as accurately as possible the original aspects of the case study. It is not restricted to electronic imaging, but also involves the general image (fixed or not) as a component of the vast domain of the human language. The visible language has been unluckily separated due to the

long-standing domination (one could even say dictatorship) of text over image. This arbitrary division has been far from beneficial, indeed, and contrary to what many continue to believe, to build and read images requires learning and practice. The revival of this methodology is based on the work of the American researcher Charles Sanders Peirce (1839–1914), the true "founding father" of Semiotics, the study of signs and symbols, and Pragmatics, the study of language in terms of the situational context within which utterances are made.

The numerous reconstruction images we drew (close to a thousand) gave us the opportunity to concretely link Semiotics theory to practice. The images depicted Egyptian and Graeco-Roman sites, especially in Gaul and northern Africa (figs. 10.2–5 and see Catalog No. 17). The images were drawn on paper with india ink and painted with watercolor, a

FIGURE 10.3. Reconstruction of Persepolis

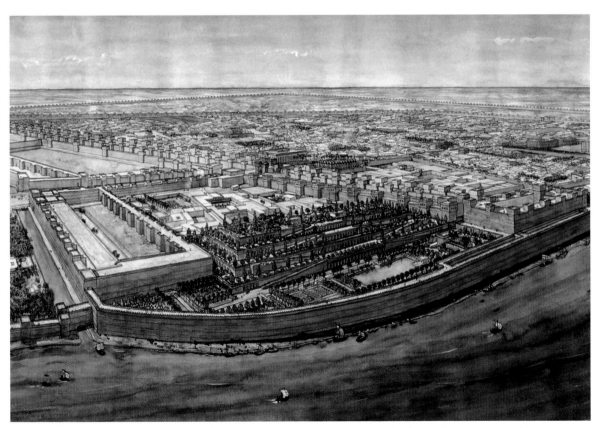

FIGURE 10.4. Reconstruction of Babylon

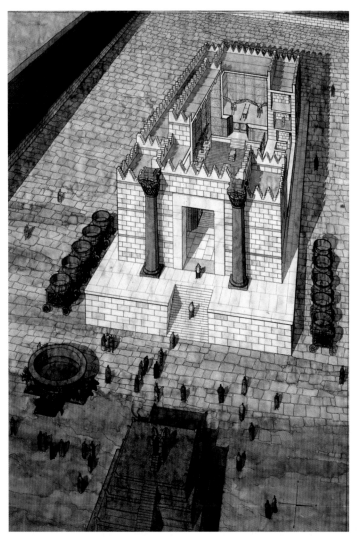

FIGURE 10.5. Reconstruction of Solomon's Temple in Jerusalem. Nothing has been found of the structure on the Temple Mound/Haram esh-Sharif. Its reconstruction is based almost completely on descriptions in the Bible

monument under study; an indicative aspect, since it includes elements whose existence has been proven; and a symbolic aspect, since it is completed according to rules of representation that are drawn from the study of other relevant examples.

The complete reconstruction of a site is not always possible. For example, in the case of an ancient city, it can only be done if sufficient information on five principal points, called "determinants," is available. These determinants are:

- Information on the topography and ancient landscape

- Contour of the city (the limits, the perimeter, the shape in plan)

- Nature of the urban fabric (regular or not)

- Form of the large public buildings

- Relative position of all the aforementioned elements

If all these conditions have been fulfilled, the process of creating an image of the city can be likened to a composite portrait of a police suspect. The image thus produced is certain to resemble its subject, which is what remains essential in terms of language. It is impossible to proceed differently or to create a better picture giving a clear idea of the whole site. We must be satisfied with it, since all the remains and monuments of a city cannot be excavated.

When it is impossible to recreate an overall picture, one must settle with partial views. After the examination of the basic data gathered by researchers, one must identify the best point of view from which to represent the site and decide the best framing for the image. It leads to a rapidly drawn sketch, which is the project or the idea of the image (fig. 10.6). The message to be conveyed is therefore clearly defined, and the image produced is the best iconographic solution to explain the original aspect of the site. The other phases of its realization simply consist of gradual adjustments (fig. 10.7).

Our goal is to create an image that would correspond to a view of the site when it was still active, as if it were possible for us to see it again. If designed systematically, the reconstruction could be finer and more balanced than subjective image of a city that we often express in everyday language. It is easy to demonstrate the poorness of this image of a town if we try to draw it on a sheet of paper.

rapid, economical, simple, and flexible mode of expression, which was fairly convenient and sufficient to efficiently express ourselves. This type of image is specific because the reconstruction can never be the result of invention or free artistic creation. On the contrary, it is the result of logical reflection and strict argumentation.

Every reconstruction image includes three parts. The first is based on the known archaeological data. The second involves a reconstruction consisting of a relevant "re-positioning" of the scattered elements discovered at the site such as blocks, traces, fragments, and the use of ancient documents and texts, as well as testimonies about the site. The third component corresponds to the portion of the image that must be completed hypothetically. Based on Peirce's terminology, a reconstruction image thus displays an iconic aspect, because of its similarity to the

FIGURE 10.6. Sketch of the Lighthouse of Alexandria. The preliminary drawing was discussed with archeologists to reflect the most recent discoveries of the underwater excavations. This kind of drawing, quickly sketched during such a discussion, plays an essential role: it fixes the orientation of the view and its frame. It represents the monument and its context according to the purpose of the text and with the maximum of efficiency

FIGURE 10.7. Representation of the Lighthouse of Alexandria, produced for the 1998 exhibit La gloire d'Alexandrie, with the two royal colossal sculptures discovered in the harbor and the bridge leading to the entrance of the monument. The image is a realistic representation of this famous monument, one of the Seven Wonders of the Ancient World

The reconstruction best reflects the idea that one might have of a site at a given time. It is further refined and modified based on advances in scientific research. If carefully done from the start, however, it reveals the essentials of what can be conceived and transmitted. Contrary to a written text, an image cannot avoid representing any part of the site, even a poorly known part of a city. The reconstruction imposes an overall representation that is partly theoretical, which the researcher must have the courage to propose.

Reconstructions should be within reach of everyone, since language used to interpret and critique an image corresponds to an aspect of the reproduction. Convenient and effective formulas, however, remain surprisingly poor when analyzed. The belief that an image is more misleading than a textual description, and other such stubborn prejudices, is now regarded as an outdated attitude known as "iconophobia" (the attitude of hating images). In fact, there is no reason to separate visual language from written language. Both are complementary and necessary and should be associated and used to the best of their individual

FIGURE 10.8. Landscape with effects of distortion and space compression to represent an entire territory, with special emphasis on the elements relevant to the accompanying text: View of the Nile Valley, Its Periods and Principal Sites, from Philae to Thebes; produced for Géo magazine

possibilities. It is better to draw what is difficult to describe with words, and to write what cannot be rendered with visual signs.

Because of its cognitive value and didactic character, a reconstruction image is subject to strict constraints and conditions. Above all, it should inform, instruct, and stimulate public interest by inviting the viewers to discover a site and a certain time period. It should be filled with information and it should be easily understood by as many people as possible. Therefore, it should be realistic, easy to read and interpret, and it should be presented in a suitable context, such as a book or exhibit, where useful additional information is available.

Nowadays, in addition to constantly having to design new reconstruction images, in-depth fundamental research on the function of visual language is necessary to better control, teach, and fully use the technique.

Archaeology provides a privileged field of research since it requires some effort for the understanding and restitution of the life of the sites and monuments it studies. It also provides very useful

data for this type of research (such as reliefs, images on coins, mosaics, etc.), all the more valuable because such remains can be compared to the actual remains of the buildings in the reconstruction. Image research in this domain can no longer ignore the advances made in other scientific disciplines, such as semiotics and neurobiology. The multiple examples that we continue to analyze have become practical experiments that need to be complemented by fundamental research on the image and some theoretical reflection on the methodology of architectural reconstruction.

Reconstruction images have been used for many purposes, fulfilling a growing interest in the technique. Its development is a reflection of the appreciation of the importance of monumental heritage everywhere in the world, with the intention to better understand, preserve, and to showcase it to the public (fig. 10.8).

NOTE

* Translated by Rozenn Bailleul-LeSuer.

11. THE PERSEPOLIS PAINTINGS OF JOSEPH LINDON SMITH

DENNIS O'CONNOR

The canvases painted by Joseph Lindon Smith at the site of Persepolis comprise a unique subset of what the artist himself often described as "portraits" of antique civilizations. The archaeological treasures to be found in locations as diverse as Egypt, India, Mexico, China, Thailand, Japan, and what was once called Mesopotamia each served to inspire the artist through seven decades of world travel and painting, during which he specialized in painting the art of the past. The images he created at Persepolis demonstrate a remarkable ability with his brush to bring to life subject matter that others often could only see as inanimate objects. To Smith's eye, the ancient artists who created the original works remained a living presence that he captured again and again. His singular vision devoted to that endeavor remains unique. The six works the Oriental Institute commissioned him to do in 1935 represent the best of the artist's Persian studies and the set as a whole perfectly demonstrates his signature dry-brush style, a technique that anchors all of his paintings.

In October 1863 Joseph Lindon Smith was born in Pawtucket, Rhode Island, and from a very early age he exhibited a strong and natural talent for drawing. Emerging from a conservative New England Quaker background, the young man's artistic aspirations were fortuitously encouraged by the American poet John Greenleaf Whittier, to whom he was related on his mother's side. Whittier perceived early on his young cousin's evident skill and passion for art and set him on a path that led to his enrollment at the School of the Museum of Fine Arts in Boston. By the age of twenty, Smith had manifested enough dedication and future potential that his parents agreed in 1883 to support his pursuit of a legitimate career as a painter by financing his attendance at the Académie Julian, a respected atelier in Paris, to perfect and finish his training.

Completing two years of intensive study in Paris, he returned to Boston in the summer of 1885 and launched his public career exhibiting landscapes and portraiture at galleries and art clubs in Boston. His work was well received by critics and quickly noticed and championed by Denman Waldo Ross, an instructor of art at Harvard University. Ross, who was a presence in Boston's vibrant art scene at the time and an amateur artist himself, was greatly impressed by Smith's professionally developed skills, especially as applied to watercolor painting, and he tirelessly promoted the artist's work as that of a painter who deserved serious attention. The two men soon traveled to Italy to paint together, and in years to follow they visited China, Mexico, Greece, and Cambodia, with Ross guiding Smith to the great works of art to be studied and painted along the way. In return, Smith instructed Ross in painting techniques. A number of his striking early paintings were collected by Ross, along with a multitude of pencil drawings and charcoal sketches, which were left as a bequest from Ross upon his death to the Fogg Art Museum at Harvard.

From the late 1880s to the early 1890s, extensive new finds of statuary and architectural elements were made on the Acropolis in Athens. Some pieces were in nearly perfect condition and many of them bore unmistakable traces of paint that could only have been applied at the time of their creation. The question of the nature of this coloring, and the extent to which it had been used, was a hotly debated topic among classical scholars of the time. Edward Robinson, the curator of classical antiquities at the Museum of Fine Arts in Boston, had mounted an exhibition in Boston in 1890 that explored the use of color on classical statuary, and in 1891 was already making plans for an expanded show with the same premise. At that time, Smith was teaching drawing at the Museum School in Boston, which was located in the basement of the museum building, and it is likely that his work came to Robinson's attention as well. He offered Smith the opportunity to be the artist who would "illustrate" the second show by applying paint to full-size replicas of famous sculpture. Their collaboration on this project would cultivate a relationship that continued

for the rest of Smith's long and productive working life. Eventually he would go on to become an honorary curator at the Museum of Fine Arts. Utilizing copies ordered by Robinson from the Louvre workshop, and with bits of documentation found in the texts of the ancient Roman writer Vitruvius, he devised an ingenious method of applying paint that left no brush marks, basing his technique upon what Vitruvius had described as *circumlitio*. The term means literally to "smear around," so he applied color by literally smearing the pigment on the statue copies by hand. He then created a finishing wax for buffing the color that imparted a lustrous, stone-like finish to the experiments (Robinson 1892). The success of the two men's collaboration introduced tangible American scholarship to the international field of study for the first time and would greatly contribute to the accepted interpretation and teaching of classical art.

Smith also applied his talent to architectural works. Along with John Singer Sargent, Augustus Saint-Gaudens, and Pierre Puvis de Chavannes, he contributed painted decoration to the Boston Public Library in 1895, creating murals for the Venetian Alcove that can still be appreciated today (McCauley, Chong, and Zorz 2004, pp. 36–38). Another major accomplishment was the design and painting of an external frieze for Horticultural Hall in Philadelphia, a building designed by noted Beaux-Arts architect Frank Miles Day. This commission would result in the longest mural ever produced in America up to that time, and upon its completion it was hailed across the country as one of the most beautiful. Sadly, the building, as well as any credible documentation of the frieze itself, did not survive Horticultural Hall's near total demolition in 1917.

In 1900, the Board of Trustees of the Museum of Fine Arts in Boston authorized Robinson to extend a second official opportunity to Smith, requesting that he paint a study of the so-called Alexander Sarcophagus, the standout piece of a fabulous trove of funerary monuments that had been discovered in 1887 near the city of Sidon, Lebanon. These artifacts were destined to become the centerpiece of the Archaeological Museum in Istanbul, where they continue to inspire visitors today. The Alexander Sarcophagus displayed a wealth of painted detail and Smith produced two full-scale images that were faithful representations of what clearly remained to be seen of the color upon the original work. For his outstanding efforts, Sultan

Abdel al-Hamid bestowed upon Smith the Order of the Mejidi, a medal of prestigious national merit. It was the highest Turkish honor ever awarded to an artist, and the first ever bestowed upon an American. During ensuing decades, almost all of the color on the Alexander Sarcophagus eventually faded away, but Smith's two full-scale paintings of it, executed when the artifact was newly found and the colors still fresh, have become invaluable documents that preserve the state of the original find for all time.

The opening decades of the twentieth century saw Smith returning again and again to the Near East and most especially to Egypt. George Andrew Reisner, the director of the Harvard/Giza Expedition from its inception in 1905 until his death in 1942, also fell under the spell of Smith's art and eventually Reisner was able to woo the artist into the professional sphere of Egyptology by arranging for him to do paintings for the Giza Expedition, with Smith attending to Reisner's work not only at Giza, but also accompanying the archaeologist to Meroe and Napata (Larkin, Lesko, and Lesko 1998, p. 3). As a result, the largest and best portions of his Egyptian and Nubian studies would become part of the collection of the Museum of Fine Arts in Boston, where his paintings would complement the core display of Reisner's remarkable Egyptian finds. A number of these works are currently on loan and on display at the Fitchburg Art Museum in Fitchburg, Massachusetts.

Smith's busy and active career during the 1920s and 1930s coincided with the most glamorous and exciting period of discovery in Egypt. For many successive years, Harvard House, Reisner's headquarters at Giza, hosted a cocktail party at the foot of the pyramids which became the highlight of many a season's work there, displaying Smith's latest paintings of Reisner's most important new finds. Notables such as James Quibell, Arthur Weigall, William Flinders Petrie, Georges Legrain, Theodore Davis, and Robert Mond, and of course James Henry Breasted, were in attendance at one time or another and they too became fascinated by Smith's work. He was welcomed to visit and paint at their sites as well, always with Reisner's encouragement and good will. These men remained friendly their entire lives and Smith's private memoirs reveal many interesting and intimate details of the daily activities surrounding more than a few of the most exciting discoveries, some of which he witnessed personally.

In 1934 Smith was on his usual painting expedition in Egypt, accompanied by his wife Corinna, when he received an official invitation from James Henry Breasted to travel to Persia, after the season in Egypt was complete, extending a request to paint a selection of scenes at the Oriental Institute site of Persepolis[1] (fig. 11.1). The invitation undoubtedly appealed to him for he would not only garner the honor of officially documenting this splendid location, but he would also have the opportunity to orchestrate a potential new outlet for his work with another prestigious archaeological entity and museum, much as he had already successfully established with the Harvard/Giza Expedition and the Museum of Fine Arts in Boston. With high hopes,

FIGURE 11.1. This photo, dated to 1934, shows the staff and guests at the headquarters of the Sakkarah Expedition. It is highly probable that Smith had just received his official invitation from Breasted to paint at Persepolis when this photo was taken. Smith is seated in the center right and his wife Corinna (in hat) is next to him at far right. Photo by Leslie Thompson (Oriental Institute photograph E6/689)

Joe and Corinna entered Persia on March 5, 1935, at Khosrovieh, bearing their luggage, canvas, brushes, and sixty-four tubes of oil paints.[2]

An amusing sidebar that serves to illustrate something of the paradoxes of time and the artistic life was the procurement of the necessary clearances through official government sources, both Persian and American, to assure the safe handling of a seven-foot-high tin tube that he needed to carry with him to transport the thirty-eight feet of rolled-up canvas to his work site. A metal object of this size seemed to confound explanation to border guards at the time, and to government officials from the Persian legation in Washington, D.C., as well, who were unable to guarantee that agents would allow the artist to pass unimpeded with such an apparatus. This was concurrent to a controversial but official name change of Persia to Iran mandated by Riza Shah Palavi, so perhaps the offending and confusing tube may have been seen as a potential security threat of some kind. Eventually, the problem of "the tube" was resolved with the help of U.S. Secretary of State Cordell Hull, who was a personal friend of Corinna. The Smiths found a communiqué from Hull upon their arrival in Persepolis that read, "Delighted tin roll received as good will. Persian

Ambassador Washington considered situation favorable omen for better relations between Iran and our own United States. Congratulations."[3]

Breasted's original mandate left the selection of scenes to be painted at Persepolis very much up to Smith's discretion, but he had suggested that "the great stairway of the Apadana ... produces a perfectly stunning impression ... would be an extremely impressive subject." In 1934 the Oriental Institute had displayed a remarkable panoramic photograph of the Apadana at the Century of Progress Exposition (fig. 11.2), and it made quite an impact with fair attendees. Breasted also hoped that Smith would "be including the scattered columns of the great colonnaded hall to which the stairway led up. I would leave to you the choice of ... other ... pictures with full confidence in your selection."[4]

The Apadana naturally became a source of Smith's immediate attention. In his memoirs, he wrote of his first exploration of the site:

I walked incessantly over every inch of the great terrace, studying the ruins from many viewpoints and tentatively measured my canvas for six subjects, three landscapes and three sculptural details on the stairway uncovered by Breasted's

FIGURE 11.2. View of the Oriental Institute's exhibit in the Hall of Social Sciences at the Century of Progress World's Fair in Chicago, 1934. The panoramic photograph of Persepolis hangs above facsimiles and photographs documenting work of the Oriental Institute. The exhibit opened the year after the inauguration of the fair; also see figure 1.8 for a slightly different view (unnumbered photograph)

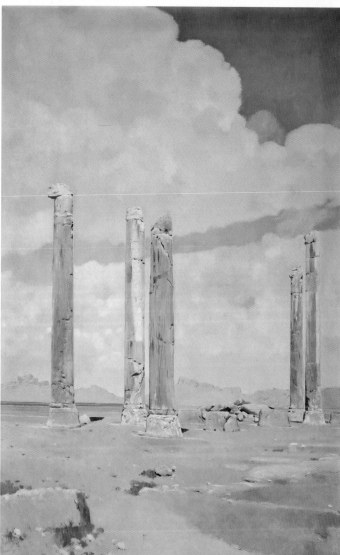

FIGURE 11.4. The main structure of the Apadana, a site Smith described as an embarrass de richesses. The dry-brush technique endemic to his work is evident in this painting and the pastel coloration he used to create the work adds a soft and dreamlike quality to the finished image (Oriental Institute photograph P. 29043)

FIGURE 11.3. A landscape image from Persepolis illustrating details of standing architectural elements remaining upon the terrace of the Apadana (Oriental Institute photograph P. 29042; Oriental Institute digital image D. 17459)

FIGURE 11.5. Smith's six paintings from the site of Persepolis as they were originally hung in the Oriental Institute gallery. The large image at the top is the striking panorama photograph that was exhibited at the World's Fair in 1934 (see fig. 11.2) (Oriental Institute photograph P. 29047)

expedition. [The Apadana] is certainly an *embarrass de richesses*. Finally I gave it up and, seated at the edge of the terrace facing the wide stairway rising from the plain below, my conscious self yielded to the magic of the changing color which sun near setting suffuses with an indescribable light over mountains and columns alike and I pinched myself to be sure I was awake.[5]

In what was an unusual detail for him, he also recorded what each of his final selections would be. The first was a landscape "of five columns with a generous supply of mountains and much blue sky [fig. 11.3], while (an)other will take in the whole of the stairway [Catalog No. 19]. The third was a panorama view including the Gate of Xerxes, with its semi-ruined bulls sculpted on the sides in a foreground and some of the stately remaining slender columns once a part of the Great Audience Hall of Darius" (fig. 11.4). Three additional scenes showing details of sculptural elements carved upon the Apadana (figs. 11.8–10) would be included in what would ultimately be six weeks of work at the site.

All six of the paintings from the Persepolis group were painted with the dry-brush technique that was Smith's signature style. That technique utilizes a thoroughly dry brush holding the paint to be applied to the primed canvas thereby creating a grainy appearance that lacks the smooth brushwork produced in blending the colors on the canvas itself. In oil paintings, dry brushing produces a powdery effect. An artist's brushwork must be kept to a minimum as the initial application and stroke optimally becomes the final product. It takes great skill to master this process, but Smith was noted for his continued use of the technique from his earliest works forward. From 1935 to 1936, these six paintings hung in the Oriental Institute galleries (fig. 11.5) along with the photograph originally shown at the World's Fair (see fig. 11.2), and after their initial exhibit, all the images entered the storage archives. Until now, none of the six Persepolis paintings have been available for public viewing.

The first three studies described in Smith's memoirs can most properly be categorized as landscapes. Although landscapes proliferated in his earlier work, as time went by, he became increasingly more attracted to the painting and sculptural skills of ancient artisans as subject matter in his "portraits." The three landscapes of the Persepolis group are notable

FIGURE 11.6. Smith at work on one of the landscape images. Note the easels and boxes around the canvases that were built on site to hold his works in progress (Oriental Institute photograph P. 26100)

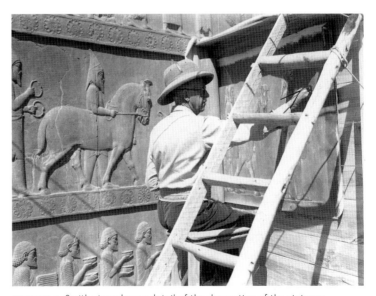

FIGURE 11.7. Smith at work on a detail of the decoration of the stairway (Oriental Institute photograph P. 26101)

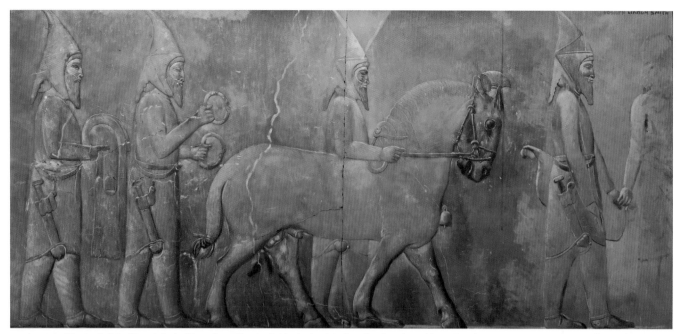

FIGURE 11.8. "Portraits" Smith painted of long forgotten individuals depicted on the Apadana. Here, Scythian groomsmen present gifts to the Persian king (Oriental Institute digital image D. 17460)

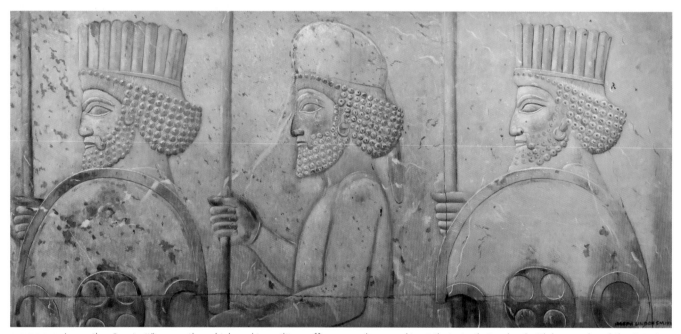

FIGURE 11.9. In another "portrait" scene, three high-ranking military officers are shown making tribute to their ruler. Smith has rendered the tiniest details of costume and toilette with a sensitivity that fully illustrates and honors the skills of the original royal artisans (Oriental Institute digital image D. 17461)

therefore, and one of the three is included in the present exhibit because of its size and color appeal and because it also reflected Breasted's wish to have him execute such a view. The second and third of the landscape paintings illustrate standing columns and structures, dominated by the blue Persian sky, and in them one can almost feel the breeze that drives the clouds as they float by overhead.

The second half of the work represents Smith's portraiture at its best. A fascinating detail of his work is that his paintings were all created freehand and that he employed no mechanical apparatus of any kind (figs. 11.6–7). Each canvas took him no longer than a few days to complete, which brings his true genius and ability into startlingly sharp focus. One of these images is that of Scythian horse grooms bearing tribute to the great Persian King of Kings (fig. 11.8).

FIGURE 11.10. In this detail of sculptural elements to be seen on the Apadana, Smith has captured the vitality and strength of the bull and lion that successfully imparts the three-dimensionality of the subject matter onto a two-dimensional flat surface. The transferred record of the weathered surface of the stone is correct in every respect (Oriental Institute photograph P. 29044)

This study is a perfectly realized product of Smith's ability to mimic the three-dimensionality and tonal quality of the weathered, carved stone surface itself into a two-dimensional plane and in so doing, he has instilled in his image a lifelike presence that somehow animates these long forgotten individuals that were so beautifully modeled by the ancient artists who composed the scene the first time. His second study was of a trio of faces in profile and he wrote of working long and hard to capture "the minor differences in beards, headgear, garments and adornment" (fig. 11.9). His sixth and final painting "was a picture of a lion and bull" (fig. 11.10), which again demonstrates his uncanny ability to make a flat surface appear three dimensional, an effect that remains constant mere inches from the surface of the finished study.

The year 1947 was a special one in Smith's life and career. He was still fulfilling a regular painting regimen at the age of eighty-four, crawling in and out of cramped tomb structures and revisiting some of his favorite sites from years gone by. Added to that

remarkable agenda, he was also hard at work teaching his unique painting style to Egyptian students in Cairo under the auspices of an Egyptian government training program. He also attained that year the honor of having his paintings shown in the galleries of the Egyptian Museum at Cairo. Many of his paintings were displayed beside the original masterpieces to the ongoing delight and amazement of the public. The showing was so successful that it was repeated again for the next two years, with some paintings being removed and new paintings being added each time. Perhaps that year's greatest legacy was his participation as a founding member of the American Research Center in Egypt (Thomas 1995, p. 70). Corinna contributed her organizational skills to help Dows Dunham, William Stevenson Smith, Edward Forbes, and her husband create the entity that has maintained an all-important American archaeological presence in Egypt to this day.

On September 18, 1949, Joe and Corinna celebrated their golden wedding anniversary with a grand fete at Loon Point, in Dublin, New Hampshire, the

site of the home they had maintained for their entire married life. Their three daughters, numerous grandchildren and great-grandchildren, along with a host of friends were there to mark the occasion with them. In April of the following year, at age eighty-seven, Smith had his final show in Cairo, and just days before his birthday in October, he passed away quietly in his sleep. It was the end of an era. His beautiful paintings and extensive contributions to Egyptology remain with us still, although his name and reputation have lost some of their resonance since

his death. This exhibition marks a renewed interest in his transcendent visions and his enduring devotion to the art of the past.

NOTES

[1] Archives of American Art, the Smithsonian Institute, Reel 5117.

[2] Ibid., Reel 5119.

[3] Ibid., Reel 5119.

[4] Ibid., Reel 5117.

[5] Ibid., Reel 5119.

12. THREE-DIMENSIONAL DIGITAL FORENSIC FACIAL RECONSTRUCTION: THE CASE OF MUMMY MERESAMUN

JOSHUA HARKER

The purpose of this paper is to outline my three-dimensional (3-D) digital forensic facial reconstruction method and how it was applied to the mummy Meresamun reconstruction for the Oriental Institute of the University of Chicago [for the study of Meresamun, see Teeter and Johnson 2009]. This work contributed to the touch-screen display currently exhibited in the Joseph and Mary Grimshaw Egyptian Gallery. This paper is not intended to serve as or provide a step-by-step guide on how to create a 3-D digital reconstruction.

I developed the first incarnation of the 3-D digital reconstruction method I now use in June 2008. It has changed little, only incorporating some new tools to better execute operations once delegated to multiple tasks or previously dependent on external software. I studied with the premier American artists in the field, Betty Pat. Gatliff and Karen T. Taylor. Both Gatliff and Taylor were specifically instrumental regarding my approach to 3-D digital facial reconstructions. Ms. Gatliff developed the techniques that have become the standard for forensic facial reconstructions and have been deemed admissible in United States and international courts in cases of victim identification. Ms. Taylor has ingeniously adapted Gatliff's method into a two-dimensional (2-D) technique worthy of study and practice in and of itself (Taylor 2000). Also key in my early research was Dr. Anne L. Grauer, professor of paleopathology in the Anthropology Department at Loyola University Chicago, who supplied the initial skull specimen and evaluation of gender, race, and age.

My method uses a combination of the three prevailing and accepted reconstruction techniques: the Gatliff/Snow American Tissue Depth Method (developed by Ms. Gatliff and Dr. Clyde Snow), the Manchester Method (adapted from Mikhail Gerasimov's anatomical musculature approach), and Karen Taylor's two-dimensional reconstruction techniques. The digital method allows me to apply each process simultaneously, which offers more potential accuracy in the reconstruction.

My digital reconstructions are not automated or "computer generated" any more than the sculptor's chisel is responsible for the art that it is used to create. All forms and interpretations must be determined and manually executed illustrating the human/artist factor still necessary in the process. The use of digital sculpture software provides an intuitive approach by offering a familiar sculpting toolset while offering sophisticated lighting, coloring, and rendering options. The 3-D digital reconstruction method is not new in regard to the fundamental process that gives us the framework from which to define the reconstruction. What is unique is the application of new tools that effectively merge the existing 2-D and 3-D methods. I developed a 3-D digital technique based on my training in the traditional 2-D and 3-D methods and my experience with 3-D computer-aided design (CAD) and sculpting software. This 3-D digital reconstruction technique combines all the benefits of both standard methods as well as being more accurate than traditional 2-D or 3-D sculptural techniques alone because:

- It offers the ability to reference the skull continuously throughout the reconstruction to confirm and maintain proper soft tissue depths and contours. This is not possible in the traditional American and Manchester methods that use clay directly on the skull.

- It offers extremely sophisticated lighting, rendering, and coloring options that provide fantastic realism and volumetric accuracy versus sole artistic intuition of the 2-D technique.

- It is perfectly suited for reconstructions where the skull is too fragile to be handled or too valuable to risk any damage or contamination, or is physically unavailable (as in the case of Meresamun).

- Endless views are available immediately.

- Easily changeable hair, eye, and skin color, hairstyles, facial hair, jewelry, clothing, etc.

- Final data can be scaled to any size, exported and built via a variety of readily available 3-D printing technologies. These models can then be finished and reproduced for display and exhibition.

- Images, movies, and data are easily disseminated to media, the Internet, or used for exhibition via standard file formats (jpeg, bmp, tif, mov, mpeg, etc.).

The standard initial procedure for a 3-D digital reconstruction is to get a 3-D laser scan or CT (computed tomography) scan of the subject skull. In the case of Meresamun, a 3-D laser scan of the surface of the skull was not a possible because the remains were enclosed in an unopened coffin. A CT scan was

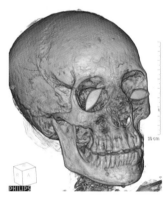

necessary to avoid opening it and causing irreparable damage to its value as an artifact. The CT scan/DI-COM data (fig. 12.1) was generated by radiologist Dr. Michael Vannier of the University of Chicago Medical Center.

Working with DICOM (Digital Imaging and Communications in Medicine)

FIGURE 12.1. CT scan image of Meresamun's skull

data is very laborious because of the voluminous file sizes and necessary processing of the data. This technical stage of the process requires multiple passes at different filter settings in the DICOM processing software to provide various levels of "cleanliness" and accuracy of the skull. Each setting does this to varying degrees of success. In many cases, removing enough soft tissue in one area means important bony structures are lost in another. Thus, it is necessary to generate multiple models of the skull at various settings in order to capture all the necessary bony structures while removing as much soft tissue as possible. Dr. Vannier provided multiple versions of the skull at various filter settings from which to extrapolate the best anatomical geometries from the different models, based primarily on retention of quality information of the bony structures, particularly of the nasal aperture, orbits, and teeth (fig. 12.2).

By having multiple models of the skull, the most accurate and cleanest areas without degradation to the bony structures can be disseminated from each model and assembled into a "master" model of the skull (fig. 12.3). Conversely, the appropriate model may also simply be referred to on an as-needed basis depending on which model is most suitable for whichever facial or anatomical feature is being worked on at any given point. 3-D models are generated from

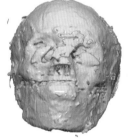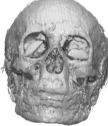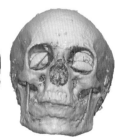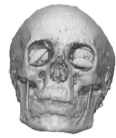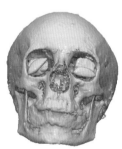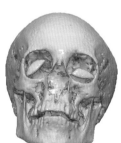

FIGURE 12.2. 3-D models of Meresamun's skull at various filter settings

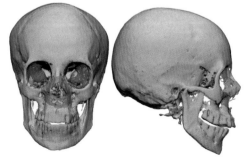

FIGURE 12.3. Master model of Meresamun's skull incorporating best data features of the various 3-D models

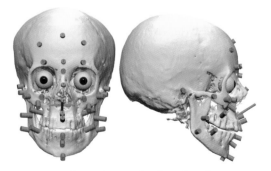

FIGURE 12.4. Eye and tissue depth marker placement

the DICOM data at the various filter settings and exported.

Once the model(s) of the skull has been imported, it is necessary to confirm scale and begin prep work. Prep includes the selection and combination of the best anatomical geometries of the skull, cleaning any extraneous digital artifacts, separation and correct positioning of the mandible regarding occlusal surfaces of the teeth, and Frankfort Horizontal positioning (fig. 12.3). This is an anthropological standard positioning that closely approximates the head's natural position in life. The lowest point on the lower margin of the orbit (orbitale) is horizontally aligned with the most lateral point on the roof of the external auditory meatus (porion).

Once the skull model(s) is prepped, tissue depth markers and eyes can be placed (fig. 12.4). The selection of the appropriate tissue depth dataset is determined by gender, age, race, and general weight (normal, obese, emaciated). Egyptologist Emily Teeter provided her assessment of these criteria and her insight to Meresamun's probable lifestyle. Eye size (including iris diameter) is remarkably typical across ethnicity and gender although consideration is given in regard to age, particularly in younger subjects.

I have built a library of tissue depth markers based on various datasets. The data for them was originally gathered by poking a needle with a small cork collar on it into a cadaver's face at various landmarks and recording the measurements. This process was pioneered and first published by Kollman and Büchly in 1898. This is now accomplished using MRI on living subjects, and there are many published datasets providing reference for a variety of ethnicities, ages, and genders.

It was necessary to generalize slightly regarding Meresamun's ethnicity in the tissue depth dataset because of uncertainty of ancient Egyptians' anthropological race. This did not greatly affect the accuracy of the reconstruction, given that we knew her gender, health, and approximate age, and most importantly, the quality of the 3-D skull data. Short of disease, the architecture of the skull is the foremost driving aspect of human's facial features regarding their placement and proportion. Even using a "wrong" tissue depth dataset would still provide great similarity in the finished reconstruction, provided all the other steps are followed. There is now a commonly used averaged tissue depth table (Stephan and Simpson 2008, no. 6) that has demonstrated the prevailing

importance of the skull in formation of recognizable individual identity regardless of gender or race. Gender and race are still major cosmetic considerations, but they play a diminished role in regard to tissue depths. However, even this dataset references different tables based on age.

I maintain a strict adherence to the findings and directive given by a forensic anthropologist or other accredited expert in determining such features from examination of the skull. A degree of ambiguity can be built in regarding perception of details such as skin color by selecting a "middle ground" color that intentionally alludes to different racial possibilities.

Now begins the anatomical reconstruction phase. Musculature and tissue geometry are added to the skull and built up to the corresponding tissue depths assigned by the markers (fig. 12.5). Once basic anatomical construction is achieved, the fleshy features of the nose, lips, and eyes are developed considering the criteria of the available information on the skull. Lip shape, width, and thickness, projection and width of the nose, slant of the eyes, arch of the eyebrows, and arguably even if the earlobes are attached or not

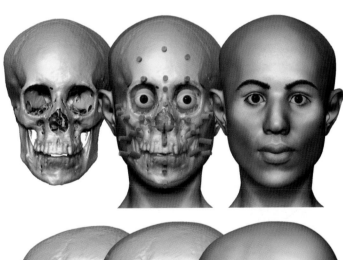

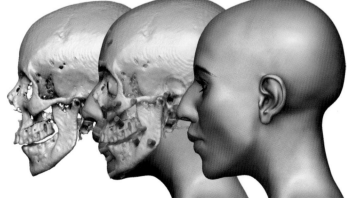

FIGURE 12.5. Frontal and profile views of (left to right) Meresamun's skull, 3-D transparency overlay showing soft tissue volume in comparison to skull, and full reconstruction

FIGURE 12.6. Stela contemporary with Meresamun. From Thebes, ca. 946–735 BC. OIM E1351

can be extrapolated from landmark and measurement information on the skull. For instance:

- the palpebral ligament anchors at Whitnall's tubercle, which defines the medial canthus/lacrimal edges of the eyes
- the lateral canthus is anchored at the anterior of the zygomatic suture
- anterior nasal spine defines projection and angle of nose
- the occlusal surface of the teeth defines jaw placement
- the CEJ (cementum enamel junction) defines the height of lips, while the width of mouth is in relation to the junctions of the canine and first premolars on each side
- the mastoid process defines lobe attachment (vertical = attached lobe, forward canted = detached lobe)
- the external auditory meatus defines the position of the ear canal opening
- the ears are typically canted approximately 15 degrees backward

After that, the texture of the skin is added based on the subject's presumed age, race, gender, lifestyle, and exposure to the sun. Consideration is also given to any information regarding pre-mortem damage to the skull indicating possible injuries that would

have been reflected in the subject's appearance. Eye, skin, hair color and/or style are then added in accordance with available information or historically applicable art. Ms. Teeter consulted art from the era of Meresamun (fig. 12.6), and based on this I added Meresamun's hairstyle and makeup to complete the presentation (fig. 12.7).

In hindsight, I should have made her hair longer to better match information provided, and her skin tone darker to help visually bridge the issue of ethnic ambiguity. Figure 12.8 is a revised image created with those issues in mind.

The facial reconstruction is now complete and images can be rendered for subject identification or, in Meresamun's case, discovery.

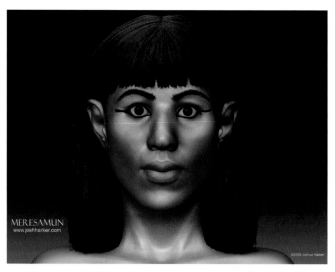

FIGURE 12.7. Finished Meresamun reconstruction with hair and makeup

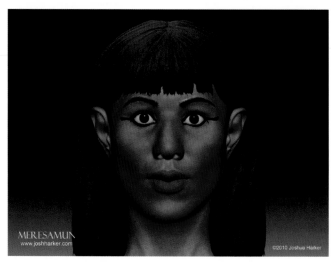

FIGURE 12.8. Meresamun reconstruction with darker skin tone

13. A BRIEF HISTORY OF VIRTUAL HERITAGE

DONALD H. SANDERS

What is Virtual Heritage? It is the use of virtual-reality (VR) technologies for the visualization of the past. For the purposes of this discourse, virtual reality is defined as interactive, self-directed, real-time navigation through a computer-generated three-dimensional (3-D) space displaying a simulated synthetic scene. The user is in control and the interaction is often associated with various senses beyond sight, such as sound and touch. Virtual reality for cultural heritage has been used successfully for excavation documentation (Genç 2008), data analysis (Barceló et al. 2000), teaching (Politis 2008; Youngblut 1998; Sanders 1997), publication (Sanders 2000; Dabney et al. 1999), museum display (the Virtual Museum Transnational Network — http://www.v-must.net/virtual_museums; Carrozzino and Bergamasco 2010), serious games (the use of video games for purposes outside commercial entertainment; Stone et al. 2008), and tourism (Guttentag 2010). Today, virtual reality for cultural heritage can be appreciated using standard web plugins, proprietary VR software, game engines, and advanced social-networking arenas.

What is not Virtual Heritage? There are a number of digitally based modes of visualization that are not strictly VR and not part of the present discussion on virtual heritage. These include: QTVR (Apple's QuickTime VR), which is more akin to a soap bubble onto whose inner surface many overlapping photos are attached to simulate being inside a three-dimensional space); computer animations, which are similar to short movies that neither allow interaction nor self-directed navigation; linked static images (as in online virtual museums or *Myst*-like games); and even simulated two-and-a-half-dimensional genres (such as Microsoft's *Age of Empires* and other similar computer games).

This essay presents a selective overview of the introduction and spread of virtual heritage, which was once also referred to as virtual archaeology, digital archaeology, digital history, and computer archaeology, but has since diverged from those other areas, each of which has developed its own emphases and technologies. The discussion explores the beginnings of virtual heritage in the early 1990s through its expansion during the early part of twenty-first century, with a glimpse into a possible future. From its inception among a handful of visionaries, virtual heritage now flourishes as a global discipline, with its own professional conferences, quasi-professional organizations, and extensive web presence.

VIRTUAL HERITAGE: THE 1990S

The 1980s brought rapid changes to VR technology, aspects of which had been in use already for over fifty years. Jaron Lanier, a founder of VPL Research, Inc., is generally credited with coining the term "virtual reality" in the late 1980s to distinguish between the immersive environments he was creating and traditional computer simulations (Sanders 1999). The general development of this new computer-based medium, the history of the different "realities" it spawned (e.g., artificial reality, hybrid reality, augmented reality, immersive reality, and telepresence), the psychological implications of a virtual reality, and the many types of hardware and software created to simulate reality, except as they relate to cultural heritage, are beyond the scope of this essay and have been discussed by, for example, Blascovich and Bailenson (2011).

In 1992, the movie *Lawnmower Man* introduced the concept of virtual reality to the public (although similar immersive computer-generated worlds were championed on television in 1987 in *Star Trek: The Next Generation*'s "holodeck," and even earlier in the original *Tron* movie, in 1982). By the mid-1990s, it was possible to virtually touch objects and feel textures and sensations (a subdiscipline called "haptics"), and perfume companies were experimenting with virtual smells to send odors electronically (and secretly) from lab to lab (Sanders 1999). The integration of this

new advanced technology into classrooms began at this time and has grown significantly in all levels of education (Virtual Reality and Education Laboratory online bibliography — http://vr.coe.ecu.edu/other. htm; Hew and Cheung 2010; Sanders 1997).

Even though high-end graphics processors (units the size of small refrigerators, not snap-in cards as we use today) and their computers could sell back then for a million dollars and exotic gear like head-mounted and beam-mounted displays required special technicians, many computer companies envisioned big commercial gains in an expanding VR market. The future seemed bright as VR was introduced into research in history, medicine, marketing, science, art, and exploration (Delaney 1994). Virtual reality's application to cultural heritage studies followed soon thereafter, spurred by simultaneous innovations in computer-aided design (CAD) software, advanced digital rendering capabilities pushed by Hollywood moviemakers and video games designers, and innovative collaborations between museums and computer programmers.

A few archaeologists were quick to experiment with virtual reality, but the use of immersive simulated environments for historical visualization focused generally on only two main purposes. The first purpose was for single specialized research projects, as typified by:

- the re-creation of the ancient Egyptian fortress of Buhen (12th Dynasty onward), undertaken in 1993 by (the late) Bill Riseman in cooperation with the Museum of Fine Arts, Boston, Eben Gay, and Donald H. Sanders (http://www.learningsites.com/EarlyWork/buhen-2.htm#tofc; it was the first detailed and precise, interactive virtual ancient environment to also feature linked databases and a virtual tour guide; fig. 13.1);

- the digital re-creation of the caves at Lascaux, France, by artists and archaeologists at the University of Cincinnati led by Benjamin Britton (begun in 1994);

- the Egyptian temple of Horus interactive world developed at Carnegie Mellon University's SimLab in 1994; and

- the virtual reality model of the lion temple at Musawwarat es-Sufra, Sudan, built in 1996 by students at Humboldt University, Berlin.

FIGURE 13.1. Screen grab from the first Buhen virtual world

The second main purpose for the early adoption of virtual heritage projects was to demonstrate the prowess of in-house programming or the power of new high-end systems, as illustrated by:

- the 1994 VR reconstruction of the Tomb of Nefertari, in Egypt, by Infobyte in cooperation with ENEL (the Italian power and light company), the Fondazione Memmo, and the Getty Conservation Institute;

- the recreation of the theater complex, triangular forum, and Temple of Isis at Pompeii by the SimLab at Carnegie Mellon University, in cooperation with the Archaeological Institute of America and Silicon Graphics, Inc., which was first demonstrated on high-end SGI machines in 1995; and

- virtual Stonehenge, developed in 1995 under the direction of Robert Stone, English Heritage, and Intel Corporation.

In 1995, the first conference dedicated to virtual heritage was held in Bath, England. It consisted of presentations about interactive models of the fortress at Buhen (by Learning Sites), Cluny Abbey (by IBM), the caves at Lascaux (by Benjamin Britton), Edinburgh and Glasgow (by the University of Strathclyde, Glasgow, and the Abacus Group), Hadrian's Wall (by the Northumbrian VR project), and Pompeii (by the SimLab of Carnegie Mellon University, and Silicon Graphics International Corporation with the Archaeological Institute of America). During that same year, a group of like-minded programmers created the Virtual Reality Markup Language (VRML) over an online mailing list. The programming language allowed

highly detailed, fast, and dynamic virtual worlds to be built and displayed on regular desktop computers without the need for high-end systems and was supported by Silicon Graphics and its VRML viewing software. In 1998, the Foundation of the Hellenic World was opened in Athens specifically to use immersive VR for the public education of the history of Greece; their first interactive models were of the ancient sites of Olympia, Epidaurus, and Miletus. Also in 1998, a special online issue of the SIGGRAPH newsletter was devoted to current projects in virtual heritage (Refsland 1998). The late 1990s also saw the popularity of online multi-player immersive environments such as AlphaWorld and Active Worlds, and dozens of general online immersive VRML communities. The wildly successful video game *Myst* (and its successor *Riven*) brought computer graphics and interactions in a simulated virtual world to gorgeous new heights. At that same time, the early virtual ancient worlds only had simple textures, relatively simplified shapes, and navigation was slow.

Regardless of inspiring beginnings and an apparently natural fit between the use of interactive 3-D graphics and cultural heritage, archaeologists did not generally embrace VR. The objections to the use of this "fringe" technology curiously mimicked the discipline's reaction to another innovative breakthrough visualization technology a century and a half earlier. During the 1840s and 1850s, photography provided archaeologists and traveling antiquarians with a more efficient and effective means of documenting their findings and providing higher-quality duplicate images for public and scholarly distribution than could

be achieved with traditional methods of drawing or painting (similar to the promise of digital models in the 1990s). Archaeologists resisted accepting photography into normal fieldwork activities for many of the same reasons preventing interactive 3-D graphics from becoming widely adopted today — the equipment is awkward, expensive, and breaks down frequently; the results cannot be trusted; and too few people can adequately operate the technology. By the late nineteenth century, however, photography finally became a common tool for recording excavations and artifacts, though, for nearly fifty years more it remained little more than a casual means of illustrating monuments, enlivening reports, and providing "eye candy" for fundraising efforts. Only by the mid-twentieth century, when Mortimer Wheeler and his photographer Maurice B. Cookson insisted that site photographs reveal every detail of the excavations as they proceeded, did archaeological photography make the transition from occasional snapshots to scientific recording (Sanders 2007, pp. 427–28). Similarly, during the 1990s, with rare exceptions, archaeologists used VR only as an afterthought, as pretty pictures to enliven popular articles or television programs.

A few projects from the 1990s that stand out as exceptional cases of using VR to best advantage include:

- the temples at Gebel Barkal (ancient Nubia, present-day northern Sudan; in cooperation with Timothy Kendall, then at the Museum of Fine Arts, Boston, used as research aids for his excavations, demonstrating how much more accurate and detailed the digital reconstructions could be than hand drawings; fig. 13.2);

- the Late Hellenistic mountaintop sanctuary at Nemrud Dagi, Turkey (developed to demonstrate the power of immersive worlds, with headsets and without, that contain image and text databases linked to objects inside the world to teach users about the site as they explored it. Users could also compare the excavated evidence against the digital reconstruction; fig. 13.3);

- the late third-century BC farmhouse at Vari (Attica, Greece; created in cooperation with the excavation team), an award-winning VRML-based educational package for elementary schools

Figure 13.2. Screen grab from the first Gebel Barkal virtual world

FIGURE 13.3. Screen grab from the first Nemrud Dagi virtual world

FIGURE 13.4. Screen grab from the first Vari House virtual world

with lesson plans, interactive linked datasets, and dynamic virtual worlds allowing students to navigate between the as-excavated reconstruction and a built version of the house for near first-person participatory learning experiences (fig. 13.4).

VIRTUAL HERITAGE — THE 2000S

The turn of the third millennium teemed with general excitement. Virtual Heritage, the international moniker under which all the previous work coalesced, was poised to become the dominant paradigm for the documentation, analysis, and dissemination of information about the past. Many factors pointed to a breakout era of innovative real-time immersive applications. Rapid technological advances in

computing power, continually increasing speed of graphics cards, and new forms of display hardware made virtual heritage projects more widely available. A dramatic increase in the global awareness of VR for heritage studies was witnessed by the expansion or addition of annual international conferences devoted to digital heritage (e.g., Virtual Systems and Multimedia [VSMM], Computer Applications in Archaeology [CAA], and the International Symposium on Virtual Reality, Archaeology, and Cultural Heritage [VAST]), and the Virtual Heritage Network was formed to address professional interests by offering services and information.

Standards and guidelines for the young discipline have been put forward (Fernie and Richards 2003; the London Charter — http://www.londoncharter.org/). The early years of the new century also renewed interest in the use of VR for teaching and museum exhibits, the phenomenal growth of the Internet, and unexpected sources of new data for virtual heritage practitioners, such as high-resolution laser scanners, megapixel photography, global positioning systems, satellite imagery, and Google Earth. Simultaneously, 3-D modeling software, part of the backbone of interactive worlds, became more widely available for regular home and office computers, easier to use, and often freely distributed (e.g., SketchUp, trueSpace, and Blender). This was the era in which virtual ancient worlds became more complex, textures became more realistic, and interactions became more sophisticated.

The number of virtual heritage projects increased steadily, especially in Europe (where such projects were encouraged by generous European Union funding, particularly from the Commission for Digital Cultural Heritage), Japan (generally under university or corporate sponsorship), Oceania, and India. New projects tended to be created by consortia of organizations (e.g., Archeoguide, an augmented-reality system for heritage sites), by students (often as school assignments that, when completed, were shelved by schools or put under restricted release), or by specific users of proprietary software that required specialized plugins to view the models, thus making availability limited.

Despite the expansion of funding opportunities and the collaborations formed to increase the applications of VR for heritage, larger issues failed to garner much attention or traction. These include

data longevity, long-term data stability, acceptance of global standards, integration of VH training into the curricula of budding digital heritage professionals, and initiation of a cooperative mentality toward understanding the past rather than creating 3-D models as isolated project pieces. As a result, virtual heritage remained a fringe approach generally shunned by field teams and researchers.

Despite clear demonstrations of the power of immersive graphics to answer questions about the past, there was still no comprehensive embrace of the real-time, interactive imaging techniques by archaeologists and other heritage professionals. Traditional but outmoded and often inaccurate methods of recording

and visualizing data about the past persisted (even though these methods were now digitally based, as from laser scanners, total stations, or satellite imagery). Virtual heritage did not yet emerge as a paradigm-shifting alternative.

Some examples of successful VH projects created during this period that were designed to solve specific archaeological questions or to address specific hypotheses include:

- the vast and detailed interactive model of the Northwest Palace of King Ashurnasirpal II at Nimrud (ninth century BC, ancient Assyria, present-day Iraq; developed by Learning Sites in concert with Samuel Paley and Assyriologists, architects, and museums around the world; fig. 13.5). The project offered significant new insight into the iconographic and propagandistic nature of Assyrian wall relief narrative decoration and spatial circulation. Samuel Paley commented, "I had all this data [about the palace] and was asked to hand it over to the computer graphics experts. I then realized more than before that what I had was not complete enough or precise enough for this new technology. Plans were inexact: some of them had been copied over by hand so many times that individual buildings had literally moved across the site" (personal communication). But the digital modeling results were convincing because, he added "I am particularly pleased with such virtual reconstructions, because I am able to visit the site and travel through it and see things that I could not see in one image before or even see easily and quickly if I were able to visit the actual ruined site; I could appreciate spatial relationships the way the ancient Assyrians intended." The VR package was made available on desktop PCs, on ImmersaDesk displays, and in a CAVE (Cave Automatic Virtual Environment) for educational, research, and museum exhibit purposes;

FIGURES 13.5. Detailed interactive model of the Northwest Palace of King Ashurnasirpal II

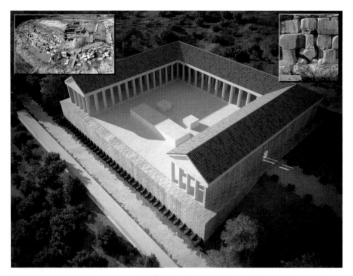

FIGURE 13.6. Battle monument of Octavian at Actium. Composite render, site and ruins

FIGURE 13.7. Kyrenia shipwreck render showing the cargo as it was excavated on the remains of the ship hull

- the battle monument of Octavian at Actium (first century BC, Greece; constructed by the Institute for the Visualization of History under the guidance of William Murray, University of South Florida), which demonstrated how interactive 3-D modeling can help understand complex construction methods and ancient warship weaponry in ways impossible with traditional two-dimensional media (fig. 13.6);

- the shipwreck dating from around 300 BC found off the coast of Kyrenia, Cyprus (fig. 13.7), from which much of the ship's hull and cargo were recovered during excavations but proved difficult to visualize and understand due to the complexities of vast numbers of overlapping objects and the occlusion of the water; the Institute for the Visualization of History under the direction of the excavation team re-created the wreck to facilitate further research and eventual publication; and

- the Athenian Acropolis (developed by Learning Sites; fig. 13.8) to test hypotheses about the old Athena Temple that could not have been resolved using traditional visualization methods. The results demonstrated that testing hypotheses using interactive 3-D models forces a re-evaluation of orthodoxy and often a needed correction in the interpretation of basic bits of evidence. To quote Gloria Pinney (Harvard University), the project's collaborating historian,

"we were not to produce an illustration. The model's value resides in the same reasons why modeling is standard practice in schools of architecture: it provides means of checking information and, most of all, of visualizing what one has in mind. It was important to reckon with the visual impact of the Archaic temple upon the Classical structures surrounding it. Most of all, accurate modeling that took into account all available data revealed existing evidence to refute the traditional argument that the temple could not have stood in that location after the Persian invasion" (personal communication).

FIGURE 13.8. Acropolis render showing remains of the old Athena Temple

VIRTUAL HERITAGE — TODAY AND BEYOND

Some projects currently employing VH to broaden and deepen our understanding of the past and the communication of cultural heritage include:

- the Northwest Palace virtual re-creation (being developed by Learning Sites; see above) has been upgraded with the addition of a virtual tour guide as the beginning of artificial intelligence-based interaction between real users and virtual characters (fig. 13.9). The tour guide currently leads virtual visitors to important locations around the palace. As the guide moves through the tour, there are linked text explanations, images, and interactives that provide the visitor with background information. The next step will be real-time question-and-answer interaction between virtual characters and real visitors;

- the small wooden model of a ship from an ancient tomb at Gurob, Egypt, was found in too many pieces to be fully understood. The fragile nature of the surviving bits meant that museum curators would not allow archaeologists to try reassembling the whole ship. The Petrie Museum of Egyptian Archaeology in London, where the remains are housed, is too far for most scholars to travel to see the pieces for study. Using VR, the Institute for the Visualization of History working with Shelley Wachsmann of Texas A&M University have digitally reconstructed the ship with interactive moving parts so that scholars can virtually try different configurations without damaging the real objects (fig. 13.10);

- combining aspects of serious games with the benefits of real-time exploration is the goal behind the virtual re-creation of a typical house from the ancient Greek settlement of Halieis (fourth century BC; being under development by the Institute for the Visualization of History in collaboration with *Archaeology* magazine and Bradley Ault of the University at Buffalo) for eventual access on *Archaeology* magazine's website (fig. 13.11).

The future looks bright for adoptees of VR for heritage visualization and for providing global access to the new insight gained. Continued advances in digital technologies allow VH to move toward innovative breakthroughs using holography, laser-plasma virtual displays, autostereo screens (stereo 3-D displays that do not require special glasses), expanded multi-touch interfaces, handheld devices, WebGL (a standard component of HTML 5 that will allow 3-D code to be embedded in web pages obviating the need for special plugins), more artificial intelligence-based avatar modeling and character controls, and social networks linking 3-D models for instant worldwide collaborations inside increasingly detailed and

FIGURE 13.9. Northwest Palace render with virtual guide

FIGURE 13.10. Gurob ship model render showing VR controls

FIGURE 13.11. Halieis game render

accurate virtual environments. However, the rapid pace of technological change in the graphics industry, multiple VR graphics viewing systems, and the perceived instability of digital data cause some to hesitate to use virtual reality for their projects.

Hundreds of ongoing VH projects exist worldwide, with the majority coming out of universities. Databases linked to worlds are now common, more complex (high-polygon-count) virtual environments are now easy to build and navigate, and an emphasis on lighting, vegetation, and character development makes worlds more realistic. Surprisingly, the new insight that is invariably gained from undertaking the scholarly process of creating ancient worlds and then viewing the past as interactive 3-D environments, from seeing ancient settlements and building spaces from a point of view like that of the original inhabitants, has not catapulted VR into routine operations for everyday excavations or research. VH procedures are in development for excavation and recording of information that translate seamlessly into databases, images, 3-D worlds, and publication-ready data. The following is a sample scenario for the fictional site of Trogitz.

The excavation season begins at Trogitz. The field team takes a few dozen overlapping digital photographs of the site, but do no surveying or measuring of any kind. Trenches are opened and as the dig proceeds, dozens more photographs are taken of the progress, showing changes in depth, soil changes, in situ finds, and some skirting shots of the surrounding landscape.

While the field team continues to enter notes, observations, and object descriptions into an online database, the photographs are automatically linked to finds, geo-referenced to the site photos and from trench to trench. Data extracted from the images are automatically converted into virtual reality models, each fully textured, dimensionable, and linked to the database notes and daily finds. Every time an artifact is uncovered, it too is fully photographed during its excavation and after its removal and cleaning. These photos also are used to automatically create and geo-reference virtual reality object models. This process continues as the season unfolds.

Simultaneously, the database and the linked VR models are uploaded to the Trogitz online collaborative network, where "friends" of the Trogitz work can explore the VR models in real-time, search the database, do interactive research, query the field team, and comment on the results by posting e-notes inside the virtual worlds of the

site or trenches. These digital comments can be instantly read by other "friends" or by the field team, allowing for global collaborations in real-time while the excavation progresses. Experts can advise the field team in ways that would normally take years. Publication-ready analyses, visualizations, and reports can be created and disseminated on demand rather than waiting years. Classroom-ready materials can be quickly prepared so that teachers and students always use the most recent, most accurate, and most comprehensive data possible.

The events described in the Trogitz scenario are becoming a reality at this time. Computer vision engineers, programmers, and archaeologists at Brown University are devising the database infrastructure and automated 3-D modeling modules to enable such a dramatic shift in excavation methods. A working prototype of the software system has already been tested at a number of sites around the world. For a glimpse into some of the technology involved, go to http://vision.lems.brown.edu/research_projects and click on "Reveal."

CONCLUSION

Over the past nearly twenty years, the new discipline of virtual heritage has been adapted to advances in display hardware, modeling and viewing software, and real-world applications. The number of VH projects continues to increase, much to the benefit of students, scholars, and the general public.

As it has since its inception in the early 1990s, VH continues to teeter at the brink of breakthrough and full recognition of its cross-disciplinary utility, despite the evident benefits and its cost effectiveness. Going forward, VH procedures should become standard in archaeology, as a younger generation sees the virtues of virtual reality and familiarity with VR becomes part of their training. Facility in using 3-D modeling programs will be embraced as a standard skill; a new apparatus for critically evaluating virtual heritage projects by peers will become part of the scholarly process; and field teams will include interactive visualizations as a key component of their documentation and analysis. Full integration of photography into excavations, teaching, and publication took nearly one hundred years; the acceptance trajectory for VR will surely not be that long.

It was recognized by a few from the beginning that "the very task of setting up a computer reconstruction obliges the archaeologist to pose the right questions, and then to answer them. This whole procedure makes the computer reconstruction a valuable research tool" (Colin Renfrew, p. 7, in his foreword to Forte and Siliotti 1997, a popular book extolling the benefits of using digital visualizations to aid comprehension of ancient sites). In that same volume, one of the editors explained,

> Why is the virtual reconstruction of an archaeological site so important? Because ... computer reconstruction allows the presentation of complex information in a visual way that enables it to be used to test and refine the image or model that has been created ... exploring a model in three dimensions and from an infinite number of viewpoints. Furthermore, it allows objective verification to be made of possible interpretations of architecture, material culture, topography, palaeo-environmental data, restoration, museum display, and any number of other factors. This makes virtual reality a highly useful tool ... (Forte and Siliotti 1997, pp. 12–13).

In the twenty-first century, where video-enabled multi-touch tablets, GPS-enabled megapixel camera smartphones, wireless high-speed home networks, and laptops for almost every schoolchild are commonplace, interactive 3-D environments are an obvious choice for instructive tools. They provide one of the best, most efficient means possible for testing hypotheses about the past and disseminating data in clear, visually reinforced, highly engaging and organized formats. How much we can gain from heritage studies depends not only on the questions we ask about the past, but equally on the content and visualizations, virtual or otherwise, chosen to illuminate the answers.

1

2

1, 2. JAMES HENRY BREASTED'S NOTEBOOKS

James Henry Breasted
Paper, ink
ca. 16.75 x 10.15 cm
Collection of the Oriental Institute
1. Oriental Institute digital image D. 17462
2. Oriental Institute digital image D. 17463

From 1899 to 1904, Breasted traveled through Europe and in Egypt making hand copies and taking photographs of historical inscriptions on Egyptian artifacts in major museums. The texts were used by the Berlin Dictionary of the Egyptian language (*Wörterbuch der ägyptischen Sprache*) and they also formed the basis of Breasted's five-volume *Ancient Records of Egypt* that was published by the University of Chicago Press in 1906–07. These small notebooks contain his meticulous copies of texts on objects in the British Museum (Catalog No. 1), the Louvre, and the Gizeh Museum in Cairo (Catalog No. 2). ET

3. PHOTOGRAPHING IN THE INTERIOR OF THE TEMPLE AT ABU SIMBEL

Friedrich Koch, February 1906
Digital enlargement from original glass plate negative
32 x 22 cm
Oriental Institute photograph P. 2403

3

In order to produce a complete photographic record of the decorated surfaces on the walls and pillars of the interior spaces in the Temple of Ramesses II at Abu Simbel, photographer Friedrich Koch needed the assistance of engineer Victor Persons. In this photo, Koch is making a time-exposure from a scaffold erected in front of the north wall at the east end of the Hypostyle Hall, behind some pillars.

Breasted's description in the expedition notebook in the Oriental Institute Museum Archives explains the procedure and its challenges:

Monday, February 12, 1906

With some interruptions it took about two weeks to facsimile the big marriage stela. Meantime Persons had been drawing off his plan of the Halfa temple, and Koch was making the negatives in the great hall of the temple. Persons was constantly called on to leave his plans and build scaffolds for Koch. We have twelve ladders with us, which we had made in Cairo. These with a supply of timbers, planks and boxes, furnish us with all necessary material for such scaffold-building. As soon as I was free from the big marriage stela, I took Koch's prints and collated all inscriptions from ladders. This work I finished on the two long walls yesterday. We have now secured facsimile records of all the historical documents in the temple, the first ever made....

The work of securing our negatives has continually involved a host of problems, many of them difficult. The great hall was only conquered after many experiments. As it is hewn into the mountain we were obliged to use artificial illumination. The placing of both camera and light was interfered with by the huge pillars, and it was constantly necessary to place the light directly in range of the objective so that it was sometimes necessary to veil the light when 25 feet from the floor. All focusing had to be done by means of lighted candles placed one at each corner and one in the middle of the section of wall to be photographed. All this on lofty scaffolds or on ladders many feet from the floor was slow and often experimental. These and other difficulties in the way of proper exposure, once overcome, the dark room also proved a fruitful source of obstacles. The Nile current carries so much sand that the water must be filtered before it can be used for washing plates, and the frequent sand-storms often leave our dried plates with a gelatin surface like sand-paper. Nevertheless the negatives of the great hall are clear, beautiful and in spite of enforced positions in focusing, are not distorted. We shall be able to make a superb volume on this matchless temple.

JAL

4. REINFORCED PHOTOGRAPH: RELIEF FROM ABU SIMBEL

James Henry Breasted
Photo, paper, ink
Photo: 21.0 x 26.5 cm;
Overall: 41.0 x 26.5 cm
Collection of the Oriental Institute
Oriental Institute digital image D. 17464

4

When the University of Chicago Egyptian Expedition was working at Abu Simbel in Egypt during January 1906, Breasted began to experiment with a new method for making accurate copies of hieroglyphic inscriptions. This system involved a combination of photography and careful comparison of the details of the image to the original surface. Some of the hieroglyphs that are indistinct in the photo have been "reinforced" on the photo in red ink. Freehand drawings of other hieroglyphs have been made on the sheet of attached paper. This system of "collation" became the basis for the sophisticated method now used by the Epigraphic Survey of the Oriental Institute.

The photograph records part of a text referred to as "The Blessing of Ptah," located in the First Hall of the Temple of Ramesses II at Abu Simbel. The translation, which Breasted prepared for his monumental *Ancient Records of Egypt* (volume 3), was completed prior to his visit to Abu Simbel and, in fact, the publication first appeared in 1906 while Breasted was in Egypt. JAL

THE EPIGRAPHIC PROCESS

The Oriental Institute is internationally recognized for its detailed, highly accurate drawings of reliefs and inscriptions in Theban temples and tombs (see Johnson, Chapter 3). The process of creating a facsimile drawing according to the Chicago method consists of a number of steps designed to ensure the accuracy of the drawing. This sequence of images (Catalog Nos. 5–9) demonstrates the process as applied to a section of wall of the Colonnade Hall of Luxor Temple.

5. PHOTOGRAPH

Friedrich Koch
Photograph
26.0 x 21.5 cm
Courtesy of the Epigraphic Survey
and Leipzig University

5

The first step in the epigraphic process is documenting the wall with large-format photography. This image was taken by German photographer Friedrich Koch, who worked with Breasted in Nubia in 1905–1906. This image from the Colonnade Hall of Luxor Temple and others by Koch were utilized by the Epigraphic Survey more than a half century later because the amount of detail on the older photograph was more complete than what was preserved on the wall at the time the Survey began its documentation. Similar large-format photographs taken by the Epigraphic Survey formed the basis for the final epigraphic drawing. The carved and painted reliefs and inscriptions in Egyptian temples are being eroded, defaced, and destroyed at an alarming rate, making older archival images like this one invaluable records of details that may now be lost.

This scene shows King Horemheb (usurped from Tutankhamun) censing and purifying an elaborate stack of offerings for the god Amun. Below is a model boat on carrying poles carrying an image of the king during the Opet Festival, when a procession of boats traveled between the Karnak and Luxor temples. Much of the wall's surface is pitted, encrusted with salt, or damaged, making it difficult to make out the original decoration in the photographs, hence the need for a facsimile drawing that clarifies the information that is only partially visible on the photograph. WRJ/ET

PUBLISHED

Epigraphic Survey 1994, pl. 9

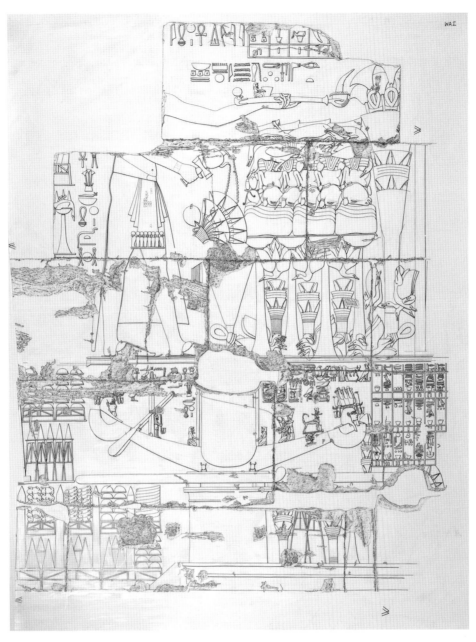

6

6. DRAWING

Ink on paper
61 x 48 cm
Courtesy of the Epigraphic Survey
Oriental Institute digital image D. 17465

In the next step of producing an epigraphic drawing, an artist takes an enlarged photograph (up to 20 x 24 inches), specially printed on matte-surface photographic paper, to the wall and carefully traces the hieroglyphs and scenes in pencil directly on the photograph. The goal is to isolate the original decoration from the distracting and obscuring damage and incrustation shown on the photograph. The penciled lines are then traced in ink. The style of carving, whether raised or sunk, is indicated by the use of heavy and lighter ink lines. Today similar drawings are also done digitally by Chicago House utilizing the same drawing conventions. WRJ/ET

7

7. BLUEPRINT

Paper

69 x 57 cm

Courtesy of the Epigraphic Survey

Oriental Institute digital image D. 17466

The inked drawing is immersed in an iodine bath that dissolves the photograph, leaving only the drawing. The drawing is then blueprinted or scanned to make a working copy and to avoid damage to the original inked drawing. WRJ/ET

8

8. COLLATION SHEET

Paper, pencil
35.5 x 21.5 cm
Courtesy of the Epigraphic Survey
Oriental Institute digital image D. 17467

The blueprint or scan is cut into small pieces, each of which is mounted on a larger piece of stiff white paper. Two epigraphers, one after the other, compare the image on the collation sheet to the wall and draw corrections and refinements directly on the collation sheet with commentary written in the margins. This system of collation — a hallmark of the Chicago House method — ensures a highly accurate copy that relies upon Egyptologist-epigraphers and artists who are trained to see many small details that are not visible on the photograph. The first epigrapher makes notations that are checked by the second epigrapher. The blue checkmarks on this collation sheet indicate that the second epigrapher has agreed with corrections suggested by the first epigrapher.

Once the two epigraphers agree, an artist takes the collation sheet back to the wall to review each change. The green checkmarks on this sheet indicate the artist's agreement with the epigraphers' corrections. Then, the epigraphers and artist meet a final time at the wall to discuss the corrections. When all parties are in agreement, the artist adds the changes to the inked drawing back in the studio. The yellow checkmarks indicate that the first epigrapher has verified that each of the corrections has been transferred from the collation sheet to the inked drawing. This complex system of cross-checking ensures the accuracy of the final drawing.

This collation sheet deals with a portion of the hieroglyphic text to the right of the king's boat in the lower right — only a tiny section of the larger drawing. WRJ/ET

9. FINAL EPIGRAPHIC DRAWING

Paper, ink
48 x 37 cm
Oriental Institute digital image D. 17468

This is a copy of the final published plate of a detail
of the overall scene. The inking of this final drawing
was done by artist Carol Meyer. WRJ/ET

PUBLISHED
Epigraphic Survey 1994, pl. 11

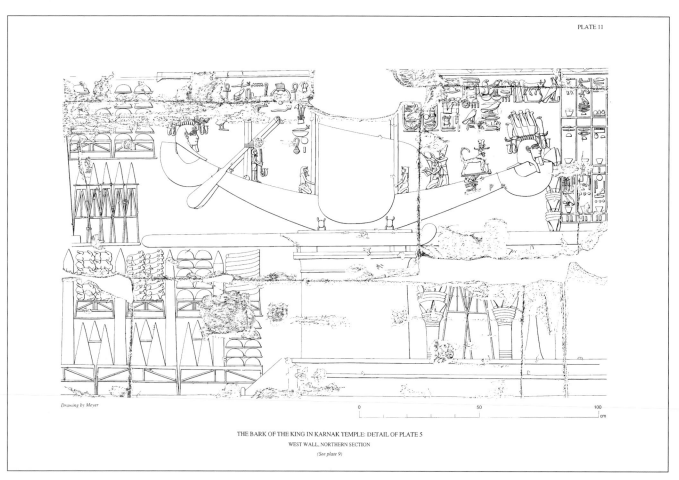

PLATE 11

Drawing by Meyer

THE BARK OF THE KING IN KARNAK TEMPLE: DETAIL OF PLATE 5
WEST WALL, NORTHERN SECTION
(See plate 9)

9

FACSIMILIES

The walls of most Egyptian tombs and temples are decorated with brightly painted scenes that are important documents of life and religious beliefs. As early as the nineteenth century there was growing concern about their preservation as they fell victim to vandalism and erosion. In the days before color photography was an option, the best way to document the scenes was to make exact ("facsimile") copies. The following examples demonstrate different techniques for producing facsimiles.

10. "VINTAGERS AND BIRD-CATCHERS"

Nina de Garis Davies, ca. 1932
Tempera on paper
42 x 116 cm
Collection of the Oriental Institute
Oriental Institute digital image
D. 17469

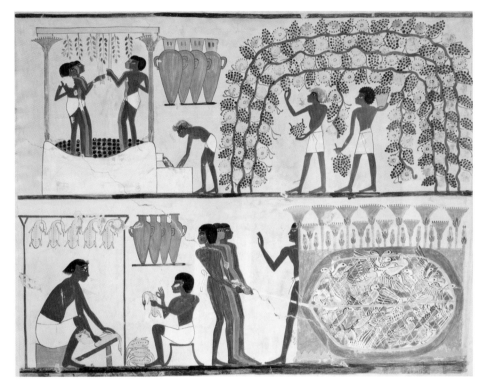

10

Nina de Garis Davies was among the most accomplished facsimile artists who specialized in scenes from Theban tombs (see Strudwick, Chapter 8). She worked from tracings of tomb walls, and then added details freehand, ensuring accuracy by working in sight of the wall.

This full-scale facsimile is part of much larger scene that included the tomb owner Nakht and his wife seated before offerings and men bringing additional offerings of birds, fish, and fruit. Davies selected parts of larger scenes to make square or rectangular compositions, although doing so removed the scene from the context that gave it greater meaning.

In the upper register of this image, men make wine. To the right, men pick grapes, and to the left, five others crush grapes in a large trellis-covered vat while another man collects the wine streaming into a basin. Four stoppered wine jars stand behind him (according to the rules of Egyptian artistic convention they are shown above the man). Below and to the right, men catch birds in a papyrus marsh with a large clap net. To the left, a man plucks the birds and another guts them and hangs them to dry. Four jars, probably containing bird fat, complete the scene.

This watercolor was published in 1936 in *Ancient Egyptian Paintings*, which consisted of two massive folios and a text volume. The publication presented an assortment of scenes from tombs from different geographic areas and time periods as exemplars of "art." This was a divergence from

usual Egyptological publications that sought to maintain the original context of tomb paintings. One might presume that the publication was intended to bridge the gap between Egyptologists and art historians, perhaps as a way of creating a greater appreciation of Egyptian wall paintings as "art" rather than as cultural artifacts.

In the preface to that publication, James Henry Breasted mused that "the problem that confronted us was the extent to which we should cater for mere archaeological interest" (Davies 1936, p. xi),

suggesting that a tension existed between the interests of the editors and the audience they hoped to reach.

The scene certainly resonated with the public, and it has become a stock image in commercial papyrus paintings and note cards. ET

PUBLISHED (SELECTED)

Davies 1936, vol. 1, pl. 47

11

11. "SHRINE OF SETHOS, WEST WALL, CENTRAL PORTION" (KING SETI I PRESENTS INCENSE TO HIS DEIFIED SELF)

Amice Calverley and Myrtle Broome, ca. 1934
Watercolor
78 x 53 cm
Collection of the Oriental Institute
Oriental Institute digital image D. 17470

The Temple of Seti I (ca. 1294–1279 BC) at Abydos is considered by many to have the most beautiful wall reliefs in Egypt (see Strudwick, Chapter 8). In 1924–1925, London's Egypt Exploration Society (EES) began work photographing the walls of the monument. After several seasons it was judged that the photos did not record the fine reliefs in enough detail and difficulties with lighting made photography simply unfeasible in some areas. Therefore it was decided that the reliefs should be recorded in line drawing (James 1982, p. 154). The EES engaged the artist Amice Calverley, who was joined slightly later by Myrtle Broome, to revise the work. They used a variety of different methods. They traced photographs that were enlarged

to full scale, they used reinforced photographs (Baines 1984, p. 14), and they apparently used a *camera lucida* to project the photographs onto a drawing board (see Studwick, Chapter 8, and Catalog No. 13). As Broome recalled, "We trace the outline and so get the whole picture correctly spaced very quickly" (James 1982, p. 154). This part of the work could be done in England, and the drawings were finished in Egypt in front of the wall to ensure accuracy.

In 1929, James Henry Breasted escorted John D. Rockefeller, Jr., through Egypt. On that trip, they visited Abydos and saw the recording project in action. Breasted persuaded his patron to support the project, underwriting what became a joint project of the EES and the Oriental Institute. In the typically lavish scale of the day, the project was envisioned to present the temple reliefs in eight huge bound folios (four appeared between 1933 and 1958). Many of the delicate reliefs retain their original pigments and so each of the volumes had a selection of colored plates. Breasted commented on the publication, "... the writer has been so impressed with the fidelity and beauty of the drawing that he feels the question may be fairly raised whether any drawing as good as this has ever before been done in Egypt" (Breasted 1933, p. 231).

This facsimile, in much smaller scale than the original, shows Seti in the guise of a funerary priest offering a flaming pot of incense to his deified and mummiform self. Isis, holding a ritual rattle (*sistrum*) and beaded necklace (*menat*), stands behind the king. ET

PUBLISHED (SELECTED)

Calverley and Broome 1938, pl. 40

12

12. MERERUKA AND WATETKHETHOR ON A BED

Prentice Duell, ca. 1935
Watercolor on board
54 x 43 cm
Collection of the Oriental Institute
Oriental Institute digital image D. 17471

The manner in which some images are presented depends upon their intended audience. In 1938, the Oriental Institute's Sakkarah Expedition published the reliefs and paintings in the mastaba tomb of the courtier Mereruka, ca. 2345 BC (see Roth, Chapter 4). In the introduction to that work, the editor argued that the material was a "treasury

of art and history" and that it was "intended for students of art and history and not exclusively for orientalists...." The editors continued:

> ... the tomb walls are an extraordinary treasury of *works of art*, both graphic and sculptural, produced at a period long before any art disclosing such astonishing power of representation had arisen among any other people. ... In the first place they are the earliest large and ambitious compositions known in the history of art ... (Sakkarah Expedition 1938, p. xii).

As a result, information that an "orientalist may find superfluous" was added to the introduction (Sakkarah Expedition 1938, vol. 1, p. xi), although, oddly, other more descriptive information that would have helped art historians decipher the scenes was not.

The choice of audience for the resulting two huge folio volumes was a marked departure for the Oriental Institute, which prided itself on its "scientific" epigraphic publications of Egyptian temples. In the effort to reach an "art" audience, *Mererkua* became a hybrid product, a beautiful book of images devoid of commentary that was essential for its intended audience. The final result is really useful only to Egyptologists, who have the academic background to decipher the images. In the usual epigraphic volumes from Chicago, color plates were accompanied by a line drawing and usually the photo, both of which served as a check on accuracy. In contrast, the ten color plates in *Mereruka* (with

the exception of pl. 45) were published without supporting documentation, perhaps justified by the plates being presented as examples of art rather than a part of the epigraphic process. Nowhere in the volumes does the field director state how these color copies of wall scenes were created, other than the vague comment, "important survivals of color have been carefully copied by our artists ..." (p. xviii), leaving one to wonder whether the color plates are freehand interpretations of the reliefs or if they are colorized versions of carefully checked epigraphic drawings.

This image of a highly charged erotic scene of Mereruka and his wife Watetkhethor seated on a bed as she strums a harp was painted by Prentice Duell, the director of the Sakkarah Expedition. Duell was a classical archaeologist and artist with no background in Egyptian art who specialized in documenting Etruscan wall paintings. He worked for the Oriental Institute from 1930 to 1936. As Ann Macy Roth notes in this volume, Duell's apparent lack of familiarity with the conventions of Egyptian art is evident in the way that the eye and mouth of Mereruka and his wife have been rendered in a more Western style, an error that would have been avoided using the standard Chicago method of copying reliefs. ET

PUBLISHED

Sakkarah Expedition 1938, vol. 1, pl. 95

ARCHITECTURAL RENDERINGS AND RECONSTRUCTIONS

Many of the ancient buildings of the Middle East are in ruins or are only partially preserved. One way of obtaining a better understanding of the form and function of a building is to do a reconstruction based on the remains revealed though archaeology. These reconstructions do not entail physically rebuilding the structure, but rather doing a "virtual" image in a variety of mediums. Architects, or archaeologists who have architectural training, lead many archaeological expeditions, and so they are especially qualified to decipher the physical remains and to do reconstructions based on a solid understanding of the ancient construction techniques, materials, and the presumed function of the building. Some reconstructions incorporate more speculation than others — some have stood the test of time as being an accurate view of the original appearance, others have not. Increasingly, these reconstructions are aided by satellite photography and computer-drawing programs.

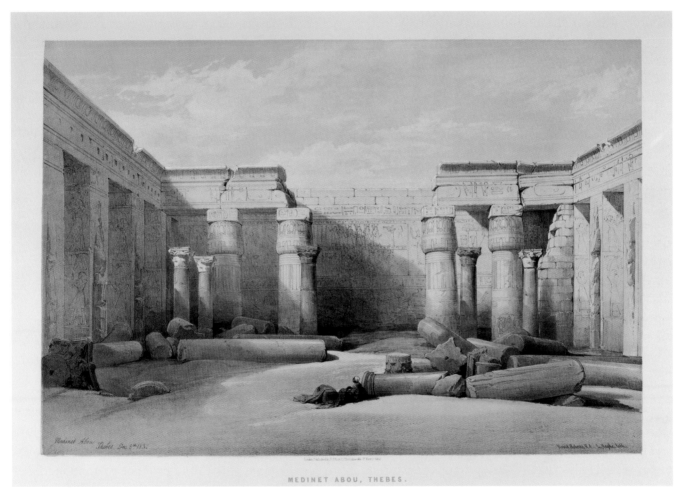

MEDINET ABOU, THEBES.

13

13. "MEDINET ABOU, THEBES"

David Roberts, December 5, 1838
Color lithograph on paper, Louis Haghe, lithographer
48.5 x 33.0 cm
Collection of the Oriental Institute
Oriental Institute digital image D. 17472

The images of Egypt, Nubia, and the Holy Land produced by David Roberts gained a degree of popularity in his time that has endured to the present. There is no other mid-nineteenth-century artist of Middle Eastern themes besides Roberts whose work can be found as broadly reproduced and distributed. Reproductions appear in almost

every medium imaginable, from books and pamphlets to postcards and notepaper. His work evokes a sense of the ancient monuments that is virtually unique and equally long lasting. His lithographs have become highly prized collectors' items and his complete books have become great rarities. Perhaps most important, Roberts's works created an idealized, Romantic image that formed the basis of the West's conception of the Middle East. The view included here is a fine example of his attention not only to detail but also to dramatic effect.

The scene depicted is the second court in the Temple of Ramesses III at Medinet Habu. Roberts recorded the condition of the court when it still contained the remains of the Church of Jeme, which was built during the Coptic occupation of the temple (Murnane 1980, p. 26). The gap in the colonnade caused by the removal of the central column was made to accommodate the apse of the church. The smaller granite or porphyry columns with classical capitals brought from elsewhere were used to define the aisles and other parts of the structure. These were removed in the mid-century excavations and restoration was begun by Auguste Mariette. Like many of Roberts's lithographs this image is a record of a monument before the widespread changes made in the second half of the nineteenth century.

David Roberts (1796–1864) was born in Scotland. Early in his career he worked as a scenic painter for the stage, and later he immigrated to London, where he was employed at Sadler's Wells and Covent Garden theaters. He soon became proficient as a painter of landscapes and architectural scenes and he worked not only throughout the British Isles but, perhaps more famously, in Egypt, Nubia, and the Middle East. His views of the monuments of Egypt and Palestine are the epitome of historical record, preserving the appearance of temples, churches, and other structures at a time when they were virtually unknown to a European public and when they were also relatively untouched by the modern good intentions meant to preserve them.

The immediate appeal of the Roberts lithographs rests in the accurate detail of architecture and geography they exhibit. He composed and organized his views and often added a compositional emphasis or dramatic color effect

that reflects the Romantic period of which he was a part, but the overriding attention to detail is always evident. Considering the large output of complex compositions and the relatively short time Roberts spent in his Eastern travels, the question remains as to how these exacting works were accomplished. An important technique that might have been employed by Roberts was the use of the *camera lucida*, a device that made the drawing of a complex subject almost as simple as tracing (see Strudwick, Chapter 8, and Catalog No. 11). Although there is no documentary evidence that Roberts used the *camera lucida*, it is probably the case. The *camera lucida* was invented (or made practical) by William Hyde Wollaston, an eminent English scientist who was granted a patent in 1806 for "An instrument whereby any person may draw in perspective, or may Copy or Reduce any Print or Drawing." A number of nineteenth-century artists and travelers took advantage of the device, enjoying its ease of use and generally satisfactory results (James 1997).

The attempt to explain Roberts's work as enabled or facilitated by a device like the *camera lucida* must rest on three considerations. First, the lithographs often have the appearance of a traced drawing. This in itself is admittedly not a particularly conclusive argument and is based on a subjective aesthetic judgment. One might argue that this is possibly attributable to the translation of Robert's original work to the medium of lithography by another hand. Second, the sheer number of works produced by Roberts on his Middle Eastern trip, when measured against the available time for work in the field, suggests that few, if any, draftsmen or artists could have produced such quantity while maintaining the high quality, accuracy, and attention to extremely complex detail. Third, it can be observed that there exists in some of the lithographs a certain degree of visual distortion, possibly the result of the use of a device incorporating a lens or necessitating a fixed viewpoint. One view of the Great Sphinx at Giza has the head tilted upward at a remarkable angle with an effect almost suggesting a "fish-eye" lens (Peck 2001).

A technique the artist certainly used was the inclusion of figural groups that were obviously derived from sketchbooks, separately done from the major composition. Examination of a number of

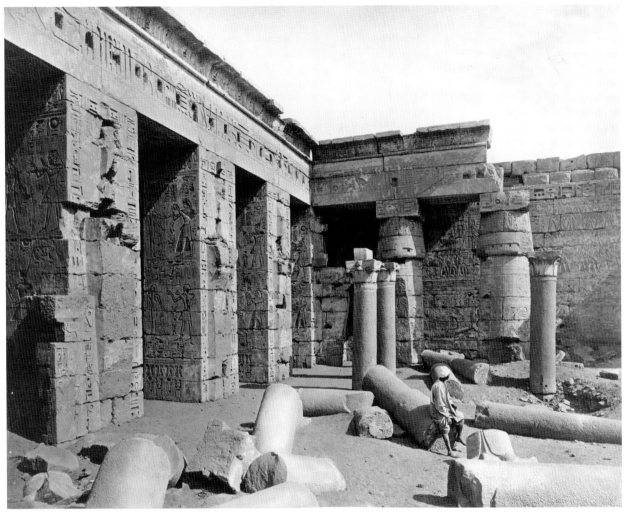

FIGURE C13.1. The Second Court in the Temple of Medinet Habu. Francis Frith, English (1822–1898) (collection of the Library of Congress, LC USZ62-108972)

Roberts's prints suggests strongly that the figures were added to the architecture or landscape after the fact. The desired effect was to add some human interest or a sense of the "Eastern" milieu. An important factor of Roberts's working methods that should be taken into consideration is the manner in which the insertion of these figural groups was carried out. A general examination of such figures shows that when they were added to compositions they were made smaller in relative scale, probably to further dramatize the architecture. This in itself would be of little interest except that for works often praised for their accuracy this is a somewhat deceptive practice as the figures have often been reduced to half normal size, making buildings appear to be far more monumental than they are in reality. This practice is demonstrated clearly when the Roberts lithograph is viewed next to a

photograph by Francis Frith taken between 1856 and 1860 (fig. C13.1). In the Frith photograph, a local is posed on one of the fallen columns; in the Roberts lithograph a figure of much reduced size leans against the end of one. The difference and the effect on the scale of the temple architecture and the fallen columns are obvious.

Taking into consideration the possible use of the *camera lucida*, the reduced scale of figures added and even the occasional visual error — sun setting in the south, Nile at two levels in a distant view of Karnak — the "views" of David Roberts provide a record of the past that presages the work of photographers who were only to begin to travel and work in Egypt a decade or so later. His accuracy of detail and his dramatic presentation in depicting the sights of Egypt and the Sudan have yet to be surpassed. WHP

119

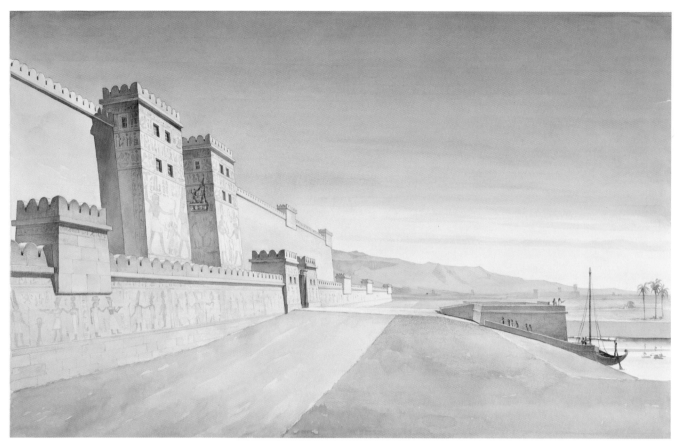

14

14. WALLS OF THE TEMPLE OF RAMESSES III AT MEDINET HABU, EGYPT

Uvo Hölscher, ca. 1930
Mixed media
44.5 x 66.0 cm
Collection of the Oriental Institute
Oriental Institute digital image D. 17473

This reconstruction of the east entrance to the Temple of Ramesses III (ca. 1184–1153 BC) in western Thebes was drawn by Uvo Hölscher, who served as the field director of the Oriental Institute's Architectural Survey from 1926 to 1933 (see fig. 3.3 in Chapter 3). Hölscher was trained as an architectural historian. Early in his career he worked with the German team of Ludwig Borchardt documenting the causeway of King Khafra at Giza. His superb plans and renderings of the site earned him a reputation for his careful draftsmanship and accuracy and led to his position with the Oriental Institute.

Hölscher produced many carefully researched plans and reconstructions of the structures at Medinet Habu. The first volume of the five that documented the architecture at the site contained very complex plans that traced the development of the temple, with each time period indicated in a different color to facilitate differentiating the different stages. His work has been described as setting "completely new standards ... in the recording of this great building, and superlative plans with an immense amount of detail were drawn for the monumental publication ..." (Bierbrier 1995, p. 206). The plans were done at a

scale of 1:100 with incredible detail. As Hölscher stated in the introduction to the volume of plans, "The bricks are not schematically sketched, but are carefully distinguished as headers, stretchers, etc. Only the very thick walls, where it seemed useless to measure each brick separately, are shown in gray tone" (Hölscher 1934, p. 4).

Hölscher's rendering of the walls and gates on the east side of the temple reflects this precision in recording. The stone Eastern High Gate and the lower stone-clad wall before it were quite well preserved (fig. C14.1). In contrast, the great mudbrick wall that encircled the complex was poorly preserved. However, the foundations allowed its thickness (10–11 meters) to be recorded. Its original height and its tapering profile were documented by marks where the wall originally abutted the stone gates on the east and west. However, nothing was preserved of the tops of the walls. The crenellations that make the structure resemble a medieval castle were copied from images of temples in Theban tombs and from the stone decoration that was partially preserved on the top of the lower wall and on the small guardhouses that stand before the gate. The challenges of

anchoring stone crenellations at the top of a tapering mudbrick wall make this feature somewhat questionable. The towers atop the brick wall are also speculative, being copied from a partially preserved tower on the lower stone wall.

What was described as a quay (shown to the right), but which may better be called a cult terrace (Arnold 1999, pp. 288–91), was well preserved and so there is no question of its original appearance.

Reconstructions that are based on good evidence, such as this one, are very effective means of presenting the past. However, such images may have a seductive quality that has the potential to impact the objectivity of archaeologists and architectural historians when they represent less well-preserved monuments and sites. This is, and has been, a potential problem with reconstructions that are more speculatively based but which, through their power and influence, have become a blueprint for restoration. ET

PUBLISHED

Hölscher 1932, pl. 1; Hölscher 1951, pl. 1

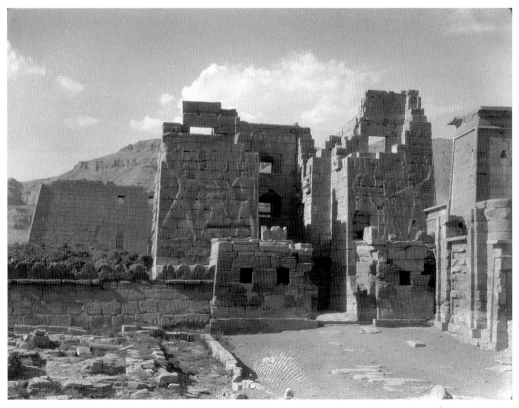

FIGURE C14.1. The facade of the Temple of Ramesses III at Medinet Habu showing the condition of the walls and gate in 1931 (Oriental Institute field negative E1/046)

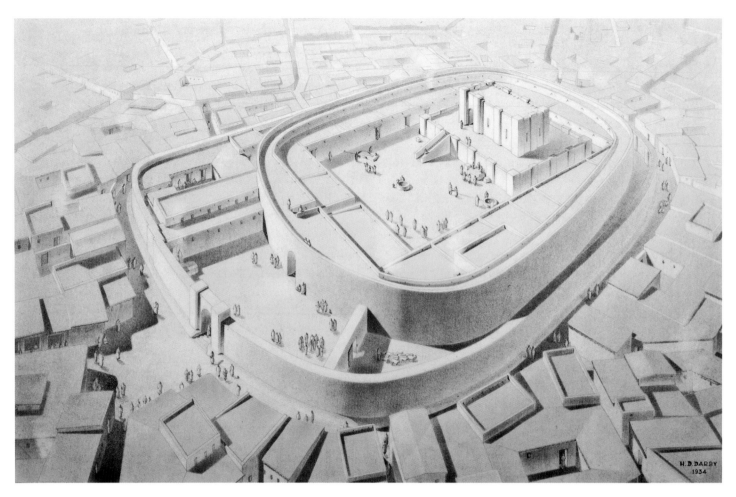

15

15. RECONSTRUCTION OF THE TEMPLE OVAL AT KHAFAJAH, IRAQ

Hamilton D. Darby, 1934
Pencil and charcoal on paper
47.00 x 64.75 cm
Collection of the Oriental Institute
Oriental Institute digital image D. 17474

The monumental Temple Oval complex at the site of Khafajah, in the Diyala region east of Baghdad, was excavated by the Iraq Expedition of the Oriental Institute for four seasons (1930–1931 and 1933–1934). Shortly after the final season of excavation, a reconstruction of the Temple Oval was drawn by Hamilton D. Darby, who was both the field architect at Khafajah and an assistant to Pinhas Delougaz, director of the excavations for the last three seasons. The reconstruction was published as the frontispiece of the final excavation report, *The Temple Oval at Khafājah* (1940). Despite the many hypothetical details, the Temple Oval reconstruction is widely accepted as an accurate evocation of a monumental temple complex of the Early Dynastic period (ca. 2900–2350 BC).

Known by multiple examples in Early Dynastic Mesopotamia, the temple oval type is named for its outer oval wall. The Temple Oval at Khafajah was constructed upon a low terrace and defined by two ovals walls. These run almost parallel to one another except at the northwest end, where the space widens to accommodate both an open area inside the entrance to the complex as well as House D, in which temple personnel were believed to reside. The inner oval wall contains a large courtyard surrounded by rooms. A platform preserved to only a few courses in height is situated at the back of the courtyard.

Although much of the restoration of the Temple Oval building was based on archaeological findings, no physical remains were encountered by the excavators on top of the platform within the Temple Oval (presumably they had eroded away). A sanctuary structure based on examples excavated at Khafajah and Tell Asmar was added. The reconstructed sanctuary had a bent-axis plan characteristic of Early Dynastic temples. In a bent-axis plan, access to the sanctuary is located at one end of a long wall, and the visitor must turn ninety degrees in order to encounter the altar, the presumed focal point of the room, against the short wall at the opposite end. The hypothetical bent-axis sanctuary of the Temple Oval was supported, according to the excavators, by the stairway leading up to the platform: its position at one end of the platform afforded a bent-axis approach. Likewise, the excavators observed that a bent-axis approach would have aligned the altar in the courtyard — set against the platform — with the sanctuary altar (Delougaz 1940, pp. 65–67).

The densely packed houses surrounding the Temple Oval are based on excavations restricted to the north-northeast side of the complex. There is no archaeological evidence, however, to support the network of streets radiating like the spokes of a wheel around the Temple Oval. According to Delougaz, the reconstruction was intended to showcase the Temple Oval complex "as the center on which roads converge, visible from a distance, rising above the houses of the community" (Delougaz 1940, p. ix). At the time of the Diyala excavations, the widely accepted theory of a "Sumerian temple-state" maintained that the temple was the principal owner of agricultural land, controlling an economy with virtually the entire population in its service. Although the temple practice of collecting commodities and redistributing them to its dependents is no longer viewed as constituting the entire economic enterprise of the Early Dynastic city-state, the temple nevertheless assumed an important role. As the home of the god, the temple was a large household that operated like a secular institution, with a variety of properties as well as commercial enterprises.

Various details for which no evidence survived were incorporated into the Temple Oval reconstruction. Particularly problematic was the lighting of interior spaces, which was solved by varying the height of the roofing and creating clerestory windows. The vaulting of the entrances is also hypothetical. No evidence survived, moreover, to explain the precise purpose of the space between the inner and outer oval walls beyond the entrance and House D. In the reconstruction, sheep are being herded into the space. In addition, various human figures congregate both inside the main entrance and in the inner courtyard. That visitors would have frequented the Temple Oval is suggested not only by the diverse functions of the complex but also by a rather unusual find. Impressions of footprints, including those of children, adults, cattle, sheep, and dogs, were excavated in the courtyard, particularly in the area adjacent to the platform. The excavators surmised that the footprints had formed during inclement weather, which had coincided with the occasion of a festival. Sometime later the impressions had been plastered over, making the surface of the courtyard even once again.

Darby's restoration of the Temple Oval, as an example of an early Sumerian temple, has become an icon of ancient Mesopotamia. It has been reproduced in scholarly and popular books on the art and archaeology of the ancient Near East, either in its original form (see Publications below), or in new illustrations based on Darby's original work (e.g., Lloyd, Müller, and Martin 1974, fig. 24). JME

PUBLISHED (SELECTED)

Delougaz 1940, frontispiece; Lloyd 1936, pl. 4; Frankfort 1954, fig. 36; Frankfort 1996, pl. 12; Orthmann 1975, pl. 3

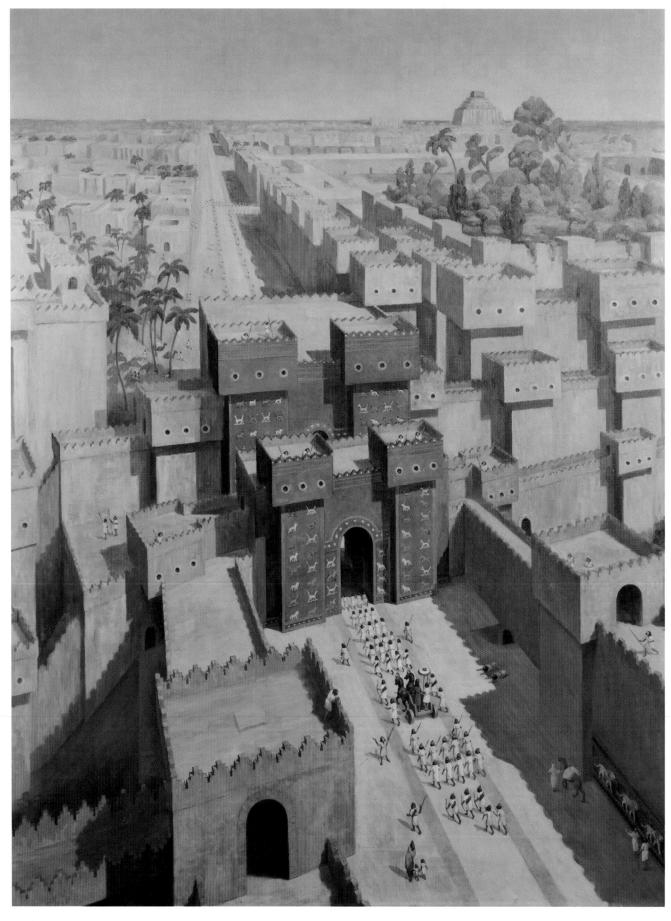

16

16. VIEW OF BABYLON

Maurice Bardin, 1936, after "View of the Ishtar Gate and
Processional Way" by Herbert Anger, 1927
Oil on canvas
122.0 x 91.5 cm
Collection of the Oriental Institute
Oriental Institute digital image D. 17475

The sixth-century Ishtar gate built by
Nebuchadnezzar II in Babylon has become as
iconic in the modern mind as it was in the ancient
world, the symbol of an opulent and polycultural
imperial city. Maurice Bardin's painted conception
of Babylon — an almost endless vista of urban
habitation — accords well with the intentions of
its royal builder as well as the historical memory
enshrined by other ancient cultures. The relative
positions of the monuments shown in the painting
are based on the excavations of Robert Koldewey,
carried out between 1899 and 1917. The decoration
of the walls and gates is based on excavated
molded-brick surfaces. Bardin, the painter, was a
fellow of the Oriental Institute who worked in Syria
from 1931 to 1935. In 1936, at the time this painting
was done, he was a curatorial assistant at the
Oriental Institute Museum.

The city of Babylon existed at least from the
twenty-first century BC, but grew relatively slowly
over the next 1,500 years as its political fortunes
waxed and waned. Following a series of destructions
at the hands of the Assyrian empire in the seventh
century, Babylon rebounded and a new dynasty
rebuilt the city on a grand scale, including more
than eight kilometers of outer walls and a massive
stone bridge straddling the Euphrates River. Two
new palaces and citadels, a revamped temple
quarter, and the famed "Processional Way" were the
monumental centerpieces of a city with a probable
total population of 250,000, including residents
from Egypt, Judah, Greece, and Persia. Babylon's
political fortunes declined after 539 BC, when the

city was conquered by the Persians. But the city
maintained its place as a center of banking and
commerce for almost three more centuries and was
only gradually replaced in importance by the new
city of Seleucia around 300 BC.

In this scene, a chariot with the telltale parasol
of the king drives southward from the palace
quarter toward the Processional Way and the
Esagila Temple of Marduk. The temple quarter's
ziggurat (Etemenanki; see Catalog No. 36), a
building used for ritual purposes, stands visible
about a kilometer in the distance. The best known
of the city's many religious ceremonies was the New
Year's Festival, which used this spectacular stage for
the "journeys" of gods from other cities to Babylon
and the reinvestiture of the king.

The memory of Babylon fired the imagination
of later centuries. To Greek writers, Babylon was
a paragon of the vain political grandiosity of
Oriental despots — note the fanciful depiction of a
"hanging garden" to the upper right. To the authors
of the Hebrew Bible, Babylon was a symbol of
oppression and idolatry, and in the New Testament,
of wickedness and apocalypse. And to the Arabic
geographers and historians left to ponder the
ruins before them, Babylon presented a paradox: a
visible marker of pre-Islamic greatness — but also
a haunted ground, a place to consort with witches,
wine, and women. These images reverberated
throughout medieval and early modern history,
propagating an iconic conception of the splendor of
Babylon that remains to this day. SR

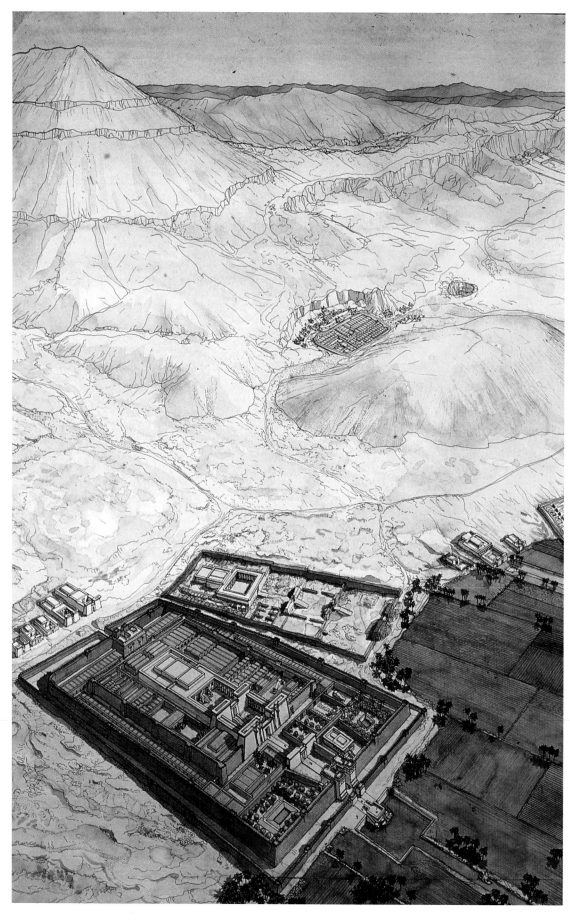

17

17. MEDINET HABU AND THE MOUNTAINS OF WESTERN THEBES, EGYPT

Jean-Claude Golvin, 1996
India ink and watercolor on paper
63 x 43 cm
Collection of the Musée départemental Arles antique

The goal of Jean-Claude Golvin's reconstructions of monuments is to give the overall concept of a site, based on archaeological data, architectural fragments, textual references, and some well-informed speculation.

This rendering of the landscape is dominated by the "Gourn," the mountain peak that towers over the monuments of western Thebes. It stands like a great natural pyramid over the tombs in the Valley of the Kings and the tombs of the nobles. Memorial temples of kings are shown nestled into the landscape below the Gourn in a way that would be impossible to show through a modern aerial view.

In the foreground is the large temple complex of Ramesses III with a row of five funerary chapels to the west. Nearly abutting the main temple is the walled temple enclosure of kings Aye and Horemheb, and farther north are the Temples of Thutmose I and Amunhotep, son of Hapu. In the middle distance is the workmen's village Deir el-Medina, the residence of the men who built the royal tombs. To the top right are the temples at Deir el-Bahari.

Today these temples are in various states of preservation; some well preserved, in the case of the Temple of Ramesses, others nearly ruined. All are shown with details that have been restored on the basis of surviving architecture, parallels from other sites, and some speculation. The process of restoring the individual monuments in their topographic setting provides an immense amount of information for understanding the overall appearance of western Thebes and the relationship of one temple to another.

Golvin described the image:

The view shows the link between temple and the royal tomb in the Theban mountains. To the contemporary observer, these natural and man-made elements seem to be separated, but they were closely associated in the ancient Egyptian's conception of the world. The Theban mountain plays a role similar to a pyramid. The tomb is inside and the temples are at the foot of this natural "pyramid." An Egyptian temple is never in isolation — it is always linked with the geographical context and its meaning.

ET

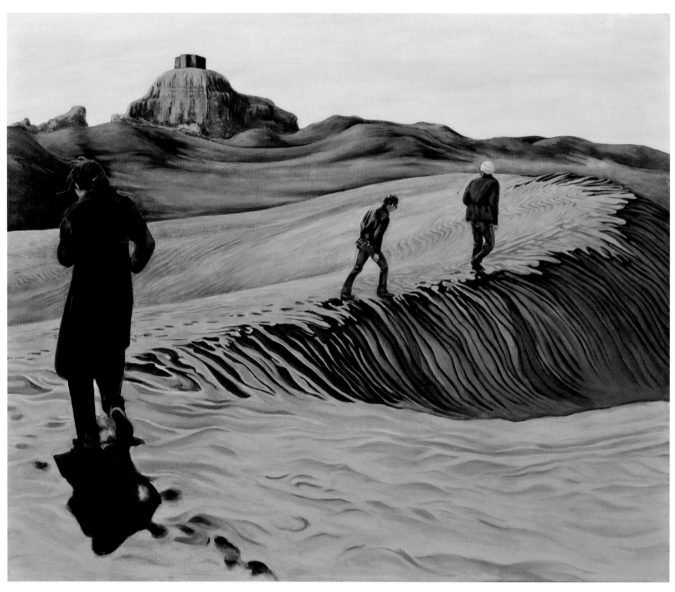

18

18. VIEW OF NIPPUR, IRAQ

Peggy Sanders, 1982
Oil on canvas
92.7 x 77.5 cm
Collection of Peggy and John Sanders
Oriental Institute digital image D. 17476

The ancient landscapes of the Middle East are important features for understanding the society and for visualizing the past. This painting of Nippur uses the terrain to provoke thought about the history of the site and also how that environment stimulates personal introspection. As Peggy Sanders recalls:

> This painting is based on a black-and-white photograph from my first season with the University of Chicago Expedition to Nippur, Iraq. Our small party is traversing the site, which has been buried

128

for most of the past century by slowly migrating dunes of sand. The ziggurat, once the religious center of ancient Mesopotamia, is our destination. Its ancient form has been softened by erosion; the baked brick house on top, where the temple once stood, is a "modern" construction.

As we trudge along the crest of the dunes, we are crossing the ancient Euphrates riverbeds. Ironically, the dunes depicted in the painting strongly suggest ocean waves, except that these waves of sand are much more firm than water.

Initially, one's perception is that the dunes are stationary. But over the years one can discern their movement, drifting eastward. This almost imperceptible change is a continuation of the evolution of the site from its days as a living city to its abandonment and physical deterioration, and its gradual burial. The ziggurat, of course, remains exposed — it is the tallest structure in the entire region and the focal point of the painting.

For me, this painting is about journey. It is a depiction of an archaeological site, but it also reflects our evolution through time, our walk through life. It reflects the adventure of exploring the site and appreciating the intriguing beauty of a deserted place. It is also about one's inner journey. You, the viewer, have become a member of this expedition, following, journeying, and pondering the past, the future and the present.

ET

FIGURE C18.1. East Mound of Nippur as seen from the West Mound across ancient Euphrates channel. Winter 1974/75 (photo by John Sanders)

19. THE APANADA (AUDIENCE HALL) AT PERSEPOLIS, IRAN

Joseph Lindon Smith, 1935
Oil on canvas
205.7 x 133.3 cm
Collection of the Oriental Institute
Oriental Institute digital image D. 17477

Joseph Lindon Smith was an American artist who specialized in archaeological subjects (see O'Connor, Chapter 11). In the 1920s and 1930s Smith worked with George Reisner at Giza, where he probably met James Henry Breasted. In 1934 Breasted invited Smith to join the University of Chicago's Persepolis Expedition to record the monuments. This painting, one of six in a series, shows the south wing of the Council Hall with its parapet carved with a file of Persian guards (foreground), looking northwest toward the Apadana (audience hall) with its four great standing columns and the Eastern Stairway. The monument was in a good state of preservation (fig. C19.1). In contrast to Smith's other archaeological paintings from other sites, which were intended to produce a very close copy or even a facsimile (see plates in Lesko, Larkin, and Lesko 1998), this painting has a dreamlike, impressionist quality that expresses more about the atmosphere of the Apadana than its appearance. Smith commented on his reaction to the site: "Finally ... seated at the edge of the terrace facing the wide stairway rising from the plain below, my conscious self yielded to the magic of the changing color which sun near setting suffuses with an indescribable light over mountains and columns alike and I pinched myself to be sure I was awake" (Archives of American Art, the Smithsonian Institute, Reel 5119). However, while at Persepolis, Smith produced other paintings more characteristic of his previous work (figs. 11.3–4, 8–9 in Chapter 11).

This painting was exhibited at the Oriental Institute in 1935–1937 alongside an enormous panoramic view of the site that was commissioned for the Century of Progress World's Fair held in Chicago in 1933–1934 (fig. 11.2 in Chapter 11). ET

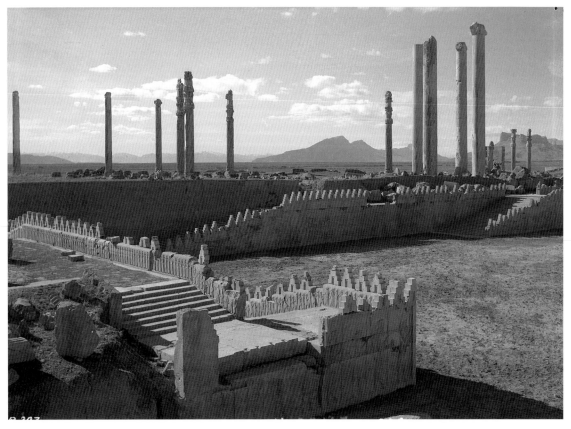

FIGURE C19.1. The south wing of the Council Hall and the Apadana, 1935–36 (Oriental Institute photograph P. 57100)

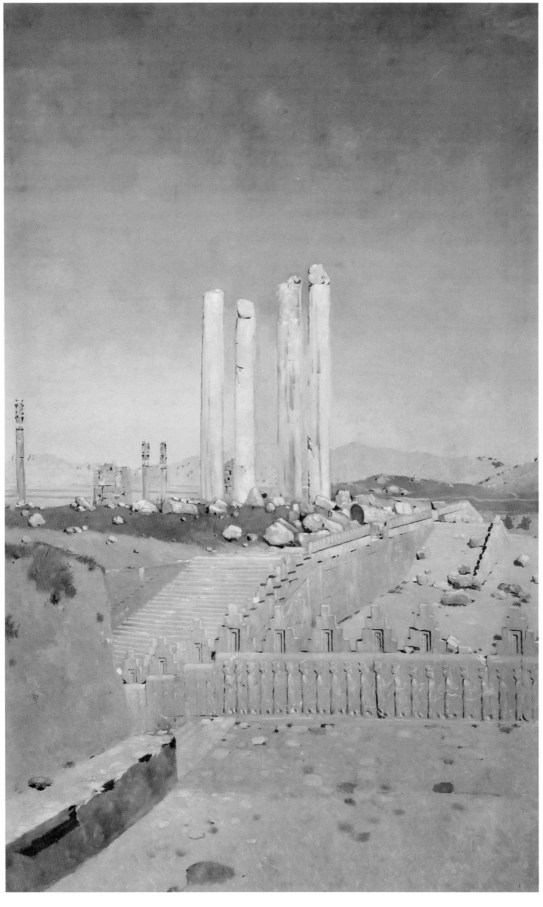

19

20. RESTORATION OF NEO-ASSYRIAN WALL PAINTING FROM RESIDENCE K, KHORSABAD, IRAQ

Charles B. Altman, ca. 1935
Archival print (as prepared for publication, Loud and Altman 1938, pl. 89)
75 x 48 cm (originally reproduced at 1:20)
Collection of the Oriental Institute
Oriental Institute digital image D. 17478

Although substantially correct, this restoration provides a good example of how some speculative elements within restorations can become accepted facts of iconography, with the potential for influencing scholarship over the generations. It depicts a large section of painted plaster decoration that once elaborated the wall opposite the central portal of a "great hall" (Room 12) in Residence K at Khorsabad, northern Iraq. The original wall painting is dated to the reign of the Assyrian king Sargon II (721–705 BC), who founded his capital there, naming it Dur Sharrukin ("Fortress of Sargon"). Residence K was likely to have been the home of a high official of Sargon's court.

Charles B. Altman, a trained architect, was primarily responsible for the excavation and recording of the Residence K painted plaster during the season of 1934–1935, as well as creating this famous restoration. He also completed several perspective restorations of the buildings and citadel at Khorsabad (see fig. 1.2 in Chapter 1) as part of the expedition to Khorsabad by the Oriental Institute of the University of Chicago between 1928 and 1935. The Oriental Institute's expedition was led initially by Edward Chiera, and then by Gordon Loud and Charles Altman, and was the first investigation of the site following the work of Paul Botta and Victor Place in the mid-nineteenth century.

The restoration is dominated by its central subjects: three gigantic male figures, each standing around three meters tall. No accompanying inscriptions survived to identify the figures (Loud and Altman 1938, pp. 20, 65); Altman designated the central royal figure as "undoubtedly" Sargon II (ibid., p. 85). An accompanying officer stands to his right and an unnamed deity (probably Ashur) stands on a platform on the left side holding the rod and ring of divine rule. The scene is further elaborated in the surrounding arch with alternating

FIGURE C20.1. Recovery (plan) and restoration (elevation) of the Room 12 wall painting, Residence K (Loud and Altman 1938, pl. 88)

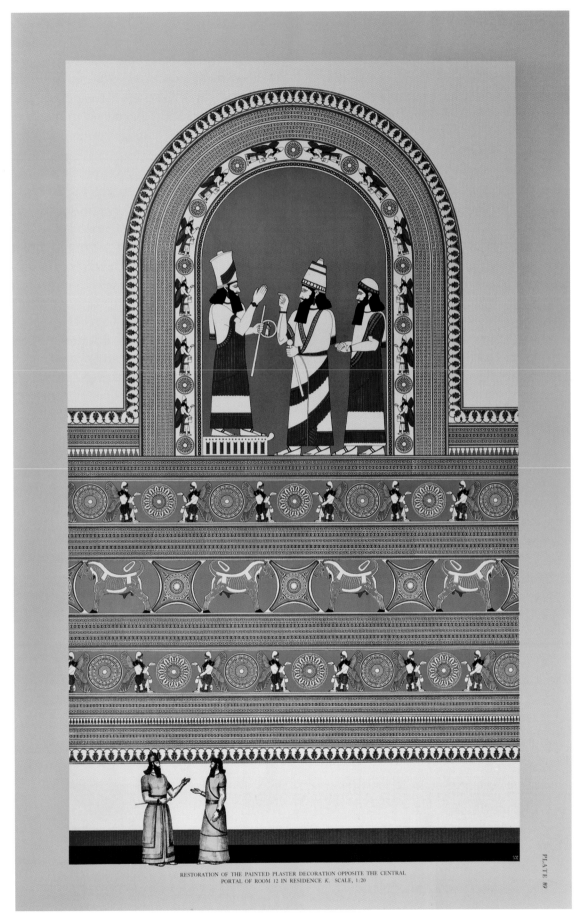

RESTORATION OF THE PAINTED PLASTER DECORATION OPPOSITE THE CENTRAL
PORTAL OF ROOM 12 IN RESIDENCE *K.* SCALE, 1:20

PLATE 89

20

rosettes or concentric circles and kneeling winged genies holding pinecones. Registers below include two rows of alternating rosettes or concentric circles and winged genies, and a central register with alternating cushion-shaped motifs with central concentric circles (imitating wall plaques) and blue bulls. Borders and spaces between registers consist of repeating lotus and bud motifs and small concentric circles. The main colors used in the restoration are based on excavated fragments of painted plaster: blue and red, with white serving as a background and black for outlines. Standing below, providing a sense of scale, are two male figures in Assyrian courtly dress. Their juxtaposition and gestures seem reminiscent of Layard's famous and fanciful restoration of an Assyrian palace throne room (Layard 1853a, pl. 2).

The restoration is based on an approximately 2.5 x 3.5 meter section of painted plaster that had collapsed face-down into Room 12 of Residence K. Although this had preserved large intact areas of the decoration, there were significant difficulties in excavating and retrieving details of the scene due to the fragility of the painted plaster and impact of the elements during excavation (Loud and Altman 1938, pp. 48, 83–86). The paint adhered to accumulated debris on the floor beneath making it easier to excavate "from the back" by removing the mud plaster and tracing the designs as they

appeared (in reverse) through a white lime-washed surface. From the intact parts, the excavators calculated an original height of thirteen meters (42 feet) for the restored scene and a minimum ceiling height of fourteen meters (ibid., pp. 20, 83). The brilliant red and blue frieze probably extended around the entire room (circumference ca. 80 meters).

Altman's restoration was possible due to the repetitive nature of the patchily preserved original motifs, with significant elements based upon a comparative assessment of "unimaginative and unvarying conventions" of Assyrian art (Loud and Altman 1938, p. 35). To the credit of the excavators, the original publication makes a clear distinction between "recovery" and "restoration" (fig. C20.1). Despite this, scholars are often drawn to Altman's confident and pragmatic restoration rather than the original line drawings and photographs. Problematically, some have used specific features of the restoration as points of comparison for motifs and scenes found elsewhere in Mesopotamian or Assyrian art.

The central scene showing the three figures was quite poorly preserved (fig. C20.2). The upper body of the raised figure was missing, leaving the platform (rather than a headdress) as the main signifier of divine status. Facial features and jewelry were not preserved and details of dress, hair, and

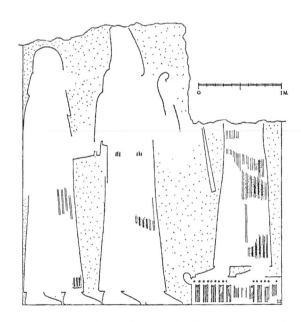
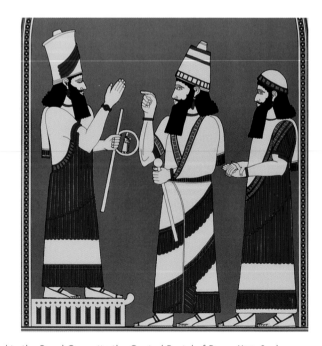

FIGURE C20.2. Before and After. Left: "Existing Remains of the Heroic-Sized Triad in the Panel Opposite the Central Portal of Room K 12. Scale, 1:30" (Loud and Altman 1938, fig. 12); right: enlarged section of the restoration for comparison (Loud and Altman 1938, pl. 89)

FIGURE C20.3. "Evolution of the Restoration of the Winged Kneeling Figure Repeated on the Walls of Room K 12" (Loud and Altman 1938, fig. 11)

beards were reduced to outlines. Altman used winged genies in other parts of the painting as a guide to restore the figures, assuming that an artist would wish to have consistency in detail and color. It is likely, however, based on paintings and reliefs elsewhere (Guralnick 2004), that costume details of the three figures were more highly elaborated. The rod and ring held by the god in the restored version is based on Assyrian conventions and is only preserved as a partial rod in the original drawing. The ring and figure of the small king restored inside it is speculative; yet this detail has been discussed as a feature for comparison with images elsewhere in Assyrian art (Boehmer 1975, p. 47, cited in Ornan 2007, p. 166 n. 5). Altman was not tempted to include divine symbols within the space above the figures. Henri Frankfort later suggested these were likely to have been present in the original scene (1996, pp. 171, 230).

The border was traced vertically only as high as the central figure, and no trace of an arch was actually found. The arch was inferred from the ornamental nature of Room 12, which the excavators assumed would have best been viewed from the courtyard through a monumental vaulted arch rather than a lintel-covered doorway (Loud and Altman 1938, pp. 24–25). This aesthetic interpretation was made despite the lack of preserved architecture in upper levels (walls were preserved little more than 3 meters in height), and greater preserved evidence for lintels at Khorsabad in contrast to vaulted portals.

There were also challenges in the restoration of the repeated and alternating motifs. No single intact example of the kneeling winged genies was preserved in the original. Each was built up from a composite of several fragmentary examples (fig. C20.3). Loud's diary illustrated the difficulties and gradual nature of the interpretation of these

figures: "What for days has seemed an elusive bird now grows more and more like a winged figure very similar to our genii in the citadel gate of last season" (Loud and Altman 1938, pp. 84).

The bulls featured in the restoration were recorded as "either bulls or horses" during their excavation.[1] In the final report they were described as animal forms "not of any evident species" (Loud and Altman 1938, p. 84). No original trace of the animal forms was reproduced in the final report. Altman may have drawn upon known bull images from sites such as Til Barsip when restoring the animals. Pauline Albenda remarks upon the stylized restoration of the Khorsabad Residence K bulls in comparison with bull images at other sites, including Til Barsip (2005, p. 53).

In summary, the most important aspects of Charles Altman's restoration will stand the test of time: its scale and monumentality, the vibrancy of colors, and the likelihood that such paintings were more common on upper sections of walls in ancient Assyria, particularly within elite residences. It is clear that some motifs and features of the restoration, if taken literally, could lead to future misinterpretation. One wonders, however, if Altman had been more cautious in his restoration would this painting be as well known today? JG

NOTE

[1] Gordon Loud's Khorsabad Expedition Day Book, November 26, 1934. Oriental Institute Museum Archives.

PUBLISHED (ORIGINAL)

Loud and Altman 1938, pl. 89

REPUBLISHED (SELECTED)

Albenda 2005: 86–89, pls. 32–33; Frankfort 1996, pp. 156, 170–71, figs. 181, 196; Guralnick 2010, p. 791, fig. 10; Orthmann 1975, pl. 22; Winter 2010, p. 172 n. 35, fig. 6

21. RECONSTRUCTION OF A DOORWAY AT MEDINET HABU, EGYPT, AND TILES FROM DECORATED DOORWAY

a. Robert Martindale, ca. 1951
Digital print
60 x 40 cm
Collection of the Oriental Institute

Tiles from decorated doorway
Faience
New Kingdom, reign of Ramesses III, ca. 1184–1153 BC
Egypt, Medinet Habu, excavated by the Oriental Institute, 1929 and 1931

b. OIM E15502: H: 7.6; W: 4.8 cm
Oriental Institute digital image D. 17480

c. OIM E15504: H: 3.8; W:5.0 cm
Oriental Institute digital image D. 17481

d. OIM E15488: H: 6.3; W: 3.8 cm
Oriental Institute digital image D. 17482

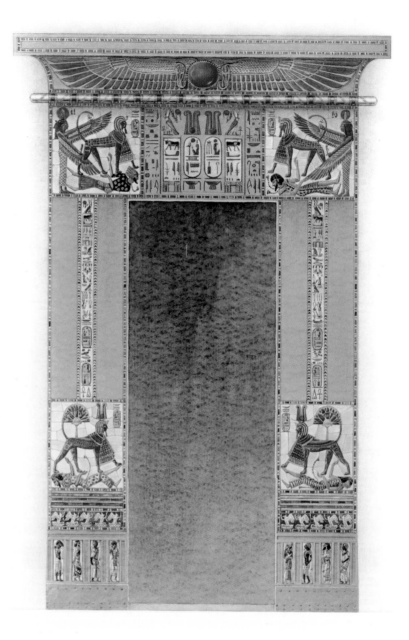

21a

21b

21c

21d

The Oriental Institute's study of the architecture and decoration of the temples at Medinet Habu in western Thebes was directed by Uvo Hölscher, a German architectural historian and archaeologist (see also Catalog No. 14 and fig. 3.3 in Chapter 3). The documentation of the temple complex of Ramesses III was especially complicated because its plan and decoration were altered numerous times during the lifetime of Ramesses and over the next 800 years.

Virtually every surface of the temple was covered with carved and painted reliefs and inscriptions, and some doors and walls were further ornamented with painted gesso, tile, faience, and pigment inlay, and thin metal overlays. Hölscher's background in architecture made him especially suited to study and document the decorative program of the temple.

This reconstruction of a sandstone doorway from the first court to the "palace" illustrates some of the challenges he faced. In its original decorative scheme, the doorjambs were covered with deeply cut painted hieroglyphs. Later in the king's reign, the jambs were recarved to accept inlay. Traces of both schemes of ornamentation were visible, making it difficult to differentiate one stage from the other.

Recesses in the sandstone (fig. C21.1) indicated that much of the later decoration was in the form of faience tiles. But a major difficulty in producing a reconstruction was determining what tiles decorated the door and in what arrangement, especially on the doorjambs. Tiles had been recovered at Medinet Habu since the early years of the twentieth century, and Hölscher and his team recovered many more fragments from all over the site. His reconstruction incorporated tiles from the immediate area of the doors as well as from those "found in various places," mostly from rubbish heaps at the temple.

It was helpful that three doors in the first court bore essentially the same motifs, and so Hölscher combined the best-preserved features of each to make a composite that was recorded as a watercolor by expedition artist Robert Martindale. The

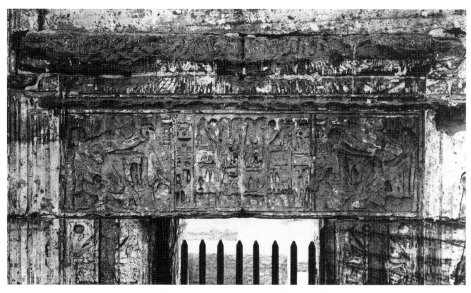

FIGURE C21.1. The doorway lintel with its carved recesses for tile inlay (Hölscher 1951, pl. 28b)

elaborate tile decoration shown in this watercolor proclaimed the power of the king, who is shown in the guise of a sphinx trampling his enemies. The bottom of the door bears a band of *rekhyet* birds (the hieroglyph for "common people"), who raise their hands in adoration of the name of the king. Below the birds are larger-scale representations of the foreign enemies of Egypt with their hands manacled or their arms bound behind their backs.

Hölscher commented on the uncertainty of the reconstruction, writing, "the narrower, middle strip consisted of tiles apparently with hieroglyphic inscriptions …" (1951, p. 42) and that the position of the tiles of the *rekhyet* birds was speculative. The publication of the tile decoration was illustrated with numerous black-and-white technical drawings (Hölscher 1951, pp. 38–41), but the colored watercolor of the composite reconstruction most clearly and emphatically conveys the grandeur of the approximate appearance of the doorway, even if it is a composite.

The example of tiles here represents sections of kilts of the bound prisoners (E15502, E15504) and the head and wing of a *rekhyet* bird (E15488). None of these fragments was recovered near the location of the doors. ET

PUBLISHED

Door reconstruction: Hölscher 1951, pl. 5
OIM E15502: Hölscher 1951, p. 43, pl. 34k
OIM E15504: Hölscher 1951, p. 43 (34o), pl. 34o
OIM E15488: unpublished

RECONSTRUCTING THE PAST FROM FRAGMENTS

The form and function of statues and architectural elements can be reconstructed from small fragments of the original. The pieces of the puzzle can consist of fragmentary archaeological remains or better-preserved statues or structures at different sites. But in some cases, so few clues remain, that educated guesswork must be used to make the subject understandable. Occasionally, incorrect assumptions about appearance, symbolism, or function have led to reconstructions that are misleading or simply wrong. Luckily, these misunderstandings are often corrected by further scholarship.

22. CLAY BALL AND RECONSTRUCTION OF A
 SEIGE GARRISON FROM CHOGHA MISH, IRAN

a. Token ball with seal impression
 Clay
 Iran, Chogha Mish, ca. 3400 BC
 D. (max.): 4.8 cm
 Excavated by the Oriental Institute
 ChM III-760
 Drawing by Abbas Alizadeh
 Oriental Institute digital image D. 17483

b. Farzin Rezaeian, 2007
 Computer reconstruction

22a

Increasingly, archaeological data and computer renderings are used together to reconstruct buildings and even entire sites.

In archaeological mounds, the foundation of buildings are usually preserved only up to a few centimeters. In rare cases, such as when a fire and/or an earthquake has destroyed a village or town causing the inhabitants to move to another site, buildings may be preserved much better, making it easier to understand and visualize their original appearance.

The building in this computer reconstruction by Farzin Rezaeian in collaboration with Abbas Alizadeh is based on traces of archaeological foundations at the site of Chogha Mish ("Mound of Ewe") when it was a major urban center in southwestern Iran around 3400 BC. The foundations were preserved to about thirty centimeters from the ground and recesses in the outer walls were also preserved, giving the basic dimensions of the structure and details of its exterior walls. The stepped and niched upper sections were reconstructed on the basis of a seal impression on a clay token ball also excavated at Chogha Mish. Such seal impressions were used to

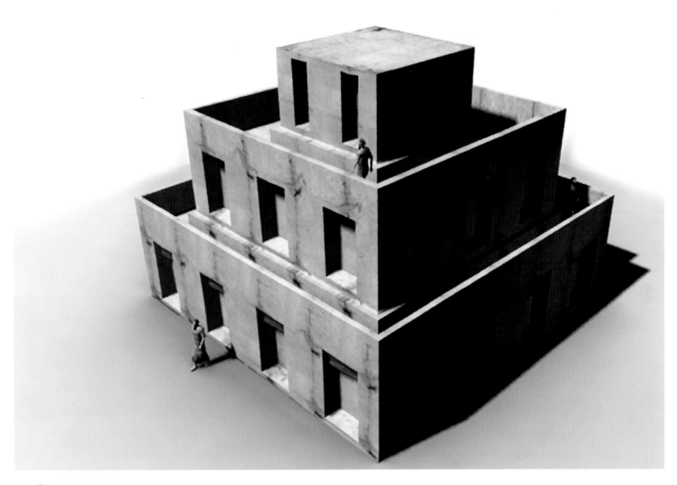

22b

authenticate administrative documents and to prevent tampering of goods. A large number of different buildings, including temples, granaries, storehouses, workshops, and regular houses, are depicted on cylinder seals from Chogha Mish. Joined with archaeological evidence, these seal impressions provide rich documentation for the reconstruction of local architecture.

The seal impression that was used to reconstruct the building was found on a clay ball that contained numerical tokens. The seal impression (see 22a) depicts what seems to be a garrison that is attacked and being defended. AA

PUBLISHED

Delougaz and Kantor 1996, pl. 151c; Rezaeian 2007, p. 22

23. ARCHAEOLOGICAL PLAN AND RECONSTRUCTION OF A TEMPLE/PALACE AT CHOGHA MISH, IRAN

a. Abbas Alizadeh, 2008
 Archaeological plan

b. Farzin Rezaeian, 2007
 Computer reconstruction

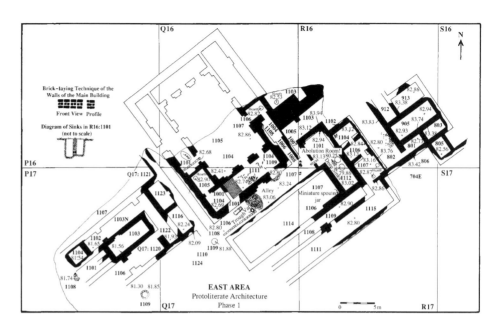

23a

This elaborate and detailed computer reconstruction of a 5,400-year-old temple or palace is based on archaeological remains. In 1977, Oriental Institute excavators recovered the almost complete plan of this monumental building with niches around its outer wall. The floor plan was further restored from the building's similarity to other known, but better preserved, Mesopotamian temple-palaces. Examples of clay cones whose flat ends were of various colors were recovered from the site. The pattern in which they were inserted into the mudbrick facade is based on the decoration of other contemporary structures. In the foreground is a reconstruction of a covered sewer channel that was found intact during the excavations. This channel led the sewage from the interior building to a deep well outside of the complex. AA

PUBLISHED

Plan: Alizadeh 2008, fig. 16
Reconstruction: Rezaeian 2007, p. 24

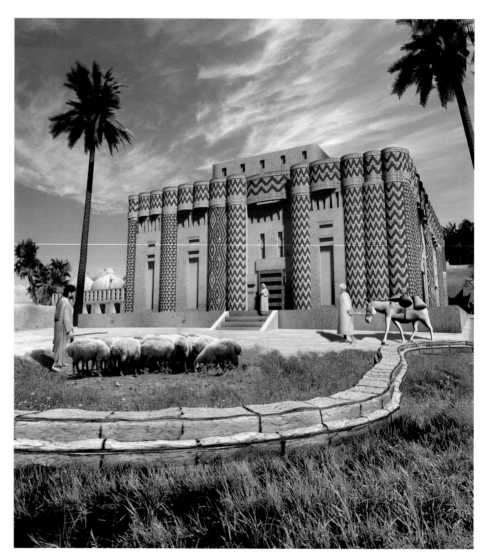

23b

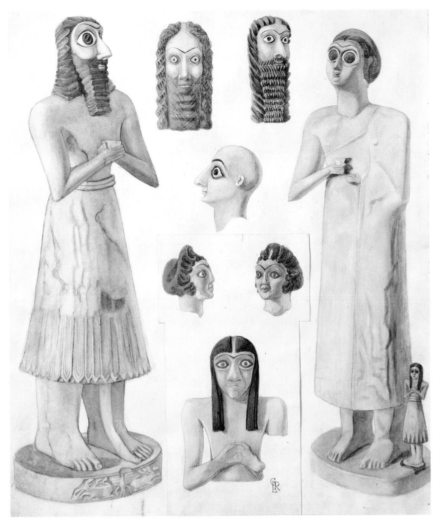

24a

24b

24. RECONSTRUCTION OF STATUES AND STATUE FROM TELL ASMAR, IRAQ

a. G. Rachel Levy, ca. 1939
 Watercolor
 38.5 x 32.5 cm
 Collection of the Oriental Institute
 Oriental Institute digital image D. 17485

b. Standing male figure
 Gypsum, shell
 Early Dynastic period, ca. 2900–2600 BC
 Iraq, Tell Asmar, Abu Temple sculpture hoard
 Excavated by the Oriental Institute, 1933–1934
 H: 55 cm
 OIM A12331
 Oriental Institute digital image D. 17486

According to a publication announcement, this color frontispiece from Henri Frankfort's *Sculpture of the Third Millennium B.C. from Tell Asmar and Khafājah* (1939) was intended to convey "in a remarkable degree the impression received when viewing the statues in favorable light." The Early Dynastic statues reproduced in the watercolor likely were chosen for their state of preservation, especially the traces of color and the use of composite materials. For example, the male head on the upper left has eyeballs made of yellow-orange paste, and the female head at the center has a strip of mother-of-pearl inlaid into the part of the hair; the hair itself is modeled in bitumen at the back of the head. In some instances, the heads belong to complete statues but they have been excerpted for this collage. In addition to evoking the original state of the statues, other reconstructions in

the watercolor supported the excavators' own interpretations of the statues.

All the statues depicted in the watercolor are from the Abu Temple at Tell Asmar. Many of them are from the famous sculpture hoard comprised of twelve well-preserved statues (cf. Frankfort 1935, fig. 12). Upon excavation in 1934, the largest male and female figures in the hoard — reproduced at the left and the right of the watercolor — were considered to represent deities. The fragmentary feet and base of a small figure set into the base of the standing female figure were understood as a clue to her identity. In the watercolor, the small figure was reconstructed as a long-haired, beardless, standing male figure, indicating that he was a youth. This combination of a female deity and a child seemingly confirmed the purely conjectural identification of the female figure as a mother goddess. That a smaller statue had been set into the base of the standing female figure is indeed unusual. However, there are no examples of children represented in Early Dynastic temple sculpture making this reconstruction dubious. Moreover, the concept of a universal "mother goddess" is no longer considered appropriate, particularly for the Early Dynastic period.

Henri Frankfort, director of the Iraq Expedition of the Oriental Institute, was the author of Sculpture as well as an additional volume aptly entitled More Sculpture from the Diyala Region (1943). His publication plans for the Diyala sculpture were tailored to its aesthetic qualities. While still in the field, Frankfort wrote to James Henry Breasted, director of the Oriental Institute, proposing a lavishly illustrated volume that would "put our finds into the hands of the increasing number of people who are keen on oriental art." Comprised of "the merest outline of the ruins in which the statuary was found," the text would instead focus on "the interest of the sculpture in the history of art." Breasted approved these plans, observing that "works of art are so buried in our usual publications of field results that they are often lost or very much obscured when sought for by people interested in the higher aspects of ancient life."

The statues from the Abu Temple sculpture hoard are representative of what Frankfort described as an earlier sculpture style, characterized by the abstraction of corporeal forms into geometric shapes. According to Frankfort's conception of this sculpture style, "the human body is ruthlessly reduced to abstract plastic form." Clarity of form is key. The result is a series of "bold simplifications which approximate, in a varying degree, the ultimate limit, namely purely geometrical bodies" (Franfort 1939, p. 19).

While aesthetic analysis had formed part of the reception of Sumerian sculpture ever since the first examples were discovered in the nineteenth century, it had been overshadowed by the belief that sculpture could provide ethnographic data regarding the Sumerians. In the early twentieth century an aesthetic reception of Sumerian sculpture was, however, increasingly favored. Frankfort definitively reoriented the study of Sumerian sculpture to art-historical methodologies. It was also Frankfort who established the Early Dynastic chronology, which relied upon the distinction between an earlier abstract and a later realistic sculpture style. It therefore is primarily Frankfort's treatment of Early Dynastic sculpture to which we still respond today.

Upon its discovery in 1934, the Abu Temple sculpture hoard made such a great impression because it was considered not only the oldest monumental stone sculpture in Mesopotamia, but in world art history. However, subsequent excavations disproved this. In addition, temple statues conforming to Frankfort's earlier abstract style have been excavated in contexts dating as late as the end of the Early Dynastic period. Rather than a developmental stage preceding realism, abstraction in its various manifestations seems to have been an important visual quality of temple sculpture throughout the Early Dynastic period. JME

PUBLISHED

Watercolor: Frankfort 1939, frontispiece
A12331 (selected): Frankfort 1935, pp. 55–56, fig. 63; Frankfort 1939, pp. 3, 20, 23, 25, 31, 38, 40, 52, 56, no. 4; pls. 6b, 9, 10, 12b, e, 13e; Frankfort 1943, p. 23, no. 4, pls. 85–85

25. LUSTERWARE JUG FROM RAYY, IRAN

Artist unknown, ca. 1936
Watercolor
63 x 48 cm
OIM RH 4759
Oriental Institute digital image D. 17487

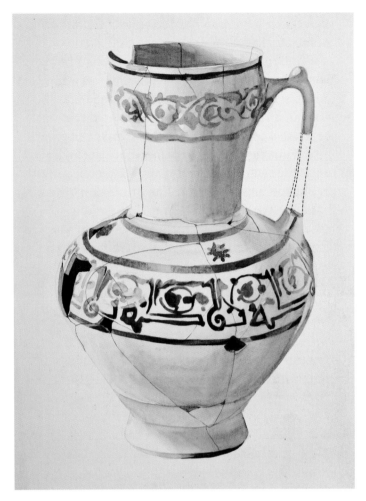

25

From 1934 to 1936, Erich Schmidt led an Oriental Institute expedition to the medieval city of Rayy, now a suburb of Tehran, the capital of Iran. At the same time, he worked at Persepolis and found magnificent artwork in the remains of both cities. While sculptures and artifacts from Persepolis are very well known and have been part of the displays at the Oriental Institute Museum from the 1930s, the results from Rayy have been largely overlooked. Schmidt actively worked on the Persepolis publications and by the end of his life had reached the final volume on Istakhr, an Islamic town near Persepolis. The publication of Rayy was delayed, and both the records and objects were divided among the supporting institutions and even individual patrons. Schmidt was extremely conscientious in making a complete record of all the artifacts obtained during these excavations before this dispersal.

Making a collection of potsherds from archaeological sites is a common activity for the archaeologist; these artifacts serve as the primary source for dating and function. They also document interactions with other sites and cultures. Schmidt was aware of these functions, but the beautiful glazed pieces from Rayy held other attractions. Schmidt's constant friend and mentor was Arthur Upham Pope, the "dean" of Iranian art, both ancient and medieval. Pope visited the site of Rayy and made extensive collections of sherds in the 1930s, hoping to find wasters (spoiled kiln products) that would prove that imitations of Chinese porcelain were being made at the site. He made large collections of complete Persian bowls and other ceramics, which were then sold to museums and collectors in Philadelphia, Boston, and Chicago.

Schmidt's excavations at Rayy were typical in recovering only the rare complete vessel. Needing to record the beautifully decorated fragments, Schmidt employed artists to make watercolor copies

because color photography was then a difficult and expensive process. To accurately record the colors of the glazes he made a color chart consisting of color patches (fig. C25.1).

The painting shown here is a typical rendering that depicts a juglet made of fritware with luster glaze decoration. The form is quite typical for Rayy. The bands of decoration feature a floriated Kufic inscription invoking blessings on the user. Schmidt's artist used the watercolor in a more subtle manner: here is a beautiful juglet that was broken and is missing pieces. The artist has reconstructed the vessel as it once existed, emphasizing both its archaeological origin and its original, unique aesthetic qualities. Thus the

watercolor depiction illustrates both Islamic art and Islamic archaeology at the same time.

The irony is that although there was a field number on the original juglet, we may now have only the painting. Schmidt once claimed that he was not a curator; he famously declared that once he made a complete, scientific record of an object, he did not care what happened to it. The juglet might be found in the extensive Rayy collections in Philadelphia or Boston (the Oriental Institute has only its sherd collection). The carefully accomplished painting records enough for modern scholarship. For instance, Tanya Treptow was able to find pieces of the same style (OIM A115014) in her recent study of the Rayy excavations (Treptow 2007, p. 52). She identifies the vessel with the Syrian tradition of luster ceramics in northern Iran during the eleventh century. The watercolor provided her with enough information to identify a relationship to Fatimid ceramics in Egypt and the relation of the inscription to the "monumental" style of epigraphy on medieval buildings. The humble watercolor is, as Schmidt intended, a record for future detailed study and a window on past lifetimes. DW

PUBLISHED

Treptow 2007, p. 52

FIGURE C25.1. Color chart developed by Schmidt's artists to accurately record the color of glazes (Oriental Institute digital image D. 17488)

PHOTOGRAPHY

Photography is an essential tool of documentation, allowing for rapid recording and easy dissemination for publications. Archaeologists have been quick to adopt new developments, from early stereo and 3-D technology and low- and high-altitude aerial photography to more recent advances in digital imaging. Photography plays an increasingly important role in stimulating interest in and support for research.

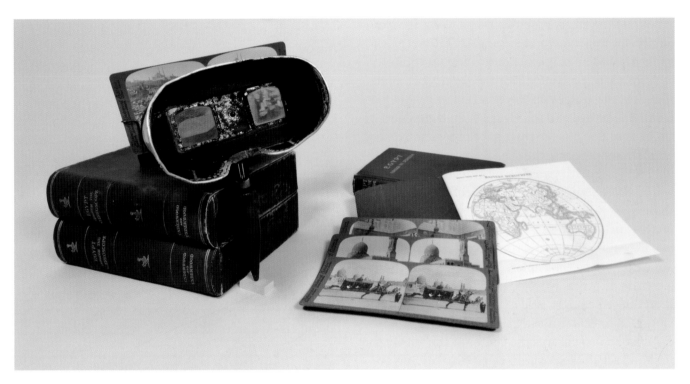

26

26. MONARCH STEREOSCOPE VIEWER,
 STEREOGRAPH CARDS, AND BOOK

Monarch Stereoscope Viewer
Manufactured by the Keystone View Company,
patented 1904
Collection of the Oriental Institute
Oriental Institute digital image D. 17489

Egypt through the Stereoscope: A Journey through the Land of the Pharaohs. Text by James Henry Breasted.
Underwood & Underwood, 1905

This Monarch model stereoscope viewer was made by the Keystone View Company of Meadville, Pennsylvania. The handle folds up to rest under the wooden bar that separates the faceplate and lenses from the stereograph cards. Stands were also available that would allow the stereoscope to rest upright so that one was not required to continually hold it as they looked at stereograph cards. Although this model was patented in the early 1900s, the stereoscope had been in existence since 1838, a year before the daguerreotype was introduced (Taft 1938, p. 170). This type of

stereoscope was invented by Oliver Wendell Holmes in 1859, and its portability led to it eventually becoming the dominant type of stereoscopic viewer used for entertainment and educational purposes. The term "stereograph" was also coined by Holmes in his seminal essay on the subject, "The Stereoscope and the Stereograph," published in the *Atlantic Monthly* (Holmes 1859). Cards did not become widely produced and so did not reach the level of worldwide popularity that they would eventually reach, until the albumen and collodion, or wet, processes came into wide use in the 1850s.

While the stereoscope appears to be a simple object of a bygone era, it is based on fairly sophisticated principles of optics and was quite technologically advanced for the time. Much of its functionality hinges on the different angle of view from the left eye and the right eye to the subject of the image. The images themselves could be created with a camera specifically made for stereoscopic photography, with two side-by-side lenses that would allow simultaneous exposure. But one of these cameras was not necessary, especially for images such as landscapes. Using a normal camera, two exposures are made, the second of which is done by shifting the camera to the left or right by a certain distance, with care being taken to keep it on the same horizontal axis. The amount of stereoscopic effect is directly proportional to the distance that separates the center of the lens in the first and second exposures, relative to the subject (Johnson 1909, p. 13). These two images are later printed side by side on a stiff card that could be set into a stereoscope viewer.

In order to create a 3-D, or stereo, image, the lenses of the stereoscope viewer are set apart at a distance of 2.5 inches, which was believed to be the distance between the pupils of the average person (Kingslake 1992, p. 227). The lenses themselves are magnifying lenses, the thickness and curvature of which determine the amount of refraction, or degree of displacement, which in turn affects the manner in which the two images are joined into a singular stereo image (Brewster 1856, pp. 73–75). The process was perhaps best described by Oliver Wendell Holmes:

> Cut a convex lens through the middle, grind the curves of the two halves down to straight lines, and join them by their thin edges. This is a squint-

ing magnifier, and if arranged so that with its right half we see the right picture on the slide, and with its left half the left picture, it squints them both inward so that they run together and form a single picture (Holmes 1859).

In order for this technology to be brought to the masses, all these optical factors needed to be understood, and the photographic and printing processes had to be advanced to a point that the cards could be easily duplicated in large quantities. But once all these things came together, stereoscopes and stereograph cards became extremely popular from the middle of the 1800s through to the early decades of the 1900s.

The stereoscope and stereograph cards quickly became so popular that by 1858 one company, the London Stereoscopic Company, had over 100,000 stereograph cards available for purchase. They sold over 500,000 stereoscopes (Malin 2007, p. 405) with an advertising slogan "No Home Without a Stereoscope" (Wells 1997, p. 128). Its popularity declined slightly in the 1870s as new photographic processes were popularized, but the stereoscope remained a form of entertainment to the turn of the century. Stereoscopes again increased in popularity when the two main American manufacturers of stereoscopes, the Keystone View Company and Underwood & Underwood, began to market their products as a method of teaching geography and as developing one's "citizenship." This was to be accomplished by touring the country, as well as the world, through the sets of stereograph cards and accompanying books that they both published. Travel had become an important part of personal development, but most long-distance travel, especially for recreation, was still out of reach for most Americans (Malin 2007, pp. 404, 410). By touring through stereoscope, Americans were assured by the stereoscope companies that they could bypass the expense of traveling and simply study the stereoscopic materials these companies had for sale.

The belief that stereoscopic images had the power to transcend the physical distance between the viewer and the subject was so great that Oliver Wendell Holmes claimed: "Form is henceforth divorced from matter. In fact, matter as a visible object is of no great use any longer, except as the mould on which form is shaped. Give us a few

negatives of a thing worth seeing, taken from different points of view, and that is all we want of it. Pull it down or burn it up, if you please" (Holmes 1859). Photographers were sent out across the country and around the world to photograph foreign lands and people unseen by Americans. Experts were hired to annotate the resulting stereograph cards. Often these annotations took the form of accompanying books sold with the cards. Frequently, the authors' cultural biases were conveyed alongside the stereographs: "These tour guides' reverence for the beauty and historical importance of their respective countries is matched only by their revilement of the people currently occupying these lands" (Malin 2007, p. 414). These books about faraway lands and foreign peoples often were written by anthropologists, at a time when cultural anthropology was changing:

> By the time the social sciences were standardized in degree-granting departments, non-Western areas and peoples were thought to be fundamentally different both in essence and in practice. They could not be known through the same scientific procedures or subjected to the same rules of management. At the same time, the desire to know and manage them had increased.
>
> It is in that context that cultural anthropology became, almost by default, a discipline aimed at exposing the people of the North Atlantic to the lives and mores of the Other. Anthropology came to fill "the Savage slot" of a larger thematic field, performing a role played, in different ways, by literature and travel accounts — and at times, by unexpected media (Trouillot 2003, p. 19).

Because so many copies of these books were sold, the images and the content of the annotations had considerable influence over the opinions Americans formed of the peoples and lands described.

The photograph here shows the set of one hundred numbered stereograph cards, a book of maps, and the accompanying book, *Egypt through the Stereoscope: A Journey through the Land of the Pharaohs*, written by Oriental Institute founder James Henry Breasted, published by Underwood & Underwood in 1905. A person could insert a stereograph into

the stereoscope to inspect the image. He or she could then flip to the page in Breasted's book that had text that corresponded to the stereograph. The viewer could check the location of the scenes by referring to the book of maps included in the set. In this way, they were told they could become better citizens of the world by becoming acquainted with the people and the lands of Egypt. For example, if the viewer were to choose to place card number nine into their stereoscope, they would be presented with a view entitled "The harem windows in the court of a wealthy Cairene's house." This card has the trunk of a large tree in the foreground. There are half a dozen men, a boy, and what appears to be a goat standing the yard. Above them, in the background, is a *mashribiya* (decorative wood lattice) screened porch. The text that addresses the titled subject of the stereograph describes it:

> The elaborately carved windows are those of the harem, and there the ladies of the house spend their time listlessly lounging and rarely going out for an airing. They lead the most uninteresting of lives, possess no culture or next to none, and by the men of their own race are given an exceedingly bad character, probably worse than they actually deserve (Breasted 1905, p. 84).

The Keystone View Company purchased the stereograph collections of publishers Underwood & Underwood in 1920 (Malin 2007, p. 405). While the stereoscope continued to be a form of entertainment and education, it eventually fell out of favor. The enthusiasm for stereo images shifted to the View-Master, introduced in 1939 at the New York World's Fair,[1] and later in the 1950s to stereo 35mm film cameras. AR

NOTE

[1] Wikipedia entry on the View-Master: http://en.wikipedia.org/wiki/View-Master.

PUBLISHED

J. H. Breasted 1905, http://oi.uchicago.edu/research/pubs/catalog/misc/stereoscope.html

27

27. RB CYCLE GRAPHIC CAMERA

Manufactured by Folmer & Schwing Manufacturing Co.,
New York, ca. 1910
Serial number 13399
Lens: Graphic Rapid Rectilinear 4x5, serial number 3252,
manufactured by "Eastman Kodak Co., Succ'rs to The
Folmer & Schwing Co."
Collection of the Oriental Institute
Oriental Institute digital image D. 17490

The RB Cycle Graphic is a large-format field, or flat-bed, camera. This particular model, owned by James Henry Breasted, accepts the 4″ x 5″ size of sheet film and was manufactured from 1900 through 1921. A field camera has most of the advantages of other forms of the large-format camera but it folds into a box when not in use. Its portability made the field camera ideal for photographing outside of the studio and was a popular choice for landscape and architectural photographers, as well as explorers like James Henry Breasted.

This camera was manufactured by the Folmer & Schwing Division of the Eastman Kodak Company in Rochester, New York. Folmer & Schwing was purchased by Kodak in 1905 and moved to Rochester that year; previously they manufactured their

cameras in New York City. Even though Folmer & Schwing was bought by Kodak in 1905, they operated as a separate company until 1907, when they became a division of Eastman Kodak.[1] This camera, with the serial number 13399, was probably one of the earlier cameras to be manufactured after Folmer & Schwing became a division of Kodak, as the last serial number is thought to be either 96033 or 113431 (the serial number for a special model built in 1920).[2]

Despite the fact that a field camera is a more portable model of a large-format, or view, camera, it is nowhere near as convenient as modern 35mm film or digital cameras. This camera model accepted plate glass negatives and sheet film. Breasted's camera case has six filmpack holders, each of which holds two sheets of film, which is only twelve exposures total. In order to have more film ready, the photographer would have had to carry another light-sealed box of filmpack holders loaded ahead of time, either in absolute darkness or in a lightproof bag. And in both scenarios, the person's hands must load the film holders without the aid of sight.

Once the photographer is ready to create a photograph, the camera must be attached to a tripod and leveled as best as possible. The bellows, which are made of fabric and are the most at risk of damage besides the glass on the camera, must be extended to the proper distance. Then the camera must be adjusted to get the desired focus, which would involve using the different knobs on the camera to change the orientation of the lens to the surface of the film back (the film itself will be inserted last). The image is projected onto a piece of ground glass in the same location where the film will be during exposure. A large dark cloth is placed over the body of the camera and the photographer's head and torso in order to block out light so that the image projected onto the glass may be seen clearly. Outdoors, in the desert, this would have been extremely uncomfortable although a white cloth can be sewn to the outside of the dark cloth to reflect some of the heat from the sun. This could reduce the temperature inside the dark cloth by a few degrees.

Once the focus is set, the correct exposure is calculated according to the length of the bellows as well as the ranges of light and dark areas in the scene to be photographed, and the length of lens used. All of this goes into account to determine the aperture setting (the size of the shutter, how much light is let in through the shutter) and the shutter speed (the amount of time the shutter is opened to allow light to pass through to the film). These settings are also needed later to determine the development time of the negative. The film is then inserted into the back of the camera, again under the dark cloth to keep out any stray light. Only after all of this was done would the shutter be opened to expose the sheet of film.

The film would either have been developed in the field on a dig or possibly in the house or hotel where Breasted was staying while traveling because the longer exposed film goes without being developed, especially in heat, the more likely it is to be damaged. Breasted noted that during the 1905–1907 Nubia expedition, the glass plate negatives were taken to the Nile to be developed to verify the results before moving the camera set-up. Developing the film would require a dark room, or light-sealed tent, multiple chemicals to be mixed up, plenty of water, non-reactive metal trays, tongs, and a lot of time. As dust is every photographer's enemy — sand even more so because it will insinuate itself into the smallest of spaces and damage otherwise smooth-moving mechanisms — shooting and developing large-format film in the desert, and while traveling away from home, was an extremely challenging and cumbersome venture (see Teeter, Chapter 2). AR

NOTES

[1] "Involvement of the Flemmang Camera Company in the Manufacture of Cameras for Folmer & Schwing," by Rodger Digilio. *Graflex Historic Quarterly* 15/1 (2010): 2.

[2] George Eastman House Information File — Technology Collection. Object Identifier F6687.00011. http://www.geh.org/fm/mees/htmlsrc/mF668700011_ful.html.

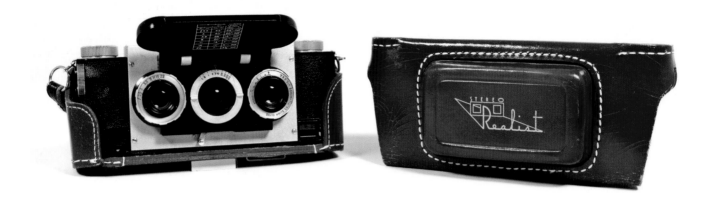

28

28. STEREO REALIST 3-D CAMERA

Manufactured by David White Company,
Milwaukee, Wisconsin
Model 1041, Serial Number A27284 Model 1041, Serial
Number A27284
Gift of Charles F. Nims
Collection of the Oriental Institute
Oriental Institute digital image D. 17491

This Stereo Realist camera, manufactured by the David White Company, is the 1041 model, which came with two side-by-side f3.5 lenses. The dual lens design of the camera meant that two nearly identical images could be recorded to the film at the same time, allowing even amateur photographers to capture images that could later be set into slides that would produce a 3-D image when looked at through a stereoscope slide viewer. The lenses are separated by 71 mm, with each recording an image of about 24 x 25 mm (Kingslake 1992, p. 224). By using a twenty-exposure roll of film, a photographer could record sixteen pairs of stereo images, or twenty-nine pairs on a thirty-six exposure roll of film.[1] The Stereo Realist was in production from 1947 to 1971.

While dual lens stereo cameras were manufactured in Europe for fifty years prior to the release of the Stereo Realist, those cameras were targeted at professional photographers.[2] The Stereo Realist cameras were the first 3-D 35mm cameras manufactured in the United States. While many film size formats were still in use at that time, it is significant that these cameras used the 135 format film cartridges, what is commonly referred to as 35mm film, as this is what became the standard film format for consumer cameras for many decades until digital photography overtook film-based photography in the consumer market. The Stereo Realist cameras were targeted to amateur photographers and hobbyists — specifically the segment of that market which had a good deal of disposable income. The Stereo Realist camera body and viewer cost about $178 in 1952,[3] and that didn't include the cost of slide film, film processing, having the film mounted into slides, and a 3-D slide projector. A plethora of other accessories were also available, including a leather camera bag, filter kits, filter holders, lens shades, a slide mounting kit, slide mounting supplies, instruction books on the principles of stereoscopic photography, flash attachments, and cases for mounted slides and slide viewers.

The Stereo Realist cameras were aided in popularity by both the development of 3-D movies and the introduction of the View-Master. Although

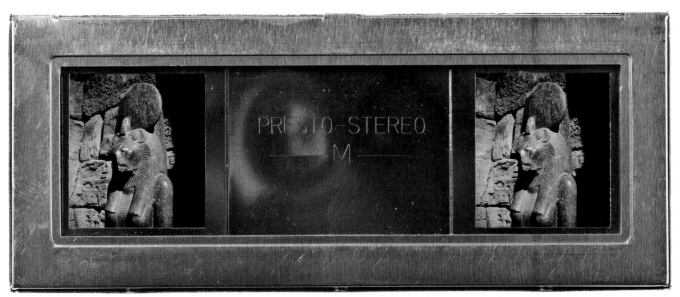

FIGURE C28.1. "Medinet Habu, Sekhmet statue." Presto-Stereo 3-D slide taken by Charles F. Nims, 4 x 10 cm (Oriental Institute digital image D. 17484)

the View-Master came to be considered a child's toy, it was originally marketed to adults, with pictures of landscapes, national parks, nature scenes, and so on. It was introduced in 1939 and steadily grew in popularity (Walsh 2005, p. 60), so that by the time the Stereo Realist camera was brought to market in 1947, the public had had eight years to grow accustomed to looking at color stereo photographs. It was more than enough time for consumers to develop the desire to create their own stereo images. The early 1950s also saw a number of 3-D movies released in theaters, which only helped to reinforce the idea of the consumption of visual media in a stereo format. Perhaps most importantly, the marketing of Stereo Realist cameras was very successful. They were shrewdly advertised with images of celebrities using the cameras (White 1995, p. 98), and they became so popular that they even enjoyed free advertising in mass media. In 1952, General Dwight D. Eisenhower was featured on the cover of *Life* magazine with a Stereo Realist hanging from his neck. The silent movie star and comedian Harold Lloyd also popularized the 3-D photographs created by Stereo Realist cameras. He published books of 3-D images of Hollywood celebrities and also presented slideshows of stereo photographs as he toured the country, earning the nickname "Mr. Stereo" (Lahue and Bailey 1972, p. 306).

The Stereo Realist cameras were in production until 1971.[4] While they did not enjoy the same level of popularity as the stereoscope, which was a cultural force in two different centuries, they did earn a loyal following of enthusiasts and hobbyists. Even today there are numerous websites dedicated to stereo photography, Stereo Realist cameras are bought and sold on eBay, and camera clubs teach each other how to cut and mount their own slides.

This camera belonged to Charles F. Nims, a professor of Egyptology at the Oriental Institute who worked on the Sakkarah Expedition (see Roth, Chapter 4) from 1934 to 1936 and for the Epigraphic Survey in Luxor (see Johnson, Chapter 3) from 1964 to 1970. He was a very accomplished photographer. His enthusiasm for the Stereo Realist camera is evident in the thousands of 3-D slides that he made of sites in Egypt and Europe. AR

NOTES

[1] Realist Stereo Instruction Manual, page 8, published by Realist Inc., A Subdivision of Davis White Instrument Company, Milwaukee, Wisconsin.

[2] "Changing Times," *Kiplinger's Personal Finance* 6/2 (February 1952): 39.

[3] Ibid., p. 39.

[4] Wikipedia http://en.wikipedia.org/wiki/Stereo_Realist #cite_note-amazing3d-35-0.

29. VIEW OF THE TREASURY
 OF THE TOMB OF
 TUTANKHAMUN

Harry Burton, ca. 1927
Ink Jet print from scan of original
Burton print
50 x 36 cm
Metropolitan Museum of Art, TAA55

29

Photography is an essential element of scientific documentation of archaeological work, but it also serves as a powerful means of communicating the excitement of discoveries to the broader public. Use of photography in archaeology was still very limited in the 1920s, and most expeditions used it sparingly. But when the Tomb of King Tutankhamun was discovered by Howard Carter and Lord Carnarvon in 1922, they immediately recognized the need for full-scale recording through photography. Harry Burton, an American photographer working for the Metropolitan Museum of Art, joined Carter from 1922 to 1933, taking more than 1,400 images that documented every step of the clearance of the tomb and its thousands of astounding objects.

Burton was trained as a fine-arts photographer and his background is evident in his artistic compositions and the carefully arranged lighting. The Tomb of Tutankhamun was a media sensation, and Burton's photos played a major role in promoting and maintaining the public's interest in the find. Carter signed an exclusive (and controversial) contract with *The Times* of London for news and photos, and those payments helped

fund his work. This added an entirely new role and significance to archaeological photography. "Tut-Mania" was further promoted by Burton's carefully posed photos of the excavators at work (fig. C29.1), introducing a new way for the public to engage with the work, making archaeology even more accessible and popular.

This view of the "Treasury" of the tomb is one of Burton's most famous images recording the chamber and its piles of objects just as they had been left 3,500 years before. It is characteristic of many of his images that fuse pure factual documentation with a keen aesthetic sense. This photograph necessitated an enormous amount of delicate preparation in lighting the scene (the carefully positioned electrical lines can be seen at the upper right of the image). Note the absence of footprints, although the chamber had been entered for an initial inspection and then again to position the lighting. The result is an incredibly dramatic and exciting image that helped to make the Tomb of King Tutankhamun one of the greatest archaeological discoveries of all times. ET

PUBLISHED (SELECTED)

Allen 2006, pp. 61, 98

FIGURE C29.1. Posed image of Howard Carter brushing the face of the second coffin of Tutankhamun. Such "behind-the-scenes" views of the excavation engaged the public with the work (Harry Burton, courtesy of the Metropolitan Museum of Art, MMA, TAA371)

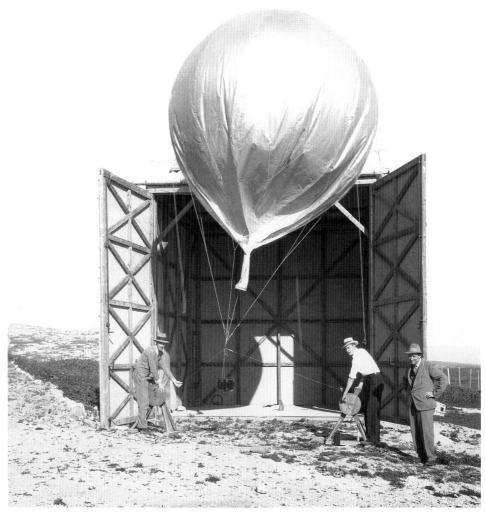

30

30. METEOROLOGICAL BALLOON WITH CAMERA ATTACHED, MEGIDDO

Olaf E. Lind, November 5, 1929
Print from glass negative
18.25 x 22.50 cm
Oriental Institute photograph P. 18637

This photograph shows a spherical meteorological balloon adapted for aerial photography by the Oriental Institute's expedition to Megiddo in Palestine (now in modern Israel). The use of a balloon for aerial photography at Megiddo was devised by Philip L. O. Guy, then field director of the Megiddo Expedition, and his assistant Robert S. Lamon, as a less costly and more efficient alternative to using an airplane for aerial photography (Guy 1932; Breasted 1933, p. 249).

The three individuals in the photograph are Robert S. Lamon (center), William E. Staples (right), and a third, unidentified figure (left). Behind them is the shed used to store the balloon when not in flight. Lamon and the third figure hold reels carrying strong cord used to control the ascent and position of the balloon and its suspended camera from any point on the mound's surface. The reel on the right also carried a copper wire connected to a battery (visible below reel). This worked the camera's electrical shutter-release from ground level once the balloon reached its desired height, which was measured from markings on the cords. The date of this photograph shows that this was the first balloon used at Megiddo, which was made from expandable rubber. It was filled with hydrogen gas imported from France. Unfortunately, this balloon burst after just a few flights (Guy 1932, p. 150). It was subsequently replaced with a balloon made from rubberized silk, which was more robust. The camera was built by Oriental Institute expedition members Olaf E. Lind (expedition photographer) and Edward L. De Loach (expedition surveyor). The electrical apparatus (ibid., p. 149, pl. 2) was made by the Department of Physics at the University of the Chicago.

The balloon reached an impressive height of over 120 meters (400 feet). This had the advantage of providing a stationary bird's-eye view (under ideal conditions). This was an improvement on their use of an extendable ladder which reached an elevation of up to ten meters. The balloon enabled top-down images of large excavated areas of the mound to be taken and reproduced at a large scale, providing an invaluable record and aid to understanding the exposed remains at the time of excavation. Tilting of the camera during flight and the slope of the ground did however lead to distortion of some photographs (Lamon and Shipton 1939, p. xxv), so these were not as accurate as ground plans. The aerial images were combined into a mosaic permitting an overview of the entire mound and its excavated areas and were also published in a series of individual images in the final report (Catalog No. 31).

Although there were precedents in Britain and Europe that inspired the Megiddo balloon (see Branting et al., Chapter 7), this was the first time balloon photography was used for archaeological purposes in the Middle East. This photograph was published in Breasted's survey of the Oriental Institute's activities, demonstrating to the wider world that the most modern and scientific techniques were employed in their expeditions to document the past (1933, p. 249, figs. 122, 124). Film footage of the balloon being operated at Megiddo can be seen in Oriental Institute's 1935 film *The Human Adventure*.

Philip Guy's instructions as set out for the Megiddo balloon equipment in the journal *Antiquity* (Guy 1932) did have some influence on aerial photography in Poland in the mid-1930s (Barford 2000, p. 55), but use of balloons appears to have fallen out of favor with Middle Eastern archaeological expeditions as more maneuverable airplanes became used for similar purposes (D. Wilson 1982). Use of unmanned balloons for archaeological photography saw a resurgence in the late 1980s, alongside other methods of low-altitude aerial photography such as kites and booms. Some examples in the Middle East include survey work in the eastern desert of Sudan (Castiglione, Castiglione, and Vercoutter 1995, pp. 59–60), Petra in Jordan (de Vries 1992), and most recently at Tel Kinrot in northern Israel (Münger, Pakkala, and Zangenberg 2009). JG

PUBLISHED (SELECTED)

J. H. Breasted 1933, fig. 122; Guy 1932, pl. 3; Oriental Institute 1931, fig. 48; Oriental Institute 1935, fig. 23; Rosenberg 2008, fig. 7 (colorized version); Teeter 2010, fig. 7.7

31

31. "AIR-MOSAIC" OF THE MOUND AT MEGIDDO

Photographer, Olaf E. Lind, 1932
Reprint from Lamon and Shipton 1939, fig. 114

This impressive mosaic of aerial images of the summit of ancient Megiddo was prepared by Olaf E. Lind, photographer of the Oriental Institute's Megiddo Expedition (1925–1939). The individual images were taken using a tethered hydrogen balloon mounted with a camera controlled from the surface of the mound (Catalog No. 30). The original mosaic (at least two were prepared) measured 1.3 meters across (Guy 1932, p. 154). It was reproduced in James Henry Breasted's survey of the Oriental Institute's activities (1933, p. 249, fig. 124, lines and annotations removed), published alongside an image of the balloon used to capture the photographs. This helped to illustrate to the wider world some of the advanced recording techniques being employed by the Oriental Institute at that time. The photograph also helped highlight one of the original aims of the Megiddo Expedition — to systematically excavate the entire surface of the mound layer by layer until virgin rock had been

FIGURE C31.1. The first aerial image captured by balloon at Megiddo. It shows the northwest corner of the tell after the removal of surface soil (Guy 1931, fig. 13, pp. 21–22; Breasted 1933, fig. 123)

(fig. C31.1). The remains shown in this photograph and also the air mosaic photo do not belong to the same strata, but from levels that spanned several centuries, although mostly belonging to the Iron Age. Areas 1 to 4 on the mound's west side largely show the uncovering of Strata III–II, which can be dated to the time of the Assyrian empire, the period of Josiah, and perhaps also into the Persian period (late eighth to fourth centuries BC). The large depression of the water system in Area 2 can also be seen on the west side of the mound. Areas 5 to 8 on the mound's east side feature mainly the walls of Strata V–IV, covering the Iron IIA–B period (tenth to eighth centuries), including parts of the casemate circuit wall (the stratum to which it belongs is still debated) and also the famously misassigned "Solomon's Stables" (Catalog No. 34).

From the excavator's perspective, the purpose of the aerial photographs was twofold. Firstly, they provided accurate and detailed records of excavated buildings, surveying points, and other features on the mound. These images are still invaluable to archaeologists as many structures were subsequently removed to expose the strata beneath. Secondly, the air-mosaic was used for checking the excavations as they progressed. Philip L. O. Guy (field director, Megiddo Expedition, 1927–1935) and his assistant Robert S. Lamon (surveyor), took the large-scale air-mosaic out onto the mound during the course of excavation, seeing it as a "very great help in disentangling one stratum from another," helping to verify wall alignments that may have been difficult to locate at surface level and comparing buildings of similar size and design separated by several hundred feet (Guy 1931, p. 21, fig. 13; 1932, p. 154). Guy recommended the projection of lantern slide images of the aerial photographs on to a screen for quiet study off-site (ibid., p. 155).

Philip Guy wrote about the plates for these aerial images: "The originals can be seen and studied by people who happen to be in Chicago, where one set will be kept, or who visit us here on the site. But I can't quite see how I am going to publish them, at their useful scale of 1:250, without producing a book or portfolio that only a son of Anak [a biblical figure of gigantic proportions] could handle" (1932, p. 155). The individual images were never published in full at this large scale,

reached (Fisher 1929, p. 9). This great scientific endeavor was clearly an impossible task, as realized in subsequent years of excavation.

In the final report, Megiddo I, *Seasons of 1925–34: Strata I–V*, this image was reproduced again followed by individual photographs of each area overlaid with a 25-meter grid (Lamon and Shipton 1939, figs. 114–23). An example of the first aerial image captured by balloon at Megiddo includes human figures, which provide an additional sense of scale

which would have resulted in an oversize folio. Instead, they were reproduced at varying scales in the standard-size final reports, ranging between 1:400 and 1:600 in scale (e.g., Lamon and Shipton 1939, figs. 115–23). Aerial images produced by the Oriental Institute were among color-tinted lantern slides intended for use in public lectures from the 1930s (fig. C31.2).

Despite the intention of aerial photography at Megiddo as a tool for disentangling complex relationships between buildings of different dates, the excavators still encountered problems when assigning buildings to particular levels. Stratigraphic methods of excavation (recording a sequence of archaeological deposits, structures, or features) were still in their infancy in the 1920s and 1930s Palestine, even for relatively experienced archaeologists such as Philip Guy (Green 2009, p. 170). Buildings tended to be dated according to pottery, scarabs, and amulets found within rooms, which were sometimes used and reused over extended periods. Large-scale open-area excavations at Megiddo involved employing large numbers of workmen (up to 200 at one time) sometimes

FIGURE C31.2. A colorized aerial image of Megiddo. Many glass lantern slides were hand-tinted by expedition participants Herbert and Helen May (courtesy of Oberlin College Library Special Collections)

moving earth at too great a speed to allow adequate or careful recording. The desire of the excavators to expose complete buildings, streets, and levels one by one, while paying less attention to stratigraphic relationships, indirectly contributed to problems with dating. The assignment of particular buildings excavated by the University of Chicago to one stratum or another (e.g., Strata V and IV) continues to be debated by archaeologists, including archaeologists from Tel Aviv University involved in present-day excavations at Megiddo. Enlarged and cropped images have been used in subsequent

publications, shedding new light on the archaeology of Megiddo (e.g., Harrison 2004). In summary, the aerial photographs were not such a reliable tool for disentangling the levels of architecture as originally envisaged, but they continue to serve as an important resource in current and future research. JG

PUBLISHED

J. H. Breasted 1933, fig. 124; Lamon and Shipton 1939, fig. 114

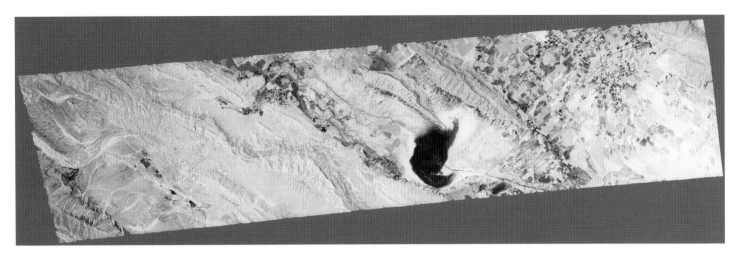

32

32. DECLASSIFIED SPY SATELLITE IMAGE

22 cm length of section shown above
77.3 x 7.0 cm length of complete section
Courtesy of the U.S. Geological Survey (USGS)

Early spy satellites put into orbit by the United States government in the late 1950s carried film cameras for taking photographs across wide areas of the landscape. The films would then be collected within the satellite and sent back to earth in a reentry capsule that would be caught in mid-air by military airplanes. These images remained highly classified until the mid-1990s, when the first of several batches were declassified and copies of them made available. This film positive is a copy of the original film from a declassified spy satellite mission that began on May 20, 1970. It includes the ancient Persian capital of Persepolis, along with a long swath of area around it in southern Iran. SB

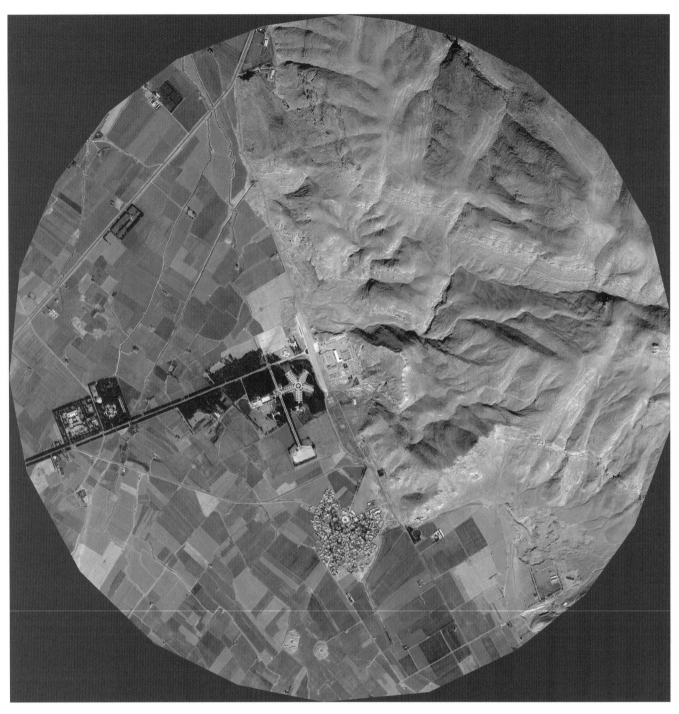

33

33. SATELLITE IMAGE OF PERSEPOLIS

Courtesy of DigitalGlobe

Today, the highest resolution satellite imagery commercially available is produced by private companies such as DigitalGlobe. This DigitalGlobe QuickBird-2 satellite image shows the ancient Persian capital of Persepolis and surrounding areas as they appeared from space on December 23, 2002. SB

MODELS AND COPIES

A three-dimensional model of a building is among the most effective means of conveying its original appearance. However, a model may present the structure with a level of confidence that obscures any uncertainty and speculation on the part of the model-maker. The long-standing tradition of presenting white casts of classical works that are made directly from a mold of the original works has generated a level of trust that they are accurate representations. Whereas copies, which are produced either freehand or through a series of measurements, should be viewed more critically.

34

34. MODEL OF "KING SOLOMON'S STABLES" AT MEGIDDO

Built by Olaf E. Lind, 1931
Architectural model, entitled "Solomon's Stable 364"
Wood, reeds (roofing), plaster, metal (door handles),
paint; plastic horses and donkey (not original)
83.5 x 55.3 x 18.0 cm (scale approximately 1:50)
OIM C469
Oriental Institute digital image D. 17492

In illustrating the past to layperson or scholar, it can be a challenge to find the most relevant supporting images to evoke a particular time or place, especially when applicable inscriptions or art images may be lacking. Yet once a modern rendering becomes convincingly connected to a historical era or figure from the past, and widely disseminated as such, it can endure well beyond

any scholarly reinterpretations. One such example is the drawing and model of the "great stables" at Megiddo, one of a group of pillared buildings excavated by the Oriental Institute in the 1920s and 1930s. The titles of the drawing, "King Solomon's Stables, Megiddo," (fig. C34.1) and the model, "Solomon's Stable 364," reflect and reinforce the strong desire of the site's excavators to link their archaeological findings with biblical history and, in particular, the golden age of King Solomon.

Philip L. O. Guy, the second field director of the Megiddo Expedition (1927–1935), first assigned the stables and the associated Stratum IV to King Solomon's reign, dating to the tenth century BC (ca. 950 BC). This interpretation was largely based on biblical passages mentioning Megiddo as one of Solomon's chariot cities (1 Kings 9:15–22; Guy 1931, pp. 44–48; cited in Finkelstein 1996, p. 178), rather than using traditional archaeological dating tools such as pottery typology and stratigraphic inquiry. According to Guy, here was a seemingly direct link between scientifically excavated evidence and a legendary figure of the Bible. "Solomon's stables" at Megiddo was to become a highlighted symbol of the United Monarchy of ancient Israel, featuring in illustrated lectures, documentary film, popular books, and as part of a permanent exhibit at the Oriental Institute of the University of Chicago. The conserved and restored remains of the stables can

still be visited today as part of the Tel Megiddo National Park in Israel, although no longer in association with the reign of Solomon.

The scale model of stable building 364 was based on L. C. Woolman's architectural drawing of the structure in plan and elevation (fig. C34.1; see also Lamon and Shipton 1939, fig. 49). It is worth noting that the plan is a restored version of how the stables were actually found, as many of the pillars, walls, and paved areas were not extant at the time of excavation (compare figs. 34.1 and 34.2). These large, stone-paved structures consist of rows of rectangular rooms, each accessed through a single doorway. Each room had a central aisle with spaces on either side, delineated by a series of upright pillars (some with tethering holes) and shallow troughs. A mudbrick basin found in the courtyard outside the buildings was interpreted as a watering tank (Lamon and Shipton 1939, pp. 32–47). These combined features, as well as the biblical connection with Solomon, contributed to the interpretation that the buildings were stables. Some scholars have suggested alternative uses as storehouses, barracks, or pillared markets (Pritchard 1970; Herr 1988), although most continue to support the original interpretation that they were intended for stabling horses (Cantrell and Finkelstein 2006; Green 2009, pp. 173–75; but see Finkelstein, Brandl, and Halpern 2006, pp. 856). The presence of a donkey as one of the animals in the current model is a probable acknowledgement of the storehouse/pillared markets theory.

The model of the stables provides three aspects of representation and restoration: firstly, how the units appeared after excavation (far right-hand unit); secondly, how they may have appeared as part of a complete structure (two left-hand units); and lastly, a combination of the two with a central cross section (second unit from right). The cross section shows the horses divided by pillars, facing each other on either side of the central passage used by the

34, detail (Oriental Institute digital image D. 17493)

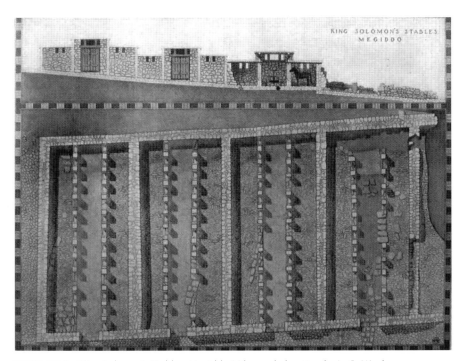

FIGURE C34.1. "King Solomon's Stables, Megiddo." Plan and elevation by L. C. Woolman (Guy 1931, fig. 28)

grooms for feeding them and accessing the stalls. A fifth unit to the far right is shown in Woolman's drawing but is not represented in the model. Each unit could have accommodated twenty-four horses (twelve on each side). Published photographs (Lamon and Shipton 1939, fig. 53) and Charles Breasted's 1935 documentary film *The Human Adventure* (fig. C34.3) show the original model with wooden model horses. These were replaced in later decades with plastic model horses and a donkey. Olaf E. Lind, the photographer for the Megiddo Expedition, built the model, probably at his home in the American Colony, Jerusalem. At least one additional model was made, which presumably remained in Palestine (Norma Franklin, personal communication). As the Megiddo Expedition photographer, Lind had first-hand experience of the stables as they were found, making use of his own observations and photographs for structural details on the model, including the feeding troughs and pillars with tethering holes (see Catalog No. 34, detail). The reconstruction of the upper levels, including the clerestory roof with ventilation windows, is based on fragments of unusually shaped masonry and evidence for a collapsed mud roof, in addition to interpretations regarding how such a structure might have served as a functional

structure for keeping horses (Lamon and Shipton 1939, p. 39 and fig. 43).

The connection between the stables at Megiddo and the golden age of Solomon was not to last. Guy's tenth-century date was challenged after Yigael Yadin's renewed excavations at Megiddo in the 1960s clearly demonstrated that the stables were later in date. He reassigned them to Stratum IVA, which he dated to the Omride dynasty of the ninth century BC, which included the reign of Ahab (Yadin 1970; Wightman 1990, pp. 178–79). Cantrell and Finkelstein (2006) suggest further lowering the date of the stables and Stratum IV to the early eighth century BC, corresponding with the reigns of Josiah and Jereboam II. The chronological debate in relation to the stables continues, although Solomon is now firmly out of the picture.

The stables model was highlighted in the 1935 documentary film *The Human Adventure* (fig. C34.3) as part of a short sequence on the Megiddo stables and their connection with the "great horse trader" King Solomon. This was combined with footage of the balloon used to capture aerial photographs (Catalog Nos. 30–31), seamlessly connecting archaeological evidence and modern photographic techniques with the stables model as a final outcome. The sequence therefore evokes a convincing interpretation of the Solomonic city with the scientifically informed and technologically advanced process of archaeology. In the film, stop animation is used to rotate the model a quarter turn clockwise, giving a view of the stable entrances and its cut-away section. This three-dimensional movie presentation demonstrates the importance the filmmakers gave to the model as a tool for visualizing the past (fig. C34.3). The animated sequence can also be seen within the context of growing popularity of models and dioramas in the 1930s and their increasing use in film. These were the precursors of modern virtual-reality

reconstructions and fly-through sequences (Sanders, Chapter 13).

The model of the stables became part of a permanent display in the Oriental Institute Museum's Syro-Palestinian Hall alongside archaeological collections from Megiddo, remaining on display until the renovations of the mid 1990s (it was not selected for redisplay in the current Haas and Schwartz Megiddo Gallery). Despite seeming old-fashioned, models continue to serve as important visual tools that break down the barrier between the viewer and archaeology in ways that two-dimensional plans and elevations cannot achieve (Evans 2008). The materiality and immediacy of "low-tech" scale models of buildings and daily life scenes also continue to have a positive impact on museum audiences, even as screen-based virtual reality reconstructions become increasingly widespread.

The educational value of the stables model as displayed within the Oriental Institute Museum shifted over the decades, although not necessarily at the same rate as the scholarly debate over its biblical and historical connections. The "Solomon's stables" interpretation endured for several decades and was still being presented in popular books on biblical archaeology well into the 1970s (e.g., *Reader's Digest* 1974, p. 187). Whereas curators, professors, teachers, and docents giving tours would certainly have made the connection between the Megiddo stables and Solomon in much the same way as the books and films had done, such received knowledge was beginning to shift in the 1970s and 1980s. Yet the presented interpretation of the stables model in the Oriental Institute did not change until 1990, when Douglas Esse composed a new label (Esse 1990), featuring the title change: "Were These King Solomon's Stables?" This acknowledged both shifts in dating and offered varied interpretations of function of the stables. The label concluded that the buildings were probably stables, but that they dated to one

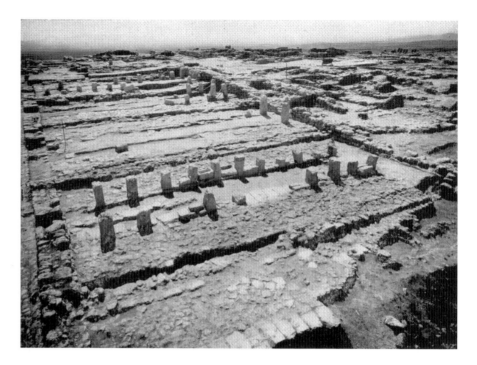

FIGURE C34.2. Photograph of Stable 364, looking southeast (Lamon and Shipton 1939, fig. 51)

of the rulers of the late tenth to mid-ninth century BC (Jereboam I, Omri, or Ahab). The model appears to have played a less prominent role in docent-led tours in its final years of display (Stephen Ritzel, personal communication) as the emphasis of the stables shifted from being an illustration of the Solomonic age at Megiddo to becoming a cautionary tale of biblical archaeology, as well as a window on later rulers of the kingdom of Israel. JG

PUBLISHED

J. H. Breasted 1933, p. 257, fig. 126; Guy 1931, pp. 37–48, figs. 22 and 28; Lamon and Shipton 1939, pp. 41–44, fig. 53

FIGURE C34.3. Still image from animated sequence showing the "Solomon's Stables" model, from the Oriental Institute's film *The Human Adventure* (1935)

35. COPY OF THE BUST OF NEFERTITI

Plaster, pigment
Purchased in Berlin, 1923
H: 50 cm
OIM C280
Oriental Institute digital image D. 17494

35

Copies of famous or unique works of art are often produced to make them accessible to a larger audience. This copy of the bust of Nefertiti (the original is in Berlin) was acquired by the Oriental Institute in 1923, and for many years it was exhibited in the museum's Egyptian gallery. The Deutsche Orient-Gesellschaft (German Oriental Society) discovered the original statue in 1913 during their excavations at Tell el-Amarna.

This is a model rather than a cast. Models are made on the basis of measurements and or photographs, while casts are made from a mold (usually of plaster or more recently of latex) that is made directly from the object that is being duplicated. The original bust of Nefertiti is made of limestone and plaster and it was deemed to be far too fragile to be encased in a plaster mold. The late Professor Hans Güterbock of the Oriental Institute, the son of the director of the German Archaeological Institute, recalls seeing the bust in the early 1920s in a "special room in the [Berlin] museum where Nefertiti was kept," before it was officially exhibited. There, the sculptor Tina Haim was in the process of sculpting an exact copy in stone from precise measurements obtained with calipers. Haim's replica was used as the source for further plaster copies, including this example.

Despite the effort to make an exact replica, the Chicago bust is not a true copy because the left eye, which is missing on the original, has been restored. This compromise between accuracy and aesthetics reflects the status of this image as an icon of ancient beauty — portraying her with a missing eye would detract from her perfection.

The bust of Nefertiti is one of the most instantly recognizable images from ancient Egypt, and one with which the public clearly associates with the grandeur of Egypt. The image appears on innumerable notebooks, tea towels, key chains, and papyrus paintings and, ironically, until recent years, it appeared on the Egyptian five-piastre note although the bust has not been in Egypt for almost a century and there have been numerous appeals for its return to Egypt. The popularity of the bust is also indicated by its appearance on a poster commissioned by the Oriental Institute for Chicago's Century of Progress World's Fair (1933), where it was shown superimposed upon, and more prominently than, the authentic winged bull (*lamassu*) excavated at Khorsabad (fig. C35.1). The strange juxtaposition of authentic and replica to publicize an institution that prides itself on scientific accuracy reflects the public appeal and marketing power of the image.

This model of the bust of Nefertiti was produced by the Gipsformerei (plaster cast workshop) of the Egyptian Museum of Berlin. Plaster copies of the bust are still available in various sizes, either painted or white, from the Gipsformerei. The workshop was founded in 1819 to make replicas of important works not represented in the Berlin museums. According to their website, they offer more than 6,500 different subjects and some of their molds are more than 150 years old. These molds can be invaluable records of art works that have vanished. For example, the famous quadriga (chariot drawn by four horses) that stood atop the Brandenburg Gate was destroyed in World War II but a replica was made from the molds in the collection of the Gipsformerei. ET

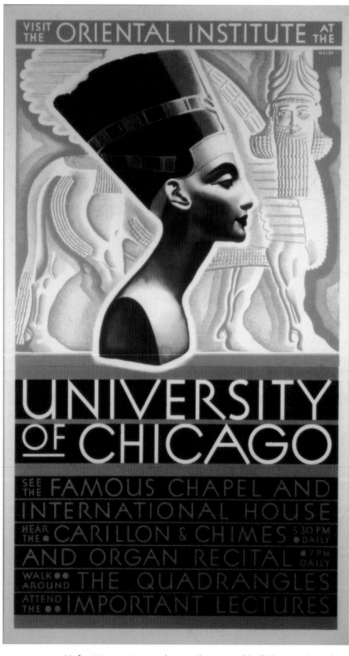

FIGURE C35.1. Nefertiti superimposed upon the winged bull (*lamassu*) on the poster for Chicago's Century of Progress World's Fair

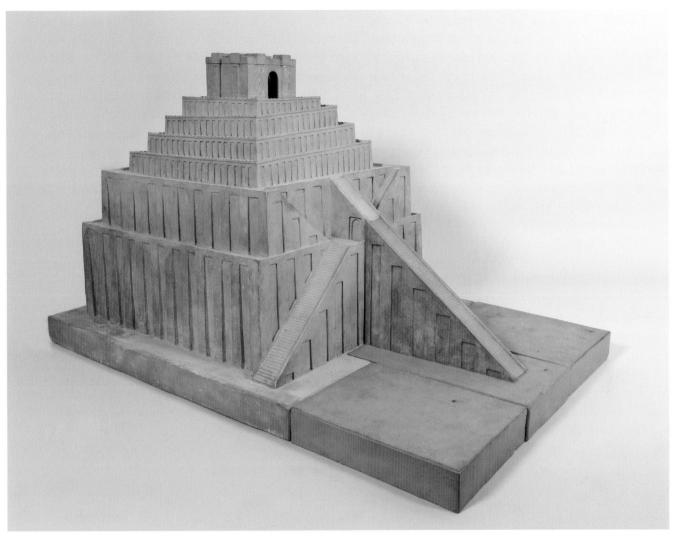

36

36. MODEL OF THE ZIGGURAT AT BABYLON

Eckhard Unger
Plaster, pigment
Purchased in Berlin, 1931
H: 42.00; L: 68.00; W: 43.75 cm
OIM C470
Oriental Institute digital image D. 17496

Ziggurats were among the earliest architectural forms built in Mesopotamia. At least two dozen ziggurats (including the famous restored one at Ur) are archaeologically identifiable from as early as 3500 BC, and as late as the Hellenistic period (around 150 BC). The geographic range of these buildings is also impressive: ziggurats were found in cities in Assyria, northern Syria, Babylonia, and modern-day Iran. This model was built by Eckhard

Unger, a German Assyriologist whose research included investigations into the plans of ancient Babylon, Assur, and other Mesopotamian cities.

The name ziggurat may derive from the Akkadian verb *zaqāru* "to raise high," but this replaced the earlier Sumerian term for these buildings, u n i r, connoting something rather different ("princely house"). The precise ritual function of the ziggurat's shrine remains obscure, but differed from the temple proper, which was the god's home and cult center.

The specific appearance of Babylon's ziggurat was a major preoccupation for archaeologists and historians of the nineteenth and early twentieth centuries who were eager to lend scientific weight

to the biblical story of the Tower of Babel (Genesis 11:1–9). By that time, the Tower had already been a popular subject for illustrators for centuries, but differently imagined. Throughout the Middle Ages and the Renaissance, the Tower was mostly represented as a cylindrical structure resembling a castle keep. This was undoubtedly an outcome of the biblical terms used to describe the Babylonian wonder — *migdal* in Hebrew, *pyrgos* in Greek, *turris* in Latin, *burj* in Arabic. All these words primarily mean "fortress" — and on this idea its depictors based their images.

When the modern study of Mesopotamia began in the early 1800s, however, travelers and archaeologists could hardly ignore the evidence from Ur and other places. If any structures there corresponded to the biblical Tower, they were the ziggurats — and ziggurats were without exception square in shape, and decidedly unmilitary.

In Babylon's case, the massive structure known as the Etemenanki ("House, Foundation of Heaven and Earth") was probably composed of seven stages surmounted by a god's shrine at the top, set within a temple close, and far from any defensive walls. Unlike Egyptian pyramids, ziggurats also had no interior space — they were solid platforms. By the nineteenth century, all that was left of the structure at Babylon was the shape of its empty foundation (cf. fig. C36.1). But that footprint provided the dimensions of the building — measuring some 90 meters on each side — and also of the walled courtyard that surrounded it, a perimeter of more than 1,600 meters.

The Berlin model of Babylon's ziggurat necessarily deals in imagination when it comes to the structure's height, however. Still, comparison with other ziggurat ruins, together with a few rough plans and elevations preserved on cuneiform tablets, provided some further guidelines: the rise of the staircase to the first stage was at least 60 meters high, with six closer-packed stages following. At the very least, the building towered over every other structure in the city, and was visible from miles away (see Catalog No. 16). SR

FIGURE C36.1. A view from the southeast of the ruins of the ziggurat at Babylon, 1920. Photo by D. D. Luckenbill (Oriental Institute photograph P. 6528)

THE FUTURE OF DOCUMENTATION

The methods that scholars use to document, reconstruct, and visualize the past have changed dramatically as new technologies are adopted. Cameras attached to balloons have been superseded by satellite images; drafting boards are giving way to computer screens, and 3-D imaging is used alongside traditional methods. Static images can now be a part of dynamic fully interactive presentations. New non-destructive imaging techniques, such as CT and magnetic resistivity, allow objects that are invisible to the human eye to be seen, analyzed, and shared. The newest technology offers exciting new ways to picture the past.

37a

37b

37. TOKEN BALL AND CT IMAGE OF A TOKEN BALL

a. Token ball
 Clay
 Late Uruk period, ca. 3350–3100 BC
 Chogha Mish, Iran
 Excavated by the Oriental Institute
 OIM A32474 (ChM II 147)
 Oriental Institute digital image D. 17497

b. Courtesy of North Star Imaging, Inc.

Small, unassuming hollow clay balls, referred to as "envelopes," and their associated clay counters, or "tokens," have come to play a pivotal role in the debate over the origins of writing, having been made famous in recent decades by Denise Schmandt-Besserat and her theory of the origins of writing (1992). These artifacts, which range from the size of golf balls to baseballs, have been excavated in Iran, Syria, and Mesopotamia (fig. C37.1). They make their first appearance in the archaeological record in the middle of the fourth millennium and are contemporaneous with, or slightly earlier than, the first texts. There is a general consensus that the envelopes represented an early administrative device, which served as a means to monitor and control the flow of materials, various commodities, and labor. The tokens, which are sealed within the envelopes, represent quantities and/or commodities of the proto-literate economies. Essentially, these devices served as receipts for various economic transactions. The act

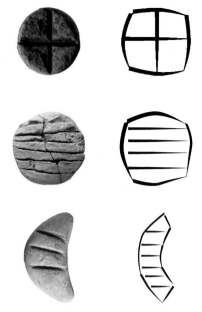

FIGURE C37.1. Comparison of complex tokens with the respective cuneiform graphs (from top to bottom) for sheep and goats, wool, and silver

of sealing the tokens within the envelope would have protected them from tampering and fraud. If the contents were contested, the envelope could be broken open and the tokens verified.

Tokens, which also occur in contexts outside of the envelopes, are often considered, somewhat arbitrarily, to belong to one of two groups: so-called simple tokens, which are unmarked and represent simple geometric shapes (spheres, cones, disks, lozenges, etc.); and complex tokens, geometric shapes that bear markings and perforations of various kinds. Schmandt-Besserat, expanding upon an idea first put forth by the French archaeologist

Pierre Amiet in the 1960s, hypothesized that the numerical signs of the slightly later cuneiform writing system evolved from the simple tokens, while the logograms, or word signs representing commodities, evolved from the complex tokens. Many Assyriologists (philologists who specialize in cuneiform documentation) reject Schmandt-Besserat's theory, particularly as it concerns the relationship between the word signs and the complex tokens, because the argument is based on the mere visual similarities between the two (fig. C37.1). A number of tokens do in fact resemble cuneiform signs, but it does not necessarily follow that they shared the same meanings in the two systems. Indeed, in several cases there is solid circumstantial evidence to suggest that they did not.

Our inability to easily inspect the contents of the vast majority of clay envelopes is a major obstacle in testing the theory, and more generally, in ascertaining how these proto-literate accounting devices worked. Some 80 of the 130 or so excavated clay envelopes are intact. Museums typically forbid opening these artifacts as doing so would destroy them and the seal impressions that most of them bear. Since the 1960s scholars have x-rayed these envelopes and scanned them with computed tomography (CT) equipment. In the past, these techniques could not offer the resolution and clarity necessary to determine the exact number of tokens and whether they have markings or not — critical data for understanding their meaning. However, CT and digital imaging technology have

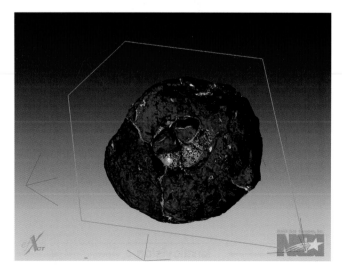

FIGURE C37.2. Views of tokens inside the clay envelope. Images courtesy of North Star Imaging, Inc.

Ch.M. II-147

Click image to activate 3D model.

kinetic**vision**

FIGURE C37.3. Exterior of the token ball. The CT scans makes the seal impressions on the exterior of the ball much more visible than they are to the eye. Image courtesy of Kinetic Vision, Inc.

made major advances in recent years and it is now possible to obtain the requisite resolution, fidelity, and much more.

The Oriental Institute is currently collaborating with North Star Imaging of Rogers, Minnesota, and Kinetic Vision of Cincinnati, Ohio, to scan and analyze the fifteen intact clay envelopes in its collection, all of which were excavated from Chogha Mish, Iran, in the 1960s and early 1970s. North Star Imaging, a leading manufacturer of state-of-the-art industrial CT systems, scanned the fifteen envelopes in July 2011 at their Rogers facility and assembled 3-D CT images of each artifact. Using

their proprietary software, we can digitally dissect the envelopes, inspect their contents, and study the structure, construction, and clay composition of the envelopes themselves at remarkably high resolutions (figs. 37.2–3). Kinetic Vision, a leading engineering firm specializing in digital media creation, generated 3-D digital models of each of the envelopes based on the raw, high-resolution CT data. These models allow us to digitally remove the tokens from the envelopes so that they may be rotated and analyzed in isolation (fig. C37.4); the models also facilitate measurements of the inner dimensions of the envelopes as well as analysis of the organization of the tokens within. Together the 3-D CT images and digital models allow us to investigate the structure and interiors of these critically important artifacts in ways unfathomable just a few years ago. Indeed, we are now at a point in terms of technology where we can collect more and better data using non-destructive methods than we could if we physically opened the balls — for with the CT technology we can return again and again to these objects and investigate their internal structures at a microscopic level. We are currently in the midst of our investigation. Now that the technological aspects of the project are nearly complete, we need to understand these results within the greater administrative, historical, and cultural context of these artifacts. We look forward to completing our work and publishing the results in 2012. CW

Ch.M. II-147

Click image to activate 3D model.

kinetic**vision**

Ch.M. II-147

Click image to activate 3D model.

kinetic**vision**

FIGURE C37.4. Tokens digitally removed from the envelope, allowing them to be analyzed in isolation. Images courtesy of Kinetic Vision, Inc.

CONCORDANCE OF MUSEUM REGISTRATION NUMBERS

Registration Number	Catalog / Figure Number	Description
ABBAS ALIZADEH		
—	Catalog No. 23a	Architectural plan of a temple/palace, Chogha Mish
EPIGRAPHIC SURVEY AND LEIPZIG UNIVERSITY		
—	Catalog No. 5	Photo from the Colonnade Hall of Luxor Temple
JEAN-CLAUDE GOLVIN		
—	Catalog No. 17	India ink and watercolor of Medinet Habu
ROBERT MARTINDALE		
—	Catalog No. 21a	Digital print (of original watercolor)
METROPOLITAN MUSEUM OF ART, NEW YORK		
MMA TAA55	Catalog No. 29	Photo of the treasury of the Tomb of Tutankhamun by Harry Burton
NORTH STAR IMAGING, INC.		
—	Catalog No. 37b	CT image of a token ball
FARZIN REZAEIAN		
—	Catalog No. 22b	Computer reconstruction of a siege garrison, Chogha Mish
—	Catalog No. 23b	Computer reconstruction of a temple/palace, Chogha Mish
THE ORIENTAL INSTITUTE OF THE UNIVERSITY OF CHICAGO		
ChM II-760	Catalog No. 22a	Token ball (D. 17483)
OI P. 2403	Catalog No. 3	Photographing the interior of the temple at Abu Simbel
OI P. 2476	Catalog No. 4	Reinforced photo (D. 17463)
OI P. 18637	Catalog No. 30	Meteorological balloon with camera attached, Megiddo
OIM A12331	Catalog No. 24b	Tell Asmar statue (D. 17486)
OIM A32474	Catalog No. 37a	Token ball (D. 17497)
OIM C280	Catalog No. 35	Copy of the bust of Nefertiti (D. 17494)
OIM C469	Catalog No. 34	Model and detail of "King Solomon's Stables" at Megiddo by Olaf E. Lind (D. 17492, D. 17493)
OIM C470	Catalog No. 36	Model of the ziggurat at Babylon by Eckhard Unger (D. 17496)
OIM E15502	Catalog No. 21b	Glazed tile (D. 17480)
OIM E15504	Catalog No. 21c	Glazed tile (D. 17481)
OIM E15488	Catalog No. 21d	Glazed tile (D. 17482)
OIM RH 4759	Catalog No. 25	Watercolor of lusterware jug from Rayy (D. 17487)
ORIENTAL INSTITUTE DIGITAL IMAGES — NEW PHOTOGRAPHY BY ANNA RESSMAN		
D. 17462	Catalog No. 1	James Henry Breasted's notebook
D. 17463	Catalog No. 2	James Henry Breasted's notebook
D. 17464	Catalog No. 4	Reinforced photo (OI P. 2476)
D. 17465	Catalog No. 6	Epigraphic drawing
D. 17466	Catalog No. 7	Blueprint of epigraphic drawing
D. 17467	Catalog No. 8	Collation sheet of small piece of blueprint
D. 17468	Catalog No. 9	Printed plate from Epigraphic Survey 1994, pl. 11
D. 17469	Catalog No. 10	Tempera on paper of the Tomb of Nakht by Nina de Garis Davies
D. 17470	Catalog No. 11	Watercolor of the Temple of Seti I by Amice Calverley and Myrtle Broome
D. 17471	Catalog No. 12	Watercolor of the Tomb of Mereruka by Prentice Duell
D. 17472	Catalog No. 13	Color lithograph of Medinet Habu by David Roberts
D. 17473	Catalog No. 14	Mixed media of the Temple of Ramesses III by Uvo Hölscher
D. 17474	Catalog No. 15	Pencil and charcoal on paper of the Temple Oval by Hamilton D. Darby
D. 17475	Catalog No. 16	Oil on canvas of a view of Babylon by Maurice Bardin
D. 17476	Catalog No. 18	Oil on canvas of a view of Nippur by Peggy Sanders
D. 17477	Catalog No. 19	Oil on canvas of a view of the Apadana by Joseph Lindon Smith
D. 17478	Catalog No. 20	Archival print for publication prepared by Loud and Altman 1938, pl. 89
D. 17480	Catalog No. 21b	Glazed tile (OIM E15502)
D. 17481	Catalog No. 21c	Glazed tile (OIM E15504)
D. 17482	Catalog No. 21d	Glazed tile (OIM E15488)
D. 17483	Catalog No. 22a	Token ball (ChM III-760)
D. 17485	Catalog No. 24a	Watercolor of statues from Tell Asmar by G. Rachel Levy
D. 17486	Catalog No. 24b	Tell Asmar statue (OIM A12331)
D. 17487	Catalog No. 25	Watercolor of a lusterware jug from Rayy (OIM RH 4759)
D. 17489	Catalog No. 26	Monarch Stereoscope Viewer
D. 17490	Catalog No. 27	RB Cycle Graphic Camera
D. 17491	Catalog No. 28	Stereo Realist 3-D Camera
D. 17492	Catalog No. 34	Model of "King Solomon's Stables" at Megiddo by Olaf E. Lind (OIM C469)
D. 17493	Catalog No. 34	Detail of Model of "King Solomon's Stables" at Megiddo by Olaf E. Lind (OIM C469)
D. 17494	Catalog No. 35	Copy of the bust of Nefertiti (OIM C280)
D. 17496	Catalog No. 36	Model of the ziggurat at Babylon by Eckhard Unger (OIM C470)
D. 17497	Catalog No. 37a	Token ball (OIM A32474)
ORIENTAL INSTITUTE NEW DIGITAL IMAGERY FOR FIGURES BY ANNA RESSMAN		
D. 17457	Figure 1.5	Restoration of Khorsabad palace complex by Félix Thomas, from Place 1867–70, vol. 3, pl. 21
D. 17458	Figure 8.10 (top)	Painting of the Temple of Seti I by Nina de Garis Davies
D. 17459	Figure 11.3	Oil on canvas Persepolis landscape by Joseph Lindon Smith
D. 17460	Figure 11.8	Oil on canvas portrait of Scythian groomsmen by Joseph Lindon Smith
D. 17461	Figure 11.9	Oil on canvas portrait of high-ranking officers by Joseph Lindon Smith
D. 17471	Figure 4.5 (bottom)	Catalog No. 12 (reduced)
D. 17479	Figure 1.3	Palace of Khorsabad from Place 1867–70, vol. 3, pl. 18bis
D. 17484	Figure C28.1	Presto-Stereo 3-D slide taken by Charles F. Nims
D. 17488	Figure C25.1	Color chart developed by Erich Schmidt's artists

CHECKLIST OF THE EXHIBIT

The Oriental Institute and the Documentation of Egypt

James Henry Breasted's Notebook for the British Museum

James Henry Breasted's Notebook for the Gizeh Museum and the Louvre

Photographing in the Interior of the Temple at Abu Simbel (OI P. 2403)

Reinforced Photo (OI P. 2476)

Photo of Wall of Colonnade Hall, Luxor Temple

Epigraphic Drawing

Blueprint

Collation Sheet

Final Epigraphic Drawing

Facsimiles

Nina de Garis Davies, "Vintagers and Bird-Catchers"

Amice Calverley and Myrtle Broome, "Shrine of Sethos, West Wall, Central Portion" (King Seti I Presents Incense to His Deified Self)

Prentice Duell, Mereruka and Watetkhethor on a Bed

Architectural and Artifact Renderings

David Roberts, "Medinet Abou, Thebes"

Uvo Hölscher, Walls of the Temple of Ramesses III at Medinet Habu, Egypt

Hamilton D. Darby, Reconstruction of the Temple Oval at Khafajah, Iraq

Maurice Bardin, View of Babylon

Jean-Claude Golvin, Medinet Habu and the Mountains of Western Thebes, Egypt

Peggy Sanders, View of Nippur, Iraq

Joseph Lindon Smith, The Apanada (Audience Hall) at Persepolis, Iran

Charles B. Altman, Restoration of Neo-Assyrian Wall Painting from Residence K, Khorsabad, Iraq (print)

G. Rachel Levy, Reconstruction of Sculpture from Tell Asmar, Iraq; Tell Asmar Statue (OIM A12331)

Artist unknown, Watercolor of a Lusterware Jug from Rayy, Iran (OIM RH 4759)

Robert Martindale, Reconstruction of a Doorway at Medinet Habu, Egypt (tiles: OIM E15502, E15504, E15488)

Farzin Rezaeian, Reconstruction of a Building from Chogha Mish, Iran; Token Ball with Seal Impression (ChM II 760)

Farzin Rezaeian, Reconstruction of a temple/ palace at Chogha Mish, Iran; Abbas Alizedah, Archaeological Plan of the temple/palace

CT Images of a Token Ball (OIM A32474; ChM II 147)

Photography

Monarch Stereoscope Viewer and Stereograph Cards

RB Cycle Graphic Camera

Stereo Realist 3-D Camera

Harry Burton, View of the Treasury of the Tomb of Tutankhamun

Meteorological Balloon with Camera Attached, Megiddo, November 5, 1929 (P. 18637)

"Air-Mosaic" of the Mound at Megiddo, 1932

Declassified Spy Satellite Image

Satellite Image of Persepolis

Models and Copies

Model of "King Solomon's Stables" at Megiddo (OIM C469)

Copy of the Bust of Nefertiti (OIM C280)

Model of the Ziggurat at Babylon (OIM C470)

BIBLIOGRAPHY

Abt, Jeffrey

2011 *American Egyptologist: The Life of James Henry Breasted and the Creation of His Oriental Institute.* Chicago: University of Chicago Press.

Adams, Robert McC.

1981 *Heartland of Cities: Surveys of Ancient Settlement and Land Use on the Central Floodplain of the Euphrates.* Chicago: University of Chicago Press.

Addison, Frank

1949 *"Jebel Moya." The Wellcome Excavations in the Sudan.* London: Oxford University Press.

Albenda, Pauline

2005 *Ornamental Wall Painting in the Art of the Assyrian Empire.* Cuneiform Monographs 28. Leiden: Brill.

2011 Review of *Assyrian Reliefs from the Palace of Ashurnasiripal II: A Cultural Biography,* edited by Ada Cohen and Steven E. Kangas. *Bulletin of the American Schools of Oriental Research* 363: 102–04.

Aldred, Cyril

1965 "Anna Macpherson Davies." *Journal of Egyptian Archaeology* 51: 196–99.

Alizadeh, Abbas

2008 Chogha Mish 2. *The Development of a Prehistoric Regional Center in Lowland Susiana, Southwest Iran: Final Report on the Last Six Seasons of Excavations, 1972–1978.* Oriental Institute Publications 130. Chicago: The Oriental Institute.

Allen, Susan

2006 *Tutankhamun's Tomb: The Thrill of Discovery; Photographs by Harry Burton.* New York: Metropolitan Museum of Art.

Altman, Charles B.

1938 "Painted Plaster Decoration." In Khorsabad 2. *The Citadel and the Town,* by Gordon Loud and Charles B. Altman, pp. 83–86. Oriental Institute Publications 40. Chicago: University of Chicago Press.

Arnold, Dieter

1999 *Temples of the Last Pharaohs.* New York: Oxford University Press.

Aufrère, Sydney, and Jean-Claude Golvin

1991 *L'Égypte restituée,* vol. 3. Paris: Éditions Errance.

Baines, John

1984 "Abydos, Temple of Sethos I: Preliminary Report." *Journal of Egyptian Archaeology* 84: 13–22.

1990 "Recording the Temple of Sethos I at Abydos in Egypt." *Bulletin of the Ancient Orient Museum* 11: 65–95.

Banks, Marcus, and Jay Ruby

2011 *Made to Be Seen: Perspectives on the History of Visual Anthropology.* Chicago: University of Chicago Press.

Barceló, Juan A; Maurizio Forte; and Donald H. Sanders, editors

2000 *Virtual Reality in Archaeology.* British Archaeological Reports, International Series 843. Oxford: Archaeopress.

Barford, Paul M.

2000 "A Bibliography of Polish Aerial Archaeology." *AARGnews: The Newsletter of the Aerial Archaeology Research Group* 20: 55–56.

Barthes, Roland

1977 "Rhetoric of the Image." In *Image, Music, Text,* edited and translated by Stephen Heath, pp. 32–51. New York: Hill & Wang.

Beek, Martin

1962 *Atlas of Mesopotamia: A Survey of the History and Civilization of Mesopotamia from the Stone Age to the Fall of Babylon.* Translated by D. R. Welsh, edited by H. H. Rowley. New York: Nelson.

Bierbrier, Morris; Warren Dawson; and Eric Uphill

1995 *Who Was Who in Egyptology.* 3rd edition, revised by Warren R. Dawson and Eric P. Uphill. London: The Egypt Exploration Society.

Blascovich, Jim, and Jeremy Bailenson

2011 *Infinite Reality: Avatars, Eternal Life, New Worlds, and the Dawn of the Virtual Revolution.* New York: Harper Collins.

Boehmer, R. M.

1975 "Die Neuassyrischen Felsreliefs von Maltai (Nord-Irak)." *Jahrbuch des Deutschen Archaeologishes Instituts* 90: 42–84.

Bohrer, Frederick

2005 "Photography and Archaeology: The Image as Object." In *Envisioning the Past: Archaeology and the Image*, edited by Sam Smiles and Stephanie Moser, pp. 180–91. Oxford: Blackwell Publishing.

Breasted, Charles

1943 *Pioneer to the Past: The Story of James Henry Breasted, Archaeologist, Told by His Son, Charles Breasted.* New York: Charles Scribner's Sons.

Breasted, James H.

1905 *Egypt Through the Stereoscope: A Journey through the Land of the Pharaohs.* Ottawa: Underwood & Underwood. Reissued in 2010 by the Oriental Institute.

1906 "First Preliminary Report of the Egyptian Expedition." *The American Journal of Semitic Languages and Literatures* 23/1: 1–64.

1908 "Second Preliminary Report of the Egyptian Expedition." *The American Journal of Semitic Languages and Literatures* 25/1: 1–110.

1916 *Ancient Times, A History of the Early World: An Introduction to the Study of Ancient History and the Career of Early Man.* Boston: Ginn & Co.

1919 *Survey of the Ancient World.* Boston: Ginn & Co.

1926 *The Conquest of Civilization.* New York: Harper & Brothers.

1933 *The Oriental Institute.* Chicago: University of Chicago Press.

Brewster, David

1856 *The Stereoscope: Its History, Theory, and Construction, with Its Application to the Fine and Useful Arts and to Education.* London: John Murray.

Bull, Deborah, and Donald Lorimer

1979 *Up the Nile: A Photographic Excursion; Egypt, 1839-1898.* New York: Clarkson Potter.

Calverley, Amice M., with the assistance of Myrtle F. Broome and edited by Alan H. Gardiner

1933 The Temple of King Sethos I at Abydos, Volume 1. *The Chapels of Osiris, Isis, and Horus.* Chicago: University of Chicago Press.

1935 The Temple of King Sethos I at Abydos, Volume 2. *The Chapels of Amen-Re', Re'-Harakhti, Ptah, and King Sethos.* Chicago: University of Chicago Press.

1938 The Temple of King Sethos at Abydos, Volume 3. *The Osiris Complex.* Chicago: University of Chicago Press.

1958 The Temple of King Sethos I at Abydos, Volume 4. *The Second Hypostyle Hall.* Chicago: University of Chicago Press.

Caminos, Ricardo A.

1976 "The Recording of Inscriptions and Scenes in Tombs and Temples." In *Ancient Egyptian Epigraphy and Paleography*, edited by Ricardo A. Caminos, pp. 3–25. New York: Metropolitan Museum of Art.

Cantrell, Deborah O., and Israel Finkelstein

2006 "A Kingdom for a Horse: The Megiddo Stables and Eighth Century Israel." In *Megiddo IV: The 1998-2002 Seasons*, edited by Israel Finkelstein, David Ussishkin, and Baruch Halpern, pp. 643–65. Monograph Series 24. Tel Aviv: Emery and Claire Yass Publications in Archaeology.

Capper, Col. J. E.

1907 "Photographs of Stonehenge, as Seen from a War Balloon." *Archaeologia* 60/2: 571–72.

Carrozzino, Marcello, and Massimo Bergamasco

2010 "Beyond Virtual Museums: Experiencing Immersive Virtual Reality in Real Museums." *Journal of Cultural Heritage* 11/4: 452–58.

Castiglione, Alfredo; Angelo Castiglione; and Jean Vercoutter

1995 *Das Goldland der Pharaonen: Die Entdeckung von Berenike Pankrista.* Mainz: Philipp von Zabern.

Champollion, Jean-François

1844–89 *Monuments de l'Égypte et de la Nubie.* 4 volumes. Paris: F. Didot frères.

Chesson, Meredith S.

2007 "Remembering and Forgetting in Early Bronze Age Mortuary Practices on the Southeastern Dead Sea Plain, Jordan." In *Performing Death: Social Analyses of Funerary Traditions in the Ancient Near East and Mediterranean*, edited by Nicola Laneri, pp. 109–39. Oriental Institute Seminars 3. Chicago: The Oriental Institute.

Cohen, Ada, and Steven E. Kangas, editors

2010 *Assyrian Reliefs from the Palace of Ashurnasirpal II: A Cultural Biography.* Hanover: Hood Museum of Art, Dartmouth College, and University Press of New England.

Curtis, John

2008 "The Site of Babylon Today." In *Babylon: Myth and Reality*, edited by Irving L. Finkel and Michael J. Seymour, pp. 213–20. London: The British Museum Press.

Dabney, Mary; James C. Wright; and Donald H. Sanders

1999 "Virtual Reality and the Future of Publishing Archaeological Excavations: The Multimedia Publication of the Prehistoric Settlements on Tsoungiza at Ancient Nemea." In *Cultural Heritage Informatics 1999: Selected Papers from ichim99*, edited by David Bearman and Jennifer Trant, pp. 125–32. Pittsburgh: Archives & Museum Informatics.

Delaney, Ben

1994 "Virtual Reality Lands the Job." *New Media* 4/8: 40–48.

Davies, Nina de Garis. Edited by Alan H. Gardiner

1915 *The Tomb of Amenemhet (No. 82)*. Theban Tombs Series 1. London: The Egypt Exploration Fund.

1926 *The Tomb of Ḥuy, Viceroy of Nubia in the Reign of Tutʿankhamūn (No. 40)*. Theban Tombs Series 4. London: The Egypt Exploration Society.

1936 *Ancient Egyptian Paintings*. 3 volumes. Chicago: University of Chicago Press.

Davies, Norman de Garis

1903–08 *The Rock Tombs of el Amarna*. 6 volumes. Archaeological Survey of Egypt 13–18. London: The Egypt Exploration Fund.

1939 Review of *The Mastaba of Mereruka*, by Prentice Duell. *Journal of Egyptian Archaeology* 25/2: 223–24.

1941 *The Tomb of the Vizier Ramose*. Mond Excavations at Thebes 1. London: The Egypt Exploration Society.

Davies, W. V.

1982 "Thebes." In *Excavating in Egypt: The Egypt Exploration Society, 1882-1982*, edited by T. G. H. James, pp. 51–70. Chicago: University of Chicago Press.

Delougaz, Pinhas

1940 *The Temple Oval at Khafājah*. Oriental Institute Publications 53. Chicago: University of Chicago Press.

Delougaz, Pinhas, and Helene Kantor

1996 *Chogha Mish 1. The First Five Seasons of Excavations, 1961-1971*. Edited by Abbas Alizadeh. Oriental Institute Publications 101. Chicago: The Oriental Institute.

Dorman, Peter F.

2008 "Epigraphy and Recording." In *Egyptology Today*, edited by R. H. Wilkinson, pp. 77–97. Cambridge: Cambridge University Press.

Dyson, Stephen L.

2010 "Cast Collecting in the United States." In *Plaster Casts: Making, Collecting and Displaying from Classical Antiquity to the Present*, edited by Rune Frederickson and Eckhart Marchand, pp. 557–75. Transformationen der Antike 18. Berlin: De Gruyter.

Earl, Graeme P.

2005 "Video Killed Engaging VR? Computer Visualizations on the TV Screen." In *Envisioning the Past: Archaeology and the Image*, edited by Stephanie Moser and Sam Smiles, pp. 204–22. Malden: Blackwell.

Edwards, Amelia B.

1877 *A Thousand Miles up the Nile*. New York: A. L. Burt.

Elkins, James

2007 *Visual Practices across the University*. Munich: Wilhelm Fink Verlag.

Emberling, Geoff, and Emily Teeter

2010 "The First Expedition of the Oriental Institute, 1919–1920." In *Pioneers to the Past: American Archaeologists in the Middle East*, edited by Geoff Emberling, pp. 31–84. Oriental Institute Museum Publications 30. Chicago: The Oriental Institute.

Epigraphic Survey

1930 Medinet Habu I. *Earlier Historical Records of Rameses III*. Oriental Institute Publications 8. Chicago: University of Chicago Press.

1992 *Lost Egypt: A Limited Edition Portfolio Series of Photographic Images from Egypt's Past*. 3 volumes. Chicago: The Oriental Institute.

1994 Reliefs and Inscriptions at Luxor Temple, Volume 1. *The Festival Procession of Opet in the Colonnade Hall*. Oriental Institute Publications 112. Chicago: The Oriental Institute.

2009 Medinet Habu IX. *The Eighteenth Dynasty Temple*, Part 1: *The Inner Sanctuaries*. Oriental Institute Publications 136. Chicago: The Oriental Institute.

Esse, Douglas L.

1990 "Megiddo Stables." *Docent Digest* (Feb.): 1–3.

Evans, Christopher

2008 "Model Excavations: 'Performance' and the Three-Dimensional Display of Knowledge." In

Archives, Ancestors, Practices: Archaeology in the Light of Its History, edited by Nathan Schlanger and Jarl Nordbladh, pp. 147–61. New York: Berghahn Books.

Evans, Elaine
2000 *Scholars, Scoundrels, and the Sphinx: A Photographic and Archaeological Adventure Up the Nile.* Knoxville: The Frank H. McClung Museum, University of Tennessee.

Fernie, Kate, and Julian Richards, editors
2003 *Creating and Using Virtual Reality: A Guide for the Arts and Humanities.* Oxford: Oxbow Books.

Finch, J. P. G.
1948 "The Winged Bulls at the Nergal Gate of Nineveh." *Iraq* 10/1: 9–18.

Finkel, Irving L., and Michael J. Seymour, editors
2008 *Babylon: Myth and Reality.* London: The British Museum Press.

Finkelstein, Israel
1996 "The Archaeology of the United Monarchy: An Alternative View." *Levant* 28: 177–87.

Finkelstein, Israel; David Ussishkin; and Baruch Halpern
2006 "Archaeological and Historical Conclusions." In *Megiddo* IV: *The 1998–2002 Seasons*, edited by Israel Finkelstein, David Ussishkin, and Baruch Halpern, pp. 843–57. Tel Aviv: Institute of Archaeology of Tel Aviv University.

Fisher, Clarence S.
1929 *The Excavation of Armageddon.* Oriental Institute Communications 4. Chicago: University of Chicago Press.

Forte, Maurizio, and Alberto Siliotti, editors
1997 *Virtual Archaeology: Re-Creating Ancient Worlds.* New York: Harry N. Abrams.

Frankfort, Henri
1935 *Oriental Institute Discoveries in Iraq, 1933/34: Fourth Preliminary Report of the Iraq Expedition.* Oriental Institute Communications 19. Chicago: University of Chicago Press.
1939 *Sculpture of the Third Millennium B.C. from Tell Asmar and Khafājah.* Oriental Institute Publications 44. Chicago: University of Chicago Press.
1943 *More Sculpture from the Diyala Region.* Oriental Institute Publications 60. Chicago: University of Chicago Press.
1996 *The Art and Architecture of the Ancient Orient.* 5th edition. New Haven: Yale University Press.

Frankfort, Henri; Thorkild Jacobsen; and Conrad Preusser
1932 *Tell Asmar and Khafaje: The First Season's Work in Eshnunna, 1930/31.* Oriental Institute Communications 13. Chicago: University of Chicago Press.

Frederiksen, Rune, and Eckhart Marchand
2010 *Plaster Casts: Making, Collecting and Displaying from Classical Antiquity to the Present.* Transformationen der Antike 18. Berlin: De Gruyter.

Gardiner, Alan H.
1942 "Norman de Garis Davies." *Journal of Egyptian Archaeology* 28: 59–60.

Genç, Elif
2008 "How We Are Using New Technology at an Old Excavation: The Seyitomer Mound Salvage Excavation Project." In *Workshop 12 – Archäologie und Computer 2007 Kulturelles Erbe und Neue Technologien, 5.–7. November 2007*, edited by Museen der Stadt Wien – Stadtarchäologie. CD-ROM only publication.

Gerster, Georg
2005 *The Past from Above: Aerial Photographs of Archaeological Sites.* Edited by Charlotte Trümpler. Los Angeles: Getty Publications.

Goode, James F.
2010 "Archaeology and Politics in Iraq: From the British Mandate to Saddam Hussein." In *Assyrian Reliefs from the Palace of Ashurnasirpal II: A Cultural Biography*, edited by Ada Cohen and Steven Kangas, pp. 107–23. Hanover: University Press of New England.

Gore, Rick
2001 "Ashkelon: Ancient City of the Sea." *National Geographic Magazine* 199: 66–93.

Gillings, Mark
2005 "The Real, the Virtually Real and the Hyperreal: The Role of VR in Archaeology." In *Envisioning the Past: Archaeology and the Image*, edited by edited by Sam Smiles and Stephanie Moser, pp. 223–39. Malden: Blackwell.

Green, John D. M.
2009 "Politics and Archaeology in the Holy Land: The Life and Career of P. L. O. Guy." *Palestine Exploration Quarterly* 141/3: 167–87.

Guralnick, Eleanor
2004 "Neo-Assyrian Patterned Fabrics." *Iraq* 66: 221–32.

2010 "Color at Khorsabad: Palace of Sargon II." In *Proceedings of the 6th International Congress of the Archaeology of the Ancient Near East, 5–10 May 2009, "Sapienza," Università di Roma*, Volume 1: *Near Eastern Archaeology in the Past, Present and Future. Heritage and Identity Ethnoarchaeological and Interdisciplinary Approach, Results and Perspectives. Visual Expression and Craft Production in the Definition of Social Relations and Status*, edited by Paolo Matthiae, Frances Pinnock, Lorenzo Nigro, and Nicolò Marchetti, pp. 781–91. Wiesbaden: Harrossowitz.

Güterbock, Hans G.

1986 "Personal Reminiscences of Amarna Art in Berlin." Manuscript of a lecture delivered at a symposium on the Amarna Period at the Oriental Institute, February 1–3, 1986.

Guttentag, Daniel A.

2010 "Virtual Reality: Applications and Implications for Tourism." *Tourism Management* 31/5: 637–51.

Guy, Philip L. O.

1931 *New Light from Armageddon: Second Provisional Report (1927-29) on the Excavations at Megiddo in Palestine*. Oriental Institute Communications 9. Chicago: University of Chicago Press.

1932 "Balloon Photography and Archaeological Excavation." *Antiquity* 6/22: 148–55.

Halliburton, Richard

1937 *Richard Halliburton's Book of Marvels: The Occident*. Indianapolis: Bobbs-Merrill.

1938 *Richard Halliburton's Second Book of Marvels: The Orient*. New York: Bobbs-Merrill.

Hamblin, Dora Jane

1973 *The First Cities*. The Emergence of Man Series. New York: Time-Life Books.

Harrison, Timothy P.

2004 Megiddo 3. *Final Report on the Stratum VI Excavations*. Oriental Institute Publications 127. Chicago: University of Chicago.

Harvard Library

2000 Papers of Prentice Van Walbeck Duell, 1894–1960: Register. Harvard College Fine Arts Library Catalog. http://oasis.lib.harvard.edu/oasis/deliver/~fal00002 (accessed 20 September 2011)

Hayes, William C.

1941 "Daily Life in Ancient Egypt." *National Geographic Magazine* 80: 419–515.

Herr, L. G.

1988 "Tripartite Pillared Buildings and the Market Place in Iron Age Palestine." *Bulletin of the American Schools of Oriental Research* 272: 47–67.

Hew, Khe Foon, and Wing Sum Cheung

2010 "Use of Three-Dimensional (3-D) Immersive Virtual Worlds in K-12 and Higher Education Settings: A Review of the Research." *British Journal of Educational Technology* 41/1: 33–55.

Holmes, Oliver Wendell

1859 "The Stereoscope and the Stereograph." *The Atlantic* 3: 738–48.

Hölscher, Uvo

1932 *Excavations at Ancient Thebes, 1930/31*. Oriental Institute Communications 15. Chicago: University of Chicago Press.

1934 The Excavation of Medinet Habu, Volume 1. *General Plans and Views*. Oriental Institute Publications 21. Chicago: University of Chicago Press.

1951 The Excavation of Medinet Habu, Volume 4. *The Mortuary Temple of Ramses III*, Part 2. Oriental Institute Publications 55. Chicago: University of Chicago Press.

James, T. G. H., editor

1982 *Excavating in Egypt: The Egypt Exploration Society, 1882-1982*. Chicago: University of Chicago Press.

James, T. G. H.

1982 "The Archaeological Survey." In *Excavating in Egypt: The Egypt Exploration Society, 1882-1982*, edited by T. G. H. James, pp. 141–59. Chicago: University of Chicago Press.

1992 *Howard Carter: The Path to Tutankhamun*. London: Kegan Paul International.

1997 *Egypt Revealed: Artists-Travelers in an Antique Land*. London: The Folio Society.

Johnson, George Lindsay

1909 *Photographic Optics and Colour Photography, Including the Camera, Kinematograph, Optical Lantern, and the Theory of and Practice of Image Formation*. New York: D. Van Nostrand Company.

Kanawati, Naguib; Alexandra Woods; Sameh Shafik; and Effy Alexakis

2010 *Mereruka and His Family, Part 3/1: The Tomb of Mereruka*. Australian Centre for Egyptology Reports 29. Oxford: Aris & Phillips.

2011 *Mereruka and His Family, Part 3/2: The Tomb of Mereruka*. Australian Centre for Egyptology Reports 30. Oxford: Aris & Phillips.

Kanawati, Naguib, and Mahmoud Abder-Raziq

2004 *Mereruka and His Family, Part 1: The Tomb of Mery-teti.* Australian Centre for Egyptology Reports 21. Oxford: Aris & Phillips.

2008 *Mereruka and His Family, Part 2: The Tomb of Waatetkhethor.* Australian Centre for Egyptology Reports 26. Oxford: Aris & Phillips.

Kennedy, David

2002 "Aerial Archaeology in the Middle East: The Role of the Military — Past, Present and Future?" In *Aerial Archaeology: Developing Future Practice,* edited by Robert H. Bewley and Włodzimierz Rączkowski, pp. 33–48. Amstedam: IOS Press.

Kenyon, Kathleen M.

1960 *Archaeology in the Holy Land.* London: Ernest Benn.

Kingslake, Rudolf

1992 *Optics in Photography.* Bellingham: The Society of Photo-Optical Instrumentation Engineers.

Lahue, Kalton C., and Joseph A. Bailey

1972 *Glass, Brass, and Chrome: The American 35mm Miniature Camera.* Norman: University of Oklahoma Press.

Lamon, Robert S., and Geoffrey M. Shipton

1939 Megiddo I. *Seasons of 1925-34: Strata I-V.* Oriental Institute Publications 42. Chicago: University of Chicago Press.

Lange, Karen E.

2005 "Unearthing Ancient Syria's Cult of the Dead." *National Geographic* 207: 108–23.

Larkin, Diana Wolfe; Barbara S. Lesko; and Leonard H. Lesko

1998 *Joseph Lindon Smith: Paintings from Egypt; An Exhibition in Celebration of the 50th Anniversary of the Department of Egyptology, Brown University, October 8-November 21, 1998.* Providence: Brown University.

Larson, John A.

2006 *Lost Nubia: A Centennial Exhibition of Photographs from the 1905-1907 Egyptian Expedition of the University of Chicago.* Oriental Institute Museum Publications 24. Chicago: The Oriental Institute.

Layard, Austen Henry

1853a *The Monuments of Nineveh, from Drawings Made on the Spot.* London: John Murray.

1853b *A Second Series of the Monuments of Nineveh, Including Bas-reliefs from the Palace of Sennacherib and Bronzes from the Ruins of Nimroud, from Drawings Made on the Spot during a Second Expedition to Assyria.* London: John Murray.

Lepsius, Richard

1849–1913 *Denkmäler aus Ägypten und Äthiopien.* 5 volumes. Berlin: Nicolaische Buchhandlung.

Lesko, Barbara

2004 "Amice Mary Calverley, 1896–1959." In *Breaking Ground: Women in Old World Archaeology,* edited by Martha Sharp Joukowsky, Brown University. http://www.brown.edu/Research/Breaking_Ground/bios/Caverley_Amice%20Mary.pdf (accessed 30 November 2011)

Lloyd, Seton

1974 *Mesopotamia: Excavations on Sumerian Sites.* London: Lovat Dickson.

Lloyd, Seton; Hans Wolfgang Müller; and Roland Martin

1936 *Ancient Architecture: Mesopotamia, Egypt, Crete and Greece.* New York: Harry N. Abrams.

Loud, Gordon

1936 Khorsabad 1. *Excavations in the Palace and at a City Gate.* Oriental Institute Publications 38. Chicago: University of Chicago Press.

Loud, Gordon, and Charles B. Altman

1938 Khorsabad 2. *The Citadel and the Town.* Oriental Institute Publications 40. Chicago: University of Chicago Press.

Malatkova, J.

2011 "Searching for an Undistorted Template: Digital Epigraphy in Action." In *Old Kingdom, New Perspectives: Egyptian Art and Archaeology, 2750-2150 B.C.,* edited by Nigel Strudwick and Helen Strudwick, pp. 192–99. Oxford: Oxbow.

Malin, Brenton J.

2007 "Looking White and Middle-Class: Stereoscopic Imagery and Technology in the Early Twentieth-Century United States." *Quarterly Journal of Speech* 93/4: 403–24.

Mann, Charles C.

2011 "The Birth of Religion." *National Geographic* 219/6: 34–59.

Manuelian, Peter Der

1998 "Digital Epigraphy: An Approach to Streamlining Egyptological Epigraphic Method." *Journal of the American Research Center in Egypt* 35: 97–113.

Marien, Mary Warner

2002 *Photography: A Cultural History*. New York: Harry N. Abrams.

Martin, Geoffrey Thorndike

1979 *The Tomb of Hetepka and other Reliefs and Inscriptions from the Sacred Animal Necropolis, North Saqqâra, 1964–1973*. London: The Egypt Exploration Society.

McCauley, Elizabeth A.; Alan Chong; and Rosella M. Zorz

2004 *Gondola Days: Isabella Stewart Gardner and Palazzo Barbaro Circle*. Edited by Cynthia Purvis. Boston: Isabella Stewart Garner Museum.

Micale, Maria G.

2008 "European Images of the Ancient Near East at the Beginnings of the Twentieth Century." In *Archives, Ancestors, Practices: Archaeology in the Light of Its History*, edited by Nathan Schlanger and Jarl Nordbladh, pp. 191–203. New York: Berghahn Books.

Mitchell, William J. T.

1994 *Picture Theory: Essays on Verbal and Visual Representation*. Chicago: University of Chicago Press.

Molyneaux, Brian L.

1997 *The Cultural Life of Images: Visual Representation in Archaeology*. New York: Routledge.

Moser, Stephanie, and Sam Smiles, editors

2005 *Envisioning the Past: Archaeology and the Image*. Malden: Blackwell.

Moser, Stephanie, and Clive Gamble

1997 "Revolutionary Images: The Iconic Vocabulary for Representing Human Antiquity." In *The Cultural Life of Images: Visual Representation in Archaeology*, edited by Brian L. Molynieux, pp. 184–212. New York: Routledge.

Münger, Stefan; Juha Pakkala; and Jürgen Zangenbergen

2009 "Tel Kinrot, Kinneret Regional Project: Preliminary Report." *Hadashot Arkheologiyot* 121 (digital edition). http://www.hadashot-esi.org.il/report_detail_eng.asp?id=1080&mag_id=115 (accessed on 30 November 2011)

Murnane, William J.

1980 *United with Eternity: A Concise Guide to the Monuments of Medinet Habu*. Chicago: The Oriental Institute; Cairo: The American University in Cairo Press.

Naville, Édouard

1898 *The Temple of Deir el Bahari*, Part 3: *End of Northern Half and Southern Half of the Middle Platform*. London: The Egypt Exploration Society.

Newberry, Percy

1893 *Beni Hasan*, Part 1: *Archaeological Survey 1*. London: The Egypt Exploration Society.

1894a *El-Bersheh*, Part 1: *The Tomb of Tehuti-Hetep*. Archaeological Survey of Egypt 3. London: The Egypt Exploration Society.

1894b *Beni Hasan*, Part 2: *Archaeological Survey 2*. London: The Egypt Exploration Society.

Nims, Charles F.

1938 "Some Notes on the Family of Mereruka." *Journal of the American Oriental Society* 58/4: 638–47.

1973 "The Publication of Ramesside Temples in Thebes by the Oriental Institute." In *Textes et langages de l'Égypte pharaonique: cent cinquante années de recherches, 1822–1972: hommage à Jean-François Champollion*, volume 2, edited by Serge Sauneron, pp. 89–94. Bibliothèque d'étude 64. Cairo: Institut français d'archéologie orientale.

Oriental Institute of the University of Chicago

1931 *The Oriental Institute of the University of Chicago (handbook)*. 3rd edition. Chicago: University of Chicago Press.

Ornan, Tallay

2007 "The Godlike Semblance of a King: The Case of Sennacherib's Rock Reliefs." In *Ancient Near Eastern Art in Context: Studies in Honor of Irene J. Winter by her Students*, edited by J. Cheng and M. Feldman, pp. 161–78. Leiden: Brill.

Orthmann, Winfried

1975 *Der alte Orient*. Propyläen-Kunstgeschichte 14. Berlin: Propyläen-Verlag.

Özgüç, Tahsin, and Nimet Özgüç

1953 Kültepe Kazısı Raporu 1949 / Ausgrabungen in Kültepe. Ankara: Türk Tarih Kurumu Basımevi.

Paley, Samuel M., with Donald H. Sanders

2010 "The Northwest Palace in the Digital Age." In *Assyrian Reliefs from the Palace of Ashurnasirpal II: A Cultural Biography*, edited by Ada Cohen and Steven E. Kangas, pp. 215–26. Hanover: Hood Museum of Art.

Peck, William

2001 "Windows on Antiquity: Egypt of the Late 1830s Captured for all Time in the Works of Scottish Artist David Roberts." *KMT: A Modern Journal of Ancient Egypt* 12/ 2: 68–83.

Perring, Stefania, and Dominic Perring

1991 *Then and Now: The Wonders of the Ancient World Brought to Life in Vivid See-Through Reproductions.* New York: Macmillan.

Place, Victor

1867–70 *Nineve et l'Assyrie, avec d'essais de restitution par Félix Thomas.* 3 volumes. Paris: Imprimerie impériale.

Politis, Dionysios

2008 *E-Learning Methodologies and Computer Applications in Archaeology.* Hershey: IGI Global.

Pritchard, James B.

1970 "The Megiddo Stables: A Reassessment." In *Near Eastern Archaeology in the Twentieth Century: Essays in Honor of Nelson Glueck,* edited by James A. Sanders, pp. 268–76. Garden City: Doubleday.

Ranke, Hermann

1939 Review of *The Mastaba of Mereruka,* by The Sakkarah Expedition. *Journal of the American Oriental Society* 59/1: 112–15.

Reader's Digest, editors

1974 *Great Peoples of the Bible and How They Lived.* New York: Reader's Digest Association.

Reeves, Nicholas, and John Taylor

1993 *Howard Carter: Before Tutankhamun.* New York: H. N. Abrams.

Refsland, Scot Thrane

1998 "Finding the Virtual in Our World Heritage History." *Computer Graphics* 32/4: 16–19. http://www.siggraph.org/publications/newsletter/v32n4/columns/fraser.html (accessed on 12 September 2011).

Rezaeian, Farzin

2004 *Persepolis Recreated.* Toronto: Sunrise Visual Innovations.

2007 *Iran: Seven Faces of a Civilization.* Toronto: Sunset Visual Innovations.

Robinson, Edward

1892 *The Hermes of Praxiteles and the Venus Genetrix: Experiments in Restoring the Color of Greek Sculpture*

by Joseph Lindon Smith. Boston: The Museum of Fine Arts.

Rosenberg, Stephen G.

2008 "British Groundbreakers in the Archaeology of the Holy Land." *Minerva* 19/1: 26–28.

Ruffle, John

2004 "Myrtle Florence Broome (1887–1978)." In *Breaking Ground: Women in Old World Archaeology.* http://www.brown.edu/Research/Breaking_Ground/bios/Broome_Myrtle%20Florence.pdf (accessed on 7 May 2011)

Sakkarah Expedition

1938a The Mastaba of Mereruka, Part 1. *Chambers A 1-10.* Oriental Institute Publications 31. Chicago: University of Chicago Press.

1938b The Mastaba of Mereruka, Part 2. *Chambers A 11-13, Doorjambs and Inscriptions of Chambers A 1-21, Tomb Chamber, and Exterior.* Oriental Institute Publications 39. Chicago: University of Chicago Press.

Sanders, Donald H.

2007 "Why Do Virtual Heritage?" In *Digital Discovery: Exploring New Frontiers in Human Heritage* (Proceedings of the 34th Annual Meetings of the Computer Applications and Quantitative Methods in Archaeology Conference), edited by Jeffrey T. Clark and Emily M. Hagemeister, pp. 427–36. Budapest: Archaeolingua.

2000 "Archaeological Publications Using Virtual Reality: Case Studies and Caveats." In *Virtual Reality in Archaeology,* edited by Juan A. Barceló, Maurizio Forte, and Donald H. Sanders, pp. 37–46. British Archaeological Reports, International Series 843. Oxford: Archaeopress.

1999 "Virtual Worlds for Archaeological Research and Education." In *Archaeology in the Age of the Internet* (Proceedings of CAA 97: Computer Applications and Quantitative Methods in Archaeology 25th Anniversary Conference, University of Birmingham, April 1997), edited by Lucie Dingwall, Sally Exon, Vince Gaffney, Sue Laflin, and Martijn van Leusen, pp. 265–66. British Archaeological Reports, International Series 750. Oxford: Archaeopress.

1997 "Archaeological Virtual Worlds for Public Education." *Computers in the Social Sciences Journal* 5/3.

Schavemaker, Margriet

2011 "Is Augmented Reality the Ultimate Museum App? Some Strategic Considerations." *Museum Magazine* 90/5: 46–51.

Schlanger, Nathan, and Jarl Nordbladh, editors
2008 *Archives, Ancestors, Practices: Archaeology in the Light of Its History.* New York: Berghahn Books.

Schmandt-Besserat, Denise
1992 *Before Writing,* Volume 1: *From Counting to Cuneiform.* Austin: Univeristy of Texas Press.

Schmidt, Erich F.
1940 *Flights over Ancient Cities of Iran.* Chicago: University of Chicago Press.
1953 Persepolis 1. *Structures, Reliefs, Inscriptions.* Oriental Institute Publications 68. Chicago: University of Chicago Press.

Smiles, Sam, and Stephanie Moser, editors
2005 *Envisioning the Past: Archaeology and the Image.* Malden: Blackwell.

Smith, William Stevenson
1939 Review of *The Mastaba of Mereruka,* by The Sakkarah Expedition. *American Journal of Archaeology* 43/2: 348–50.

Sontag, Susan
1977 *On Photography.* New York: Farrar, Straus & Giroux.

Speiser, Ephraim A., and Herbet M. Herget
1951 "Ancient Mesopotamia: A Light that did not Fail." *National Geographic Magazine* 99: 41–105 Reprinted in 1951 by the National Geographic Magazine in *Everyday Life in Ancient Times: Highlights of the Beginnings of Western Civilization in Mesopotamia, Egypt, Greece, and Rome,* pp. 5–69.

Stanley-Price, Nicholas
1995 *Conservation on Archaeological Excavations.* Rome: ICCROM (International Centre for the Study of the Preservation and Restoration of Cultural Property).

Stanley-Price, Nicholas, and Joseph King, editors
2009 *Conserving the Authentic: Essays in Honour of Jukka Jokilehto.* Rome: ICCROM (International Centre for the Study of the Preservation and Restoration of Cultural Property).

Stephan, Carl N., and Ellie K. Simpson
2008a "Facial Soft Tissue Depths in Craniofacial Identification, Part 1: An Analytical Review of the Published Adult Data." *Journal of Forensic Science* 53/6: 1257–72.
2008b "Facial Soft Tissue Depths in Craniofacial Identification, Part 2: An Analytical Review of the Published Sub-Adult Data." *Journal of Forensic Science* 53/6: 1273–79.

Stone, Robert; David White; Robert Guest; and Benjamin Francis
2008 "The Virtual Scylla: An Exploration of 'Serious Games,' Artificial Life and Simulation Complexity." *Virtual Reality* 13/1: 13–25.

Strudwick, Nigel
2004 "Nina M. Davies — A Biographical Sketch." *Journal of Egyptian Archaeology* 90: 193–210.

Taft, Robert
1938 *Photography and the American Scene: A Social History, 1839-1889.* New York: Dover Publications.

Taylor, Karen A.
2000 *Forensic Art and Illustration.* Boca Raton: CRC Press.

Teeter, Emily
2010 "Epilogue: An Appraisal of the First Expedition." In *Pioneers to the Past: American Archaeologists in the Middle East, 1919-1920,* edited by Geoff Emberling, pp. 101–14. Oriental Institute Museum Publications 30. Chicago: The Oriental Institute.

Teeter, Emily, and Janet H. Johnson, editors
2009 *The Life of Meresamun: A Temple Singer in Ancient Egypt.* Oriental Institute Museum Publications 29. Chicago: The Oriental Institute.

Thomas, Nancy, editor
1995 *The American Discovery of Ancient Egypt.* Los Angeles: Los Angeles County Museum of Art.

Thompson, Jason
1992 *Sir Gardner Wilkinson and His Circle.* Austin: University of Texas Press.

Tillett, Selwyn
1984 *Egypt Itself: The Career of Robert Hay, Esquire, of Linplum and Nunraw, 1799-1863.* London: SD Books.

Treptow, Tanya
2007 *Daily Life Ornamented: The Medieval Persian City of Rayy.* Oriental Institute Museum Publications 26. Chicago: The Oriental Institute.

Trouillot, Michel-Rolph
2003 *Global Transformations: Anthropology and the Modern World.* New York: Palgrave Macmillan.

Unattributed
1928 "Notes and News." *Journal of Egyptian Archaeology* 14, no. 1/2: 180–84.

University of Chicago, Oriental Institute

1935 *The Oriental Institute of the University of Chicago (handbook)*. 4th edition. Chicago: University of Chicago Press.

1939 *Buried History: A Catalogue of Oriental Institute Publications, Twentieth Anniversary Number, 1919-1939*. Chicago: University of Chicago Press.

von der Osten, Hans H., and Erich F. Schmidt

1930 Researches in Anatolia 2. *The Alishar Hüyük Season of 1927*, Part 1. Oriental Institute Publications 6. Chicago: University of Chicago Press.

De Vries, Bert

1992 "The Balloon Project." *American Center of Oriental Research Newsletter* 4/2: 11.

Walsh, Tim

2005 *Timeless Toys: Classic Toys and the Playmakers Who Created Them*. Kansas City: Andrew McMeel Publishing.

Wartke, Ralf-B., editor

2008 *Auf dem Weg nach Babylon: Robert Koldewey, ein Archäologenleben*. Mainz: Philipp von Zabern.

Weeks, Kent R.

1979 "Art, Word, and the Egyptian World View." In *Egyptology and the Social Sciences: Fice Studies*, edited by Kent Weeks, pp. 59-81. Cairo: The American University in Cairo Press.

Wells, Liz, editor

1997 *Photography: A Critical Introduction*. London: Routledge.

Weyer, Edward M., Jr.

1929 "Exploring Cliff Dwellings with the Lindberghs." *The World's Work* 58: 52-57.

White, Robert

1995 *Discovering Cameras, 1945-65*. Buckinghamshire: Shire Publications.

Wightman, Gregory J.

1990 "The Myth of Solomon." *Bulletin of the American Schools of Oriental Research* 277/278: 5-22.

Wilson, David R.

1982 *Air Photo Interpretation for Archaeologists*. New York: St. Martin's Press.

Wilson, John A.

1964 *Signs and Wonders upon Pharaoh: A History of American Egyptology*. Chicago: University of Chicago Press.

1972 *Thousands of Years: An Archaeologist's Search for Ancient Egypt*. New York: Charles Scribner.

Winter, Irene J., editor

2010 *On Art in the Ancient Near East*, Volume 1: *Of the First Millennium B.C.E.* Leiden: Brill.

Woolley, C. Leonard, and P. Roger S. Moorey

1982 *Ur 'of the Chaldees': A Revised and Updated Edition of Sir Leonard Woolley's Excavations at Ur*. Ithaca: Cornell University Press.

Yadin, Yigael

1970 "Megiddo of the Kings of Israel." *Biblical Archaeologist* 33/3: 66-96.

Youngblut, Christine

1998 *Educational Uses of Virtual Reality Technology*. Technical Report D-2128. Alexandria: Institute for Defense Analysis.